LANDSCAPE DRAWINGS OF FIVE CENTURIES, 1400-1900

FROM THE
ROBERT LEHMAN COLLECTION
METROPOLITAN MUSEUM OF ART

Landscape Drawings of Five Centuries, 1400-1900

From the
Robert Lehman Collection
Metropolitan Museum of Art

Mary and Leigh Block Gallery
Northwestern University

Landscape Drawings of Five Centuries, 1400-1900:
From the Robert Lehman Collection, Metropolitan Museum of Art
is published to accompany an exhibition of the same title on view at the
Mary and Leigh Block Gallery from January 14, 1988 through March 20,
1988.

Metropolitan Museum of Art (New York, N.Y.)

Landscape Drawings of Five Centuries, 1400-1900

"Published to accompany an exhibition of the same title on view at the Mary
and Leigh Block Gallery from January 14, 1988 through March 20,
1988"--T.p. verso.

Bibliography: p. 198

1. Landscape drawing--Exhibitions. 2. Lehman, Robert, 1892-1969--Art
collections--Exhibitions. 3. Landscape drawing--Private collections--New York
(N.Y.)--Exhibitions. 4. Metropolitan Museum of Art (New York,
N.Y.)--Exhibitions. I. Szabo, George. II. Mary and Leigh Block Gallery. III.
Title. IV. Title: Landscape Drawings of Five Centuries, 1400-1900.

NC790.M48 1988 741.94'074'01731 87-34829
ISBN 0-941680-06-1

Landscape Drawings of Five Centuries, 1400-1900 has been organized
by the Robert Lehman Collection of the Metropolitan Museum of Art and
the Mary and Leigh Block Gallery of Northwestern University. It has been
funded by the Friends of the Mary and Leigh Block Gallery and the Hulda B.
and Maurice L. Rothschild Foundation.

Cover: Rembrandt Harmensz van Rijn
Dutch, 1606-1669
Two Cottages
Cat. No. 22

LANDSCAPE DRAWINGS OF FIVE CENTURIES, 1400-1900

FROM THE ROBERT LEHMAN COLLECTION METROPOLITAN MUSEUM OF ART

Foreword

David Mickenberg
Director
Mary and Leigh Block Gallery
Northwestern University

Catalogue

George Szabo
Curator
Robert Lehman Collection
Metropolitan Museum of Art

Essays

Larry Silver
Department of Art History
Northwestern University

Levi P. Smith III
Martha Ward
Department of Art History
University of Chicago

Contents

Foreword . IX

 David Mickenberg

Essays

 Town and Country: Early Landscape Drawings . 1
 Larry Silver

 Topography and the Imagination, Modern Landscape Drawings 19
 Levi P. Smith III with the assistance of Martha Ward

Color Plates . 31

Exhibition Catalogue . 49

 George Szabo

Catalogue Abbreviations and Bibliography . 198

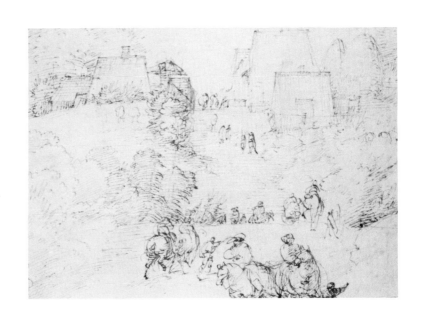

FOREWORD

David Mickenberg

FOREWORD

Landscape Drawings of Five Centuries is an exhibition whose occurrence is uniquely appropriate and timely for the Block Gallery. Drawn from the massive holdings of the Robert Lehman Collection at the Metropolitan Museum of Art, the works in this exhibition are amongst the finest in American drawing collections. With works by Rembrandt, Titian, Fragonard, Tiepolo, Gainsborough, Ruskin, Daubigny, Corot, Boudin, Renoir, Seurat, Signac, Van Gogh, and others, the exhibition presents a series of beautiful and important works illuminating a panoply of ideas and interpretations in the image of the landscape over a 500-year period.

As a university museum, such an exhibition and its accompanying catalogue presents the Block Gallery with an opportunity to put forth new ideas and research not only on these works, but on the history of landscape drawing in general. As an educational asset for Northwestern University, the exhibition's presence on campus at a time when courses concerned with the importance and varied meaning of landscape imagery (such as those taught by Professors Larry Silver and Holly Clayson) are offered, is both fortuitous and an act of good planning.

Exhibitions of this magnitude are not the product of one particular individual's efforts, but of the efforts of many. Landscape Drawings of Five Centuries could not have been presented without the assistance, advice and cooperation of Dr. George Szabo, Curator, Robert Lehman Collection, Metropolitan Museum of Art. His constant willingness to lend and share works in the Lehman Collection has provided for many fascinating exhibitions as well as numerous forums for scholars to contribute to a wide spectrum of the history of art. He has been a constant source of ideas and is a cherished friend. The staff of the Lehman Collection, Susan Romanelli, Amy Willig and Loretta Lorrance, have all patiently provided assistance in logistical arrangements, editing and a myriad of other technicalities that enabled this exhibition to come to fruition.

It is also our pleasure to recognize Philippe de Montebello, Director, Metropolitan Museum of Art; Herb Moskowitz, Registrar, Metropolitan Museum of Art; the President and Directors of the Robert Lehman Foundation; and the Trustees of the Metropolitan Museum of Art. All have approved, encouraged and supported this exhibition.

It is also a pleasure to recognize Arnold Weber, President, Robert Duncan, Provost, Jeremy Wilson, Associate Provost and the members of the Block Gallery Committee, Northwestern University, for their constant support of the growth and excellence of the Gallery. Other members of the Northwestern Community, Cathy Tritschler and Karen Bassett in Budget; Nancy Liskar, Lynda Karr, and Lee Yost in University Relations; and George Wendt, Al Blum and Ann Robinson in Development have all been of immense assistance and have offered advice and counsel that made Landscape Drawings of Five Centuries a reality.

From editing and publishing the catalogue, to designing the installation, writing didactic labels and organizing the lecture series held in conjunction with the exhibition, the staff of the Mary and Leigh Block Gallery has been a pleasure to work with. For a small staff, they have undertaken and met enormous goals with incredible professional acumen. Elizabeth Boone, Curator; Jim Riggs-Bonamici, Registrar/Preparator; Barbara Wolf, Departmental Assistant; and Tracy Tanaka and Martha Averill, Graduate Interns, have all ensured that this exhibition would be a success.

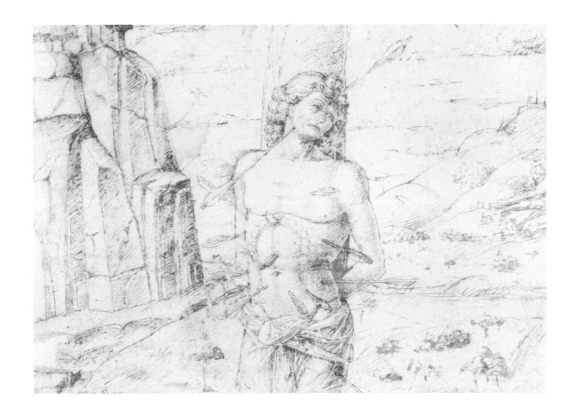

TOWN AND COUNTRY:
EARLY LANDSCAPE DRAWINGS

Larry Silver

In memory of Selma Sprecher Harris
(Northwestern University Class of '36)

TOWN AND COUNTRY:
EARLY LANDSCAPE DRAWINGS

Nature surrounded mankind long before there were any pictures described as "landscapes."[1] In fact, despite some isolated, early instances of painted landscapes, particularly in 14th-century Siena, there are very few instances of consistent interest in landscape before well into the 15th century, when religious imagery in both Italy and Flanders vivified the activities of spiritual subjects by placing them within richly realized landscapes. The first actual mention of "landscapes" with words resembling that English term do not appear until early in the 16th century, at which time the making of landscapes appears to have been a fairly widespread practice in both Flanders and Italy, as well as in Germanic countries.[2] The earliest specific use of the term *landscape* as we know it seems to have been Albrecht Dürer's characterization of his fellow-painter in Antwerp, Joachim Patinir, as "Master Joachim, the good landscape painter."[3] A few days later Dürer mentioned giving Patinir a drawing with four St. Christopher figures on it, a gesture that might well tally with what we know of Patinir's practice of collaborating in some of his pictures with other artists, who painted the figures, while Patinir painted the vast, panoramic landscapes.[4] Ernst Gombrich's assertion, namely that in Italy the revival of classical terms for landscape had to take place before any such pictures could be made to conform to this new notion, reverses both the logic and the actual cultural practice of making landscapes. As if anticipating Robert Frost's poetic statement, "The land was ours before we were the land's," artists had already established their relationship to making pictures of nature considerably earlier than they had named those works as "landscapes."[5]

The task of this essay is to trace some of the aspects of meaning implicit in the early cultural practice of making landscapes. Using the remarkable range of drawings from the Lehman Collection, as well as the larger corpus of both paintings and other works on paper that survive, we can glean something of the special relationships of man to nature that are inscribed in the early history of landscapes.

At the outset, it should be stated that there is no necessary outside reference for the landscapes depicted from the 15th through the 17th-centuries. In fact, the later distinctions made in practice between "classical," sublime," and "picturesque" landscapes point to the greater importance of prior concepts rather than observed sites in the formulation of such landscape pictures (although, as the term *picturesque* suggests, drawing from a site eventually became a recommended practice, culminating in the 19th-century *plein air* paintings of Barbizon and impressionism, and cannot be excluded from this earlier period). However, topographical renderings of specific sites were also considered the appropriate province of artists, as another quotation of Dürer makes clear: "By aid of delineation in painting, the measurements of the earth, the water, and the stars have come to be understood."[6] Indeed, this dialectic between the imagined or ideal landscape and the topographic rendering of a recognizable site is one of the polarities within which much early landscape is defined.

The other chief interrelationship that defines landscape vision in art is the presence or absence of humans and/or habitation within a depicted setting. Of course, there is always the question of the audience for a work of art as well, even if no humans are rendered within a landscape. But at its most basic level, landscape defines a particular interaction between man and nature, between figure and landscape, and we can often consider questions of meaning precisely in terms of this fundamental relationship.[7]

Kenneth Clark and others are surely right to emphasize the watershed moment of Petrarch's ascent of Mount Ventoux as symbolizing a new view of man's surroundings as a definition of his nature and his limitations. Cast in the framework of an Augustinian vision of life as a pilgrimage (and including a dialogue with his transported text of

Augustine's *Confessions*), Petrarch's experience of a mountainside as a personal test and a personal measure introduces a new mentality, in which, like landscapes in art, the human is assessed in relation to the natural. One must stress here, however, that Mount Ventoux is read as much allegorically as topographically in Petrarch's account; indeed, his successive reflections on his experience are analogous to the gradual ascent by Dante up the steep slope of Purgatory and to the successive stages of interpretation of sacred texts, from the literal to the anagogical, in Dante.[8]

This emphatic self-awareness and confident assertion of individual capacity by Petrarch cannot be divorced from developments in both international trade and religion. Petrarch made his ascent in the neighborhood of the exiled papacy in Avignon at a time when religious turmoil and corporate uncertainty reinforced a new individuation of spiritualism, perhaps best known from the medicant preaching order that arose in the train of Francis of Assisi. Those friars preached within the emerging trade and finance centers of Italy, and both Siena and Florence became assertive rivals for commercial and political as well as artistic hegemony. Thus, the central role of the individual burgher of the cities assumed increasing importance in contrast to the traditional domination of the other two "orders" of feudal society: the institutional clergy and the noble knights.[9] As a consequence, the art produced for Italian, and eventually also Flemish, city-states as well as for their prosperous burghers also incorporated their assertive new confidence in pictorial imagery.

The most concrete assertion of civic self-confidence in the form of landscape is the fresco image, *Good Government*, by Ambrogio Lorenzetti in the Public Palace, or city hall, of Siena (1337-39), a work that has often been singled out as one of the first pure landscape images.[10] This is quite clearly a vision intended to depict Siena and its surrounding countryside, and it evenly balances the enclosed city within its walls at the left with the expansive golden fields and Tuscan hills to the right. Both urban and rural habitation and activities take place in this landscape, and both labor and leisure coexist in the form of dancing townspeople as well as aristocratic hawkers at the outskirts of the gate. The gate itself seems to be the nexus of an easy commercial interchange between the farmers beyond and the burghers within, amidst the rapid construction of their city fabric.

The larger context of this scene is an adjacent allegory of Good Government, with personifications of virtues and the Body Politic, based on the tenets of Aristotle by way of Aquinas.[11] On the other two walls is the negative perversion, the damaged frescoes of both the ruined city under Bad Government as well as the allegory of Tyranny. The kind of reading that Lorenzetti's fresco is supposed to receive in its original context is conveyed by yet another personification, a winged, youthful woman, above the gateway. She is Securitas, and she holds a scroll announcing that the people will be safe as long as she (justice) rules: "Without fear let everyone travel freely..." Below, a long inscription, to be read by the city magistrate of Siena, captions the larger landscape in similar fashion:

"Behold the good things she provides us with and how sweet and tranquil is life in the city in which she is maintained."

Thus we realize that this most urban of frescoes is designed by and for the ruling elite of the city-state of Siena. Hence, its landscape is meant to be taken as the ideal image of *pax civitatis*, where these happy farms are the satellites and providers for the well-run city. For all of its topographical reference, including the Duomo of Siena in the upper left corner of the city section, this is a fundamentally ideal vision of the country from the city's point of view. Seen as such, the landscape's articulation is also clearer, with its head-on view of the elevated city site looking downward onto the farms of the adjacent *campagna*. With respect to its origins in the eyes and minds of its viewers, such a fresco is not unlike a civic version of the patronizing views of productive peasants found in calendar illustrations produced early in the 15th century for wealthy princes. One example is the renowned *Très Riches Heures* of Jean, Duke of Berry, whose castles dominate the backgrounds of these farms, and whose alternate seasonal scenes display aristocratic pastimes, such as hawking and horseback riding.[12] That Michael Baxandall reminds us of strife within the commune of Siena as well as between the city and the subject countryside in no way lessens the importance of these frescoes as ideal images; on the contrary, it reminds us of how much art often presents us with images of wishes and hopes, of ideals that sometimes contrast with harsher realities—in this case the obvious imbalance between town and country. This distinction between *society*, as revealed to us through the historical record of economic and political documents, and *culture*, as recorded in images, often collective, such as this fresco or literature, thus becomes analogous to the relationship between literal *topography*, depiction of a specific site "for the record," and *landscape*, the cultural practice of rendering a natural site according to some conceptual vision, perhaps idealized, but perhaps also quite often based on familiar forms of the environment. We must also be on our guard throughout the history of landscape to distinguish between illusionistic means of rendering and the actual objects being rendered. Realism of means in no way implies, though it may surely reinforce the desired suggestion of, realism of depiction in the topographical sense.[13]

What we learn to look for in terms of meaning is not unlike the overlapping terms in Baxandall's "Bouguer Principle:" namely, that the use of art within institutional contexts of viewing constitutes common (visual) culture. We cannot exhaust the relationships between works of art and the society for which they are made, nor can we fully describe all of the pertinent features within the works of art. But if we focus our attention on the dialectic between man and nature, between landscape art as a cultural practice and the institutions in which it is viewed, then we can come closer to interpreting the local meanings of such works for their contemporary viewers.

I

A good starting point for our series of local analyses is

the very first drawing from the Lehman Collection: *The Bear Hunt,* attributed to the Flemish artist Frank van der Beecke (second half of the 15th century; no. 1). With this subject, we are brought very close to the world of luxury manuscript calendar illustrations and other late medieval court works of art, such as tapestries, depicting hunting as a noble or princely pastime.[14] More often, these courtly hunts used stags, or occasionally (as in the December page of the *Très Riches Heures*) boars, as their quarry, and these images often included women present, dressed in costly fashions and riding on horseback. The hunting of a bear was usually less luxurious, because it involved much more danger, and the professional attendants usually had to dispatch the animal with long spears in order to stay out of its reach. Against such a violent reality, the Lehman drawing seems quite tame, although it includes the dogs and spears of the actual boar hunt of the day. But with its ladies and its background castle, this busy court scene seems to have more in common with the peaceful fishing or falconry scenes in works associated with Jan van Eyck and with his courts of Holland or Burgundy.[15] In similar fashion, the anonymous Housebook Master includes a stag hunt among his drawings of courtly scenes in the manuscript at Schloss Wolfegg, made for a knight from the circle of the counts of Württemberg.[16] Thus, the background castle and the equestrian party, including ladies, in *The Bear Hunt* link it to the courtly drawings produced by the Housebook Master for an aristocratic audience in southwestern Germany, and we may well surmise a courtly milieu, probably that of the ruling dukes of Burgundy, for *The Bear Hunt.* Rubens's hunt scenes for noble patrons in the early 17th century continue this tradition.

Another drawing surely intended to be viewed within a courtly context is that of *Venus Embracing Cupid,* by Francesco del Cossa (no. 4), an artist celebrated for his work for the Este family at Ferrara.[17] The very use of classical subjects suggests, as does the series of mythologies made by Botticelli for the Medici circle in Florence, a cultivated audience of learned and sophisticated *cognoscenti.*[18] In contrast to Botticelli's classically inspired nude Venus, however, the fashionably clad beauty of Cossa's drawing must be understood within a courtly context that is still linked to the labors of the months and to the astronomical progression of the seasons. Cossa also took part in the production of the celebrated frescoes in the Schifanoia Palace in the early 1470s, in which court life is pictured along with the same kind of zodiacal cycle of time as can be found in the miniatures of Franco-Flemish court manuscripts.[19] The taste at such courts for eroticism (often pagan; the Este family also had a now-lost cycle of Psyche) accords with the inherited medieval courtly traditions of such themes as the Castle of Love, still current for the Housebook Master. In the Housebook itself (fo. 15r) as in the Schifanoia cycle, Venus appears within the medieval context of the Children of the Planets, whose followers enjoy music and love. In the Ferrara frescoes Venus is the ruler of April, then the second month on the calendar, and she supervises a world of lovers in the upper zone in the same kind of clinging fashion as in the drawing, although the three Graces appear nude in the upper right. If we turn again to Cossa's

drawing, we find tiny cupid figures populating the landscape and the draped figure of Venus and the other young women, presumably the three Graces along with a fourth maiden, who holds a mirror like an attendant to a court lady. From a background palace emerge other well-dressed women to join this amorous yet courtly precinct. Fertile animals of Venus, rabbits and doves, and a courtly bird of paradise, the peacock, animate the setting, while springtime flowers shower down from a cupid in the upper right. One clear image that continues the astrological character of Schifanoia Palace is the bull of Taurus, zodiacal sign of April, in the sky above the background palace. The older male figure below has been identified as Vulcan by means of the forge underneath the site with the women, but he is also a laborer, humbly dressed and busy with the seasonal task of creating a wattle fence for the courtly precinct, like the pruners in the March scene of the fresco cycle. Thus paganism and courtliness mix freely to create a joyous image of springtime amours, appropriately attended by a bevy of cupids, but otherwise more appropriate to palace entertainments than to the myths of ancient Greece and Rome. This is Venus the planet, whose springtime dominance brings forth music and love to the leisured life of nobles, such as Cossa's Este patrons in Ferrara.

II

If these early examples of art produced for a courtly audience offer more references to their beholders than to actual sites (the chief markings of place are those generalized palaces in the distant backgrounds), then religious subjects depend in no way on topography for their effects. Of course, the Holy Land of the Bible is the local setting for these events, but the fact that virtually no artists prior to the 16th century had actually visited Jerusalem meant that all were free to suggest or evoke whatever setting the text seemed to mandate.[20] Quite a representative image of the later 15th-century Italian use of nature in religious pictures is the drawing *St. Sebastian* (no. 5), by Cossa's Ferrarese colleague, Ercole de' Roberti. This saint enjoyed a special popularity among worshipers on account of his powers to prevent or heal the plague, and he was equally favored by Renaissance painters because his ordeal as a target for arrows made him an early "pinup" for the rendering of the standing male nude in art. This image also echoes the dominant paintings by Andrea Mantegna, at the Gonzaga court in nearby Mantua, of St. Sebastian in a rocky landscape.[21] This dry and barren wilderness is the arena of spiritual trials, a site in which the individual saint is tested, whether by bodily torments, such as Sebastian's arrows, or by spiritual trials and meditation in such a site (Christ on the Mount of Olives, St. Jerome, John the Baptist, or St. Francis with his stigmata).[22] Here the landscape is not just a scenic background; rather, it is the essential setting for such a test, akin to the allegorical use of a mountain climb by Petrarch as a moral proving ground for the individual: "What you have so often experienced today while climbing this mountain (Ventoux) happens to you, you must know, and to many others who are making their way toward the

blessed life."

Within the realm of German art, the wilderness settings took on a mysterious and dominant Alpine character, with tall pine trees and craggy, distant mountain peaks. For the holy figures, such settings often provided a haven or retreat, congenial to their true spiritual humility and far from the madd'ing crowds of the cities. Thus, when Albrecht Altdorfer (or his close follower) rendered *The Holy Family* (no. 11), he placed them out of doors, with none of the angelic retinue or elaborate haloes or costumes that might otherwise be expected. This quiet scene also stresses the value of landscape for meditation, as the pensive St. Joseph turns his back to the main figures to remain absorbed in the religious text he is studying. Altdorfer's image offers a later treatment of a famous Dürer woodcut, *The Visitation* (ca. 1504), from the series *The Life of the Virgin,* in which the meeting of the saintly cousins Mary and Elizabeth takes place under trees and in front of mountains. But Altdorfer has produced a virtuoso study of dramatic lights and darks in his use of both black and white inks on paper with a colored ground; this was surely a work prepared for a sophisticated collector. In addition, it is a scene not mentioned in any biblical text, for here the two holy infants, Christ and John the Baptist, have already been born, and the visit can be seen to offer a kind of fulfillment of prophecy, almost like an ideal vision. This is precisely the kind of epiphany that Leonardo da Vinci produced in his *Virgin of the Rocks* (Paris; London),[23] but it also has an internal coherence, as if the women and children were the realization of the spiritual meditations of the contemplative reader, Saint Joseph, behind them. Thus, in a highly evocative drawing, Altdorfer used landscape to underscore both the local and the mystical significance of pious meditation for the devout beholder of such an image. This is the same kind of visual assertion of the immanence of holy figures and of the links between heaven and earth that Altdorfer depicted in his paintings, most notably in the Munich *Madonna and Child in a Glory.*[24]

In the Netherlands, it was Patinir who perfected the formula of the wilderness landscape in which a saint, in isolation, meditates in the highlands, while farms and towns and human cultivation in general fill out lowlands. This kind of encompassing panorama of opposing features—saint versus cultivation, highlands versus lowlands—has come to be called a "world landscape," and it was Patinir's legacy to Flemish and Dutch art for well over a century.[25] A major heir of Patinir was Peter Bruegel in such religious works as the engraving of St. Jerome or the drawing (ca. 1555; Antwerp) and print of *Pilgrims to Emmaus,* but Bruegel was one of the first artists who successfully divorced landscapes from the spiritual figures that had almost invariably inhabited nature in the art of Patinir and his followers for half a century (see below). Another heir of this same concept was Bruegel's neighbor, Hans Bol, from Mechelen, whose drawing, *Landscape with Abraham and the Angels* (no. 16) utilizes the same landscape formula: an elevated corner foothold with figures, which overlooks a flatland river valley with habitation and then gives way to a distant mountain range at the horizon.[26] Here again we are in the

realm of the interaction between earth and heaven in the secluded setting of a holy man's retreat. If the formula for a retreat in Italy was a rocky barren, or in Germany an Alpine forest, then in Flanders it was the fertile exurb of a hilly countryside that mixes Belgian town and country with entirely foreign, "fantastic," imported elements like the mountains. (According to Bruegel's biographer, Carel van Mander, in 1604, the artist had "swallowed" the Alps during his travels and spat them up onto his drawings after returning home to the aptly named Low Countries).[27]

The story of Abraham and the angels (Genesis 18) takes place in the text on "the plains of Mamre" in front of the "tent" of the patriarch, and it is a text of epiphany, in which the three servants of the Lord announce to Abraham that his barren wife, Sarah, will at last bear a child—an Old Testament type for the New Testament Annunciation of the angel to Mary. Thus this scene acquires significance not only by virtue of its placement of a spiritual figure on the outskirts of a conventional, if partly local, landscape, but also through the message of the event—that out of the realm of the everyday the righteous followers of God can receive a miraculous message of divine intervention. This reaffirmation of the covenant between Abraham and God was nothing less than the fulfillment of the personal, mystical piety practiced ever since St. Francis and renewed in the various Protestant creeds of the 16th century.[28]

In the context of examining religious landscape images, we have seen the significance and the frequency of secluded havens of retreat, which we might call "landscapes of meditation." One of the earliest kinds of landscape without human figures was created by the simple process of removing the religious subjects from their "native habitat" of retreat, thereby isolating the setting. The meditator who remains is the pious viewer or collector of the landscape. This is precisely what happens in the first landscape etchings by Altdorfer, where the setting is clearly on the edge of a tranquil Alpine meadow, usually overlooking a lightly inhabited countryside in the foothills of great mountains.[29] A later German example, datable to 1543, is the Lehman drawing of a quiet rural view beside a pond (no. 13). As in the case of the Altdorfer landscape etchings, the viewpoint here is extremely low, as if the artist, and then the viewer, saw this setting from a kneeling position. The plants, shrubs, and trees, as well as the bank of the pond, are all seen close-up and near their lowest points. Also important to our understanding of the meditational aspects of this site is the progressively greater habitation that enters with depth, from an isolated, open spot to walled villages and castles in the distance. Here, nature is a quiet comfort, fit for contemplation.

Slightly after mid-century, Bruegel too came to develop the uninhabited landscape, this time a scenic overlook, in his prints and drawings.[30] That Bruegel seems to have made several of his landscapes directly from nature only adds to the immediacy of the contemplative experience of God within nature, especially the isolated and formidable nature of Alpine mountains. For these are landscapes of meditation, just as surely as if the viewer were equated with the figure of St. Jerome in the corner of the

Washington drawing (1553) (fig. 1). Thus, the Lehman drawing *River Landscape* (no. 15), probably by an imitator of Peter Bruegel, perhaps from later in the century, features a dark hermitage at its left foreground margin and overlooks a river prospect into great, yet peaceful distance. This is a deep, dynamic spatial setting that attracts the viewer's attention quickly to its high horizon. Its sketchy, rapid technique also gives the impression of having been made on the spot, as the direct response to an actual broad expanse for contemplation.

At the end of the 16th century, Gillis van Coninxloo, a religious refugee from Flanders to Protestant Holland, also produced a landscape of meditation: *Wooded Landscape* (no. 17).[31] Typically, his landscapes feature thick forests, of which van Mander declared in 1604 that trees in nature began to follow his model: "The trees which were a little bare and defoliated have become leafier and more developed." Such forests began with the example of Bruegel's drawings, such as the Prague forest with five bears.[32] But in the case of Coninxloo, they are often populated by the same kind of isolated spriritual figures that we have met since the time of Patinir, such as *Elijah with the Raven* (Brussels). Thus, when we find in the Lehman drawing a vacated forest with rocks, rendered in the same kind of low, almost kneeling viewpoint as Altdorfer's landscape etchings, we can conclude that it,

too, would have suggested personal retreat as well as personal progress (allegorical as well as physical, like Petrarch) up the steep and rocky path to the right. Here, as with the bears of Bruegel's drawing, it is the very wildness of the setting that makes it particularly appropriate for contemplative isolation.

What must be stressed here is the integral and dialectical relationship between the figures (and then, eventually, the absent figures in favor of the meditative, pious viewer) and the landscapes they inhabit. For one cannot be in retreat or isolation without having a natural setting. Nor can one be in retreat without putting literal space and distance from the inhabited towns and cities of "civilization." Just as a vacation must be marked out from the normal, working times of the year, or *negotium* be made out of *otium,* so is the wilderness or landscape of meditation fundamentally related to the everyday world but set apart from it. This logical interdependency needs to be underscored, because it counters the standard, anachronistic, but often repeated explanation of early landscapes with figures: that the subjects were chosen merely as an "excuse" for making the landscapes. Such landscapes themselves may be formulaic, often with internally logical oppositions of spaces (upland/lowland; empty wilderness/populated towns) but this set of oppositions supports the argument for interdependence

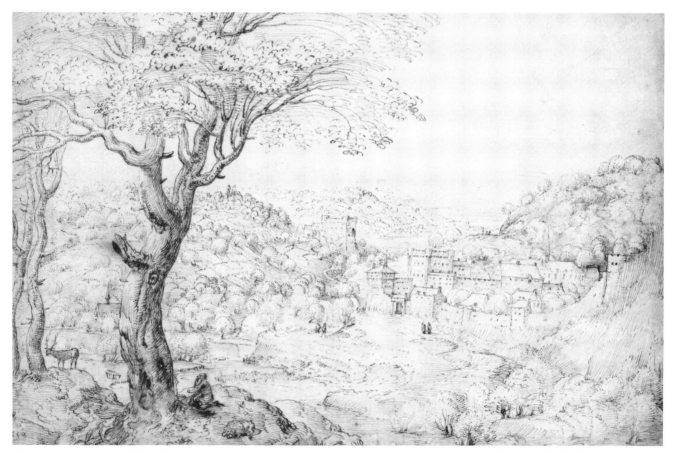

Fig. 1. Peter Bruegel, The Elder, (Flemish, 1525/30-1569), *Landscape with the Penitence of Saint Jerome.* Ailsa Mellon Bruce Fund. National Gallery of Art, Washington B-26, 196

advocated here. Yet when a recent catalogue discusses Coninxloo's design for an engraving, *Elisha Cursing the Children of Bethel,* an event from II Kings; 2, in which bears are the literal, wild instrument of a prophet's curse, it concludes that "the obscure Old Testament subject...merely provided an opportunity for Coninxloo to show a forest landscape with a town in the middle distance. It is formulaic in its general composition and its detail."[33]

III

In Venice in the early 16th century, yet another imaginative landscape realm was created, bearing the generic modern heading of "pastoral."[34] It, too, is related to courtly taste, for its patrons doubtless included many of the same kinds of sophisticated nobles who had earlier sponsored hunting scenes or erotic mythologies.[35] In this kind of landscape, however, the emphasis is on the rustic rather than the noble, and the inhabitants are usually shepherds or their tutelary deity of the flocks: the satyr Pan with his pipes. Some of the inspiration for this pastoral idiom is learned and literary, based on the *Idylls* of Theocritus and the *Eclogues* of Vergil, and worked out in contemporary verses, such as Sannazaro's *Arcadia* of 1502 and Bembo's *Gli Asolani* of 1505. This is a world of the *concert champêtre,* as represented by the figures of Titian's(?) famed Louvre painting.[36] That it could also contain mythic creatures whose lives are lived close to nature can be seen in the Lehman collection drawing by Romanino, *Pastoral Concert* (no. 8), where a satyr accompanies the courtly women in their lyrical string music outdoors.[37] The definitive turn of outdoor scenes toward a shepherd population in landscape with huts, mills, and rustic houses was made in Venice by the Campagnolas, Giulio (d. 1515) and Domenico (1500-64), who are primarily known today through their fine, stippled intaglio prints.[38]

Once again, the character of the landscapes is inseparable from the distinctive figures who inhabit them. In this case, we find shepherds, but not the simple peasants of Bruegel's Northern landscapes; instead, these are shepherd-poets, in retreat. Thus, their sensibilities—and, more important, their audience—derive from the world of courtly sophistication, despite the suggestion of world-weariness and "dropping out" to a simpler life. By implication, they will return to the world of nobility and power after this sojourn to celebrate its ancestry and great deeds in epic verse, thus recapitulating the career of Vergil, who progressed from the *Eclogues* to the *Aeneid.* This, then, is a kind of courtly or secular pose, equivalent to the spiritual isolation of the landscapes of meditation that we have just examined. And the landscape, known from antiquity onward as Arcadia, a mountainous region, defines the shepherd-poet and is reciprocally defined, and sung, by him.

No ancient pictures survived to offer models, akin to the verses of Theocritus or Vergil, for arcadian landscapes, but in the circle of Giorgione in early 16th-century Venice, that dreamlike setting was given pictorial form, as were the flute-playing young shepherds, such as the boyish

Shepherd with Flute (Hampton Court). As Bellini had created the rocky wilderness for hermit saints in paintings, so did the Giorgione circle produce enchanting, verdant fields appropriate for mythological figures, such as the *Sleeping Venus* (Dresden), or for poetic shepherds (Andrea Previtale, *Four Scenes from an Eclogue of Tebaldeo,* London).[39]

The only drawing securely connected with Giorgione already features a shepherd outside a city (Rotterdam), a delicate red chalk that evokes balmy atmosphere and contrasts the lonely figure on his grassy hillside with the sturdy city walls behind. The "definitive" Venetian pastoral formula is already clear in Giulio Campagnola's pen drawing (Louvre) with two bearded men before a hilly landscape with buildings. (Later engraved by Domenico Campagnola, the contours of this drawing are pricked for transfer).[40] Here the atmosphere, the hills, as well as the rustic buildings are all derived from Giorgione's painted prototypes, especially the background behind the Dresden *Venus* (which might have been added by Titian), and they find echoes in the early paintings of Titian. Again, the specific authorship is less important here than the widespread diffusion in Venice of this new convention of pastoral hillside settings.

This is precisely the kind of landscape to be found in Domenico's *Landscape with a Rock and Buildings* (no. 6), a work that seems to be almost a reverse of one of Giulio's Louvre landscape drawings.[41] In this formula, we find a rocky stand of trees at the margin of a foreground ledge of viewing, from which we gaze across a relatively flat zone to typical Venetian country buildings framed within the silhouette of distant background mountains. Giulio's brush drawing technique, with all of its suggestions of atmosphere, has hardened somewhat into the system of lines by Domenico, revealing the mentality of the engraver.[42] Nonetheless, this drawing has the effect of placing the viewer firmly within the pastoral version of the landscape of meditation—and at just the same seated level as the shepherds who appear in the engravings of the Campagnolas or the reclining, sleeping shepherd of the early but anonymous Venetian drawing (no. 10).

In the other Lehman collection drawing ascribed to Domenico Campagnola, *Landscape with Satyr* (no. 7), there is a greater suggestion of atmosphere by means of the greater variety of strokes with the pen in passages for the leaves on trees, the fur of the satyr, or the delicately outlined distant vista. Here, the setting is populated, most notably by the distracted satyr with his pipes (accompanied by a nestling hind) in the left foreground. A pair of truly rural peasants with their donkey intrude at the right middle ground, but the background hillside with trees contains the other aspect of the pastoral, implied by the music players of Romanino: the erotic potential of this secluded, natural privacy. A couple, featuring a seated satyr from the back and a standing, frontal, nude woman, repeats in miniature one of the typical encounters of Venetian art, from the satyr with sleeping nude in the woodcuts of the 1499 *Hypnerotomachia Poliphili* to the Bayonne Titian drawing of a landscape with satyrs a generation later.[43] Ultimately, this world of eros and pastoral will climax with Titian's spectacular tour de force,

the Vienna *Shepherd and Nymph* from his *ultima maniera*.[44]

Titian himself may be responsible for the vivacious pen drawing *Landscape with Seated Figures* (no. 9), in which these pastoral formulas achieve their mature expression. Quite characteristic of Titian is his interest in denser woods than most other Venetians depicted; a good comparison is his *Edge of a Wood* (New York, Metropolitian Museum), which was itself made the basis of landscape in Ugo da Carpi's woodcut *Sacrifice of Abraham*.[45] The Lehman drawing also has the strong sense of outline with conscious avoidance of the crosshatching that is the hallmark of designing for woodcuts (cf. Domenico Campagnola, no. 6, above).[46] Nonetheless, it captures the bright yet breezy cloud-filled skies and full growth of pastoral nature, and this lush setting provides an ideal setting for the kind of candid and intimate conversation beneath the trees that is being conducted by this secluded pair of shepherd-poets. Such arcadian images had a long life in Western art.[47]

IV

Landscape, especially without dominant figures from religion or mythology, remained an anomaly elsewhere in Italy, but there is one exceptional artist who produced no fewer than 41 landscape drawing studies: Fra Bartolommeo, a Florentine monk whose real name was Baccio della Porta (1472-1517).[48] These pen drawings of similar size were occasionally used as models for backgrounds of some of his religious paintings, but for the most part the drawings themselves omit major figures from their settings. Instead, they focus on quiet country sites, not unlike the environments that we characterized above as landscapes of retreat, but now featuring hamlets, farms, or mills, as well as rocks and forests. What is distinctive about these drawings is precisely their quotidian aspects; they are not produced just as the settings for historically significant figures or even for isolated meditation. Instead, they offer integrated pieces of convincing countryside, punctuated by travellers or peasants, as in the case of the Lehman drawing (no. 2). The ensemble of cottages nestled in trees in front of dimly suggested mountains evokes an atmospheric totality by means of varied strokes and flicks of the pen. There is no way to be certain whether this humble site actually existed in the Tuscan hills around Florence, but it might well have. What matters is its representative local character, its *typicality*. This is an inhabited and a living landscape, not an isolated world of pure contemplation, and its tiny figures and lively pen strokes suffuse this "slice of life" with animation.

If we turn our attention once again north of the Alps, we can find a similar mixture in landscapes of local views, sometimes specifically documentary or topographic in intent, along with the ongoing production of evocative, conventional, or imaginary realms that predominated during the first century of landscape pictures. Here, too, one of the earliest contributions was made by Peter Bruegel or someone from his artistic circle. In addition to the panoramic vistas in the tradition of Patinir's "world landscapes," Bruegel and/or someone from his circle also devised local, closeup views of the countryside near Antwerp. Some of these images were printed in 1559 as engravings by Bruegel's publisher at Antwerp, Hieronymus Cock, under the title "The Features of Various Cottages and Country Places Shown Carefully from Life."[49] Because of scholarly uncertainty about whether Bruegel actually drew these intimate views of villages, they have been grouped together under the label "Master of the Small Landscapes." In addition, various Bruegel imitators also produced careful studies of individual sites in his characteristic dotted ink style, such as Jacques Savery's *Landscape with Castle,* which even carries a false Bruegel signature and date (1561).[50] Within the Lehman drawings, this phase is represented by *Castle in Flanders* (no. 14), which does not aspire to the atmospheric dotting of Bruegel himself but presents a kind of direct and dominant view of a castle keep. This vision closely matches the Boston drawing (also by Jacques Savery and falsely inscribed as Bruegel, 1562) of the Saint Anthony Gate at Amsterdam. It can be compared as well with Bruegel's authentic depiction of the *Ripa Grande* on the River Tiber in Rome, produced when the artist was visiting the city in 1553.[51] Both works share a low vantage point and a high profile of the buildings' skyline above. It is this kind of careful and local appreciation of a picturesque building that would have such meaning for Savery and other Bruegel imitators as well as for the early 17th-century Dutch printmakers who also began to illustrate their own countryside in the manner of the Small Landscapes of Cock.[52]

In the current state of our knowledge, we cannot easily generalize about the significance of such works for their owners, but the specificity of the works as distinctly local sites points to a sense of local, even national (in so small a region as the Netherlands) pride, and the publication of the printed views in series was a market strategy calculated upon the premise of provincial patriotism. Their emphatic realism, clearly based upon studies from actual, if picturesque, sites in the regions around Antwerp or Haarlem, is surely based on an appeal to the familiarity of such views to collectors from the same region. It is surely significant that these are views of the classes other than the middle-class, urban buyers of such prints. One kind of site – lordly castles, including historic ruins important in Dutch history – is complemented by the rustic hamlets of farmers and peasants. Both of these settings lay outside the crowded, if prosperous, cities of Holland and offered country scenery (or imaginary travel to the country through such views) as an alternative locality.[53] This nature provides more "down to earth" Dutchness in the countryside, without the heavy air of wistful nostalgia of pastoral images; nevertheless, its topographic truthfulness is admixed with careful compositions and with a genuine attraction for this "simpler" life.[54] Some of these Dutch views may have had a direct reference to the recent, "heroic" past when historic sites had been destroyed in the War of Independence. The same views reappear in the newly published guidebooks, such as Samuel Ampzing's *Description and Praise of the City of Haarlem* (1628), themselves tokens of civic or national pride.

The Lehman collection Dutch drawings call up many of

these associations, including both historic beauty spots and distinctive local civic skylines. From the first category, Lambert Doomer's *View of Monterberg* (no. 21) shows the ruined castle of the counts of Cleve in a work carefully finished for a discerning collector in watercolor over pen and ink. It also includes the typical Dutch rural scene, a prosaic pastoral, as it were, with characteristic cows overshadowing a trio of visitors to the countryside (perhaps with erotic intentions, if the seated couple can be made out clearly).[55] What Doomer has produced in this landscape is a combination of site-specific topography within a conventional and composed countryside scene. The site itself was located in the Rhine valley near the Netherlands' border with Germany; a favorite among artists arond mid-century in Holland, it was also represented by Aelbert Cuyp in several drawings (Berlin-Dahlem; from opposite direction, Groningen) and paintings (Castle Howard; New York, Metropolitan Museum; Washington, National Gallery). An adjacent scenic spot was the Elterberg, with the church and the ruins of the monastery of Hochelten, and sometimes the two sites are difficult to distinguish in landscape renderings.[56]

More civic in its resonances is the distinctive skyline of Dordrecht in an exceptional chalk and watercolor study by native son Aelbert Cuyp (no. 20), whose paintings and drawings often featured this subject.[57] The drawing is dominated by the principal feature of the city: the Grote Kerk, or Great Church, with its distinctive crowned tower. As the Cuyp drawings of the region of Cleve make clear, Dutch artists clearly made site studies in sketchbooks before sitting down in their studios to produce such careful and refined reference drawings as the Lehman *View of Dordrecht*.[58] Of course, the culmination of this kind of topographic view across a body of water by a native son is the unsurpassed *View of Delft* (The Hague) by Vermeer, but it stems from half a century of Dutch landscape paintings, as well as from a broad tradition of artist-topographers in the previous century.

Yet "Dutchness" in landscapes derived from the local models of the Small Landscapes was usually not so closely tied to specific sites as were these drawings by Doomer and Cuyp. Instead of the topographic, they often featured the typical, presenting country life through the hamlets and huts of villagers and peasants. In the case of Jan van Goyen as well as Salomon van Ruysdael, this kind of typical landscape became a formula, known today as the "river landscape."[59] Its principal feature is a diagonal composition with a low horizon and a high sky. Usually as a painting, this kind of river landscape strives to dissolve local colors into tonal harmonies, particularly in van Goyen's works. Often a ferry or a fishing boat plies the foreground waters, and the far bank is lined with a few trees, a cluster of houses; sometimes a rural church steeple breaks the horizon line, à la Bruegel. All of these elements can be seen in the 1651 Lehman drawing *Boating Party on a River* (no. 19), by van Goyen, executed in the typical broad black chalk favored by the artist. Unlike his sketchbook chalk works, this larger, colored drawing was surely intended for sale by van Goyen; moreover, its numerous lively little figures are intended to provide human interest and an ongoing sense of discovery for the

viewer. In similar fashion, other smaller boats have been inserted at varying depths in order not only to provide convincing space, but also to enrich the sense of an inhabited landscape. This, then, is a "working" landscape, populated by country villagers with all of the anonymity and typicality that had been their role in the cycles of the seasons from calendar pictures through Peter Bruegel to the 17th century in Holland. This drawing is thus as much as work of "genre," or everyday life, as it is a landscape. Here, too, figures and setting cannot be separated from one another, and the activity of simple country laborers is pictured to delight their city "betters." In similiar fashion, the isolated landcape by Ferdinand Bol, one of Rembrandt's leading pupils, seems to echo the wooded cottages of Fra Bartolommeo and of Rembrandt himself (see below) in presenting the advent of *Travellers at a Village* (no. 26).[60]

Rembrandt did not engage as fully in landscape images as he did in biblical scenes or portraits, but landscape did occupy a substantial part of his prints and drawings during the decade of the 1640s[61] after a burst of interest in landscape paintings from the mid-1630s. Whereas in many of his early pictures, Rembrandt strove for the history painting tradition, featuring landscapes populated with either mythological figures or biblical scenes, as adumbrated by the model of Rubens, his landscape works on paper conformed rather closely in most instances to the contemporary Dutch traditions of river scenes (often with identifiable topography from the vicinity of Amsterdam) or rustic cottages. The two Lehman examples belong to the latter category (nos. 22, 23). Indeed, the *Cottage Near the Entrance to a Wood* is one of the finest of Rembrandt's landscape drawings; it also stands out by virtue of its signature and rare date, 1644, as well as by its size: it is his largest landscape drawing.[62] This is quite a finished drawing, produced with a delicate and subtle, yet often sketchy, repertoire of pen strokes plus the same distribution of washes for lighting and atmosphere that Rembrandt employed in his most careful river scenes during the later 1640s. What is striking about the Lehman drawing is its very marginality, in which the unusual element of a stand of trees produces heavy shadows beside the cottage on its edge. The drawing also stresses the foreground dune rill in the manner of previous Dutch artists, such as Peter de Molijn or Jan van Goyen.[63] Both of Rembrandt's cottages show their inhabitants, but these are small, anonymous figures, framed within the doorposts of their huts. For Rembrandt, the quiet dignity of eking out a humble living on the edges of the countryside is symbolized by the cottage itself and its occasional foreground cart or tool. The *Two Cottages* stresses a diagonal arrangement in composition like a river landscape, as well as a sketchy freedom of stoke and density that Rembrandt used both in pen and in his experimental etching technique. In this work, the two dwellings, close to each other, are still presented as completely isolated from any other indications of setting or signs of life.

If we compare these two related studies of cottages to the Rembrandt etchings of the same subject from the 1640s and early 1650s, we find the same isolated, tight clustering of the huts along a diagonal and under the

shadows of trees (*Three Cottages,* 1650) or a large, single building that dominates a stark, empty landscape (in one case accompanied by an artist, drawing, *Landscape with Draftsman,* ca.1645; *Cottage by a Large Tree,* 1641; *Cottage with Haybarn,* 1641). In these latter two instances, Rembrandt has appended vistas to the sides based on topographic sketches from the outskirts of Amsterdam, but these only serve to reinforce the sense of isolation and their distance and difference from the humble, agrarian settlement. There is even a marked contrast in technique between the heavily worked foreground cottage and the light, dimly sketched background vista. Here, then, it is internal oppositions and structural relationships between near and far, cottage and skyline, and the general creation of a notion of peasant marginality that create the meaning of rural isolation in contrast to the crowded, urban world of the beholder.[64]

A continuing fascination with thick forest wildness, deriving ultimately from the model of Bruegel (see above), must also underlie the brilliantly lighted, silhouetted trees of Antoine Waterloo (no. 25), as well as the more domesticated forest of Jan van Kessel, a principal follower of Jacob van Ruisdael (*Landscape with Bridge,* no. 27). In each of these works, the marginality and isolation of the setting are emphasized by the very absence of human figures, although van Kessel's bridge suggests cultivation and human order in the manner of the corn fields, edged by forests, by van Ruisdael.[65]

The small drawing ascribed to Valentin Klotz, an artist who normally specialized in topographical renderings of particular sites, is evocative in an even more explicit and spiritual way. Klotz's *Roadside Shrine and Cross* (no. 28) evokes the rare direct expressions in Dutch art where nature and piety are deliberately fused, such as Jacob van Ruisdael's *Jewish Cemetery* (Detroit and Dresden).[66] Yet this kind of spiritualization of nature occurred with some frequency in 17th-century Dutch literature.[67] Didactic verses by Vondel, "Reflections on God and Religion" *(Bespiegelingen van Godt en Godtsdienst),* reveal a pervasive concept of God as the master artist and nature as his greatest creation; this view of course leads the painter to seek no higher subject than nature itself. Anslo, a Mennonite preacher and poet, further reflects:

> This landscape shows how well God did himself acquit
> How all is richly wrought and not a thing neglected.
> That might adorn and serve the wondrous work
> While staying well within the limits set.

In similar fashion, the great courtier and scholar Constantine Huygens, who was also one of the most enthusiastic connoisseurs of painting during Rembrandt's lifetime, finds the revelation of God behind the surface appearances of nature before his eyes: "The goodness of God is to be seen on every dune's top." We cannot know how many of the painters shared these views of Dutch poets or how much of this spiritual acknowledgment of "God's Providence apparent from the beauty of creation" (Vondel) is a literary convention repeated as a formula. Yet a private and intense combination of blooming nature with signs of death and piety, as in the van Ruisdael and Klotz works cited above, serves to remind us of how such sentiments could be produced clearly in certain instances,

while remaining potential and immanent for the pious beholder in many other works, even if these works are no longer perceived in such a light today.

V

While Rembrandt turned increasingly in his landscape drawings to the mainstream of Dutch art that he had denied in his ever more distinctive paintings, in Rome the pastoral and classical precedents of Venetian landscapes were receiving a new incarnation in the works of a French emigré: Claude (Gellée) Lorrain.[68] In about 300 paintings, 50 etchings, and in beautiful ink and bister wash drawings, Claude provided a new synthesis of landscape, producing a summery meadowland site for religious and mythological subjects in settings derived from his close studies of the Roman *campagna.*

Out of Claude's 1,200 surviving drawings, the three Lehman examples suggest in their themes and their techniques something of his range and achievement.[69] The bedrock for his other landscapes is his outdoor studies of sites near Rome, *vedute* such as the *Roman Landscape* (no. 31). This drawing shows Claude's masterful sense of composition and technique, particularly in the coordination of dark shadows, produced with bister washes, with contrasting passages of brilliant sunlight. This is a broad panorama, rendered with delicate and meticulous, yet economic subtlety; surely a finished drawing rather than a preparatory study, it juxtaposes the cubic geometries of Roman buildings against the irregular masses of surrounding trees and foliage. Claude assembled such studies into albums, such as the so-called Campagna Book or Tivoli Book or the recently-dispersed Wildenstein Album.[70] This Lehman drawing shows considerably more pen work and less wash than the typical album leaf, usually dominated by chalk and brush work. In this view the panoramic landscape setting and its summer light dominate over the topographical specificity of the Villa Doria, whose gardens near St. Peter's were famous for their views of the city from the other direction.[71]

Religious subjects formed a substantial portion of Claude's painted output, and he often made preparatory studies for these compositions and figures, especially in the "grand manner" phase of his career during the 1650s. Probably his favorite subject was the Rest on the Flight into Egypt, and the Lehman drawing of this theme (no. 29) has all the characteristics of a careful and purposeful study, presumably for the Cleveland *Rest on the Flight* (fig. 2): prepared blue paper for middle tone, subtle gradations of light with ink and white paint, and detailed study of both figures and plants.[72] As far as the subject is concerned, we should remember that unlike Rembrandt's Protestant Holland, the Rome of Claude remained the center of Catholic Europe, and many of the artist's patrons were ecclesiastics, including prominent cardinals and popes.[73] Compared to most paintings and drawings of this theme in Claude's work, the holy figures here assume greater importance. They are larger, and they are centered in a vertical format rather than the usual horizontal sweep of landscape. This is a nurturing nature that provides a bower of foliage above the nestling family below. In addition, the

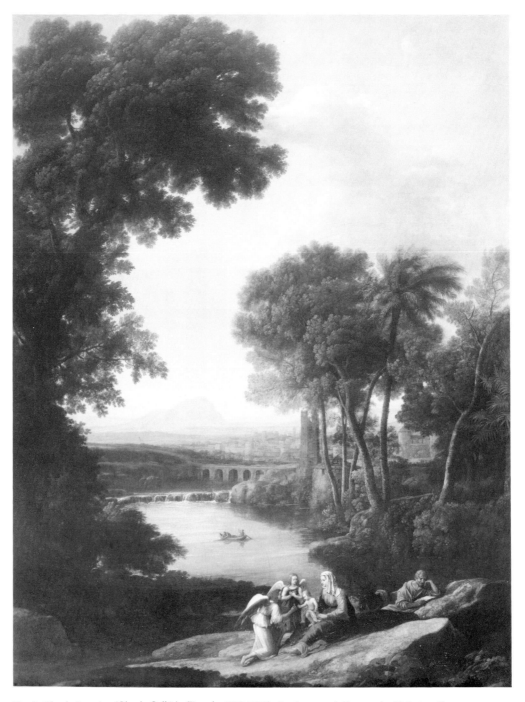

Fig. 2. Claude Lorrain (Claude Gellée), (French, 1600-1682), *Landscape with Rest on the Flight into Egypt.*
Oil on canvas. The Cleveland Museum of Art, Leonard C. Hanna, Jr. Fund.

ministering angel who attends the Madonna and Child
echoes with his wings the spiky boughs of the palm tree
above the figures. Nearby a donkey grazes placidly and un-
disturbed during this period of repose, while St. Joseph sits
quietly apart from the other holy figures, reading. In
general, this tranquil scene offers an updated, Italianate
river landscape, but its harmony between figures and set-
ting recalls the quiet mystery and contemplation of
Altdorfer's earlier Germanic *Holy Family,* with its own
meditative St. Joseph reading.

Finally, Claude's drawing of *The Origin of Coral* (no. 30)
exemplifies the artist's unsurpassed contribution of

paintings and drawings of landscapes with mythological
figures and his working method of linked sequences of
preparatory drawings. In this case, the final painting
(Collection Viscount Coke, datable to 1674 by Claude's
own record book, the *Liber Veritatis*) was commissioned by
the sophisticated collector Cardinal Camillo Massimi.[74]
The subject is Ovidian (*Metamorphoses,* IV) and details
the origin of coral from the blood of Medusa after
Perseus's heroic rescue of Andromeda from the back of the
winged horse, Pegasus.[75] This compositional study on
white paper with chalk, pen, and brown wash is
complemented by two others on prepared blue paper, like

12

the Lehman *Rest* by Claude. Unlike the other two drawings, this Lehman study does not explore the characteristic sunlit glow that distinguishes many of Claude's paintings and often includes a reflection in the painted sea. An inscription in the lower left corner of the drawing offers a unique instance of identification of the patron, the artist, and the concept of this drawing: a "pensier," or compositional sketch for the approval of Cardinal Massimi, who suggested the subject and also owned a drawing of it by Poussin (Windsor Castle).

The learned significance of this instance is paralleled by the image of Pegasus, for the winged horse, too, had been created out of the blood of Medusa, and his flight enabled Perseus to enhance his heroic deeds with wings. He rescues Andromeda from a prison of stone, and the residue of his bravery transforms in turn to a healing stone, for coral was formerly considered not only beautiful and decorative but apotropaic as well.[76] In this case, nature becomes suffused with supernatural powers that can be used for good or for ill, and we see how a clever man with vision, like Perseus, can turn such forces to his advantage.[77] Metaphorically, he can fly like the gods on the wings of Pegasus, and for the learned cardinal this theme then would have had the allegorical significance of the triumph of reason over brute matter.

Regardless of the specific allegory that was attached to this unusual subject, the origin of coral, by its erudite owner, that picture can serve us as a fitting climax to the landscape developments we have been considering. Such an artistic vision of nature sees the visible as an image of the invisible, replete with associations and values. Whether the starting point is religious or whether it derives from antique traditions of pastoral or mythic fable, the segment of nature selected as landscape art has the power to evoke its associated values, emotions, and ideas. Whenever we have been able to determine the specific patrons of such works—courtiers, burghers, or learned ecclesiastics, like Massimi—their formative influence on the conventions and the subjects of landscape have proven to be essential.

With Claude Lorrain, we reach a convenient overlook for our panoramic survey of landscapes. Like some Dutchmen, Claude was capable of constructing finished drawings from specific sites, like the papal villa, or from typical countryside scenes in the Roman *campagna*. Like all artists before the Reformation, he built up landscapes appropriate to individual holy figures, settings that were discretely remote from urban distractions and worldly concerns. But his most characteristic works were noble and sunlit stages for either mythic or epic subjects (even if there is still debate about whether or how often Claude painted his own figures).[78] These are "golden age" visions, grandly ordered and tranquil ideals for either heroes or for shepherd-poets.[79] Claude's brilliant light in his pictures was to have immediate (cf. the Dutch drawing attributed to Roeland Roghman, no. 24, amid the general phenomenon of "Italianate" Dutch landscape painters)[80] as well as lasting influence on Western landscapes.[81] But his art remained ideal rather than real, inhabited rather than wild, intended for the eyes—and for the allegorical interpretations—of learned, elite connoisseurs. For such images, figures and settings simply cannot be separated from an integral reciprocity, and such landscapes are inextricably tied to the cultures of their cultivated audiences. In this respect, they offer a poetic, glowing finale to the early history of landscapes, a tradition well represented by the drawings from the Lehman collection.

NOTES

1. For the changing attitudes towards nature itself, see Clarence Glacken, *Traces of the Rhodian Shore: Nature and Culture in Western Thought from Ancient Times to the End of the Eighteenth Century* (Berkeley, 1967); for medieval notions of nature, Derek Pearsall and Elizabeth Salter, *Landscapes and Seasons of the Medieval World* (Toronto, 1973). Among the various surveys of landscape drawings akin to this essay, two deserve mention for their comprehensiveness and their vivacity: Agnes Mongan, "European Landscape Drawing 1400-1900; a Brief Survey," *Daedalus* (1963), 581-635; Curtis O. Baer, *Landscape Drawings* (New York, [1973]).

2. For discussions of early landscapes and terms used to describe them, see Ernst Gombrich, "Renaissance Artistic Theory and the Development of Landscape Painting," *Norm and Form* (London, 1966), 107-21, and the appropriate reply by Charles Talbot concerning the independent tradition of landscape in Germany, "Topography as Landscape in Early Printed Books," in Sandra Hindman, ed., *The Early Illustrated Book: Essays in Honor of Lessing Rosenwald* (Washington, 1982), 105-16.

3. "Maister Joachim, der gut landschafft mahler." Quoted from Dürer's diary of his journey to the Low Countries in 1520-21, in the entry dated 5 May 1521. Text edition by Hans Rupprich, *Dürer Schriftlicher Nachlass* (Berlin, 1956), I, 169, n. 595. See also the edition by J. Goris and G. Marlier, *Albrecht Dürer Diary of his Journey to the Netherlands* (Greenwich, Ct.; 1971), 89.

4. For the Dürer reference, Rupprich, 172, n. 644: "Den maister Joachim hab ich 4 Christophel auff graw papir verhocht." The closest surviving related drawings by Dürer with multiple images of St. Christopher is in Berlin-Dahlem, with a single figure in the British Museum (W. 800-01), Goris-Marlier, 93, figs. 48, 90; See also *Albert Dürer aux Pays Bas*, exh. cat. (Brussels, 1977), no. 80. This kind of collaboration between Patinir and a fellow painter is surely the case with the signed work, now in the Prado, Madrid, of scenes from the life of St. Anthony, in which the figures were the work of Quinten Massys; see Larry Silver, *The Paintings of Quinten Massys* (Montclair, N.J.; 1984), 217f., no. 26. For Patinir in general, see Robert Koch, *Joachim Patinir* (Princeton, 1968).

5. This logical development conforms closely to the process argued by Whitney Davis for depictional systems of prehistoric cave art in Europe. See both Davis's "The Origins of Image Making," *Current Anthropology* 27 (1986), 193-215, as well as his forthcoming book, *Seeing through Culture: The Possibility of the History of Art,* "Cultural practices are simply special states of preexisting cultural traditions."

6. From *Food for Young Painters,* an uncompleted training manual, as quoted by Wolfgang Stechow, *Northern Renaissance Art 1400-1600: Sources and Documents* (Englewood Cliffs, N.J.; 1966), 112. On early topographical images in general, see Talbot, as cited in n.2, Karen Pearson, "The Multi-Media Approach to Landscape in German Renaissance Geography Books," in *ibid.,* 117-35. Also J. Harvey, *Topographical Maps* (London, 1980), esp 66-103, 153-85. Jurgen Schulz, "Jacopo dé Barbari's View of Venice: Map Making, City Views, and Moralized Geography before the Year 1500," *Art Bulletin* (1978), 425-74; Margarita Russell, *Visions of the Sea* (Leiden, 1983), 3-50. A rather one-sided view of later Dutch landscape as a form of topography is given by Svetlana Alpers in *The Art of Describing,* (Chicago, 1983), 119-68, and in "The Mapping Impulse in Dutch Art," 51-96, in David Woodard, ed., *Art and Cartography* (Chicago, 1987). See also, Jurgen Schulz, "Maps as Metaphors: Mural Map Cycles of the Italian Renaissance," 97-122, in David Woodard, ed., *Art and Cartography* (Chicago, 1987).

7. A fine general discussion that considers landscape from antiquity through Renaissance Venice is Götz Pochat, *Figur und Landschaft* (Berlin, 1973), a work that I have utilized much in the pages that follow. For later Dutch works, a most useful set of essays appears in Christopher Brown, ed., *Dutch Landscape: The Early Years,* exh. cat. (London, 1986), 11-78. See also Matthias Eberle, *Individuum und Landschaft,* (Giessen, 1980).

8. For the text, see H. Nachod, in E. Cassirer, P.O. Kristeller, and J. H. Randall Jr., *The Renaissance Philosophy of Man* (Chicago, 1948) 36-46. For interpretations of the significance of this event, Kenneth Clark, *Landscape into Art* (London, 1949), 7-8; Pochat, 181-83. Eberle, 115-21. Already in his 1860 *History of the Renaissance in Italy,* Jacob Burckhardt had drawn similar meaning from Petrarch's ascent as essential to the new consciousness of landscape in the modern sense. I am grateful to my colleague, Prof. Leonard Barkan, for many discussions of this text.

9. For the ongoing medieval concept of the "three orders," namely those who pray, those who fight, and those who labor, see Georges Duby, *The Three Orders,* trans. Arthur Goldenhammer (Chicago, 1980).

10. Pochat, 206-08; Eberle, 95-114; Pearsall and Salter, 181-82; Erwin Panofsky, *Renaissance and Renascences in Western Art* (Stockholm, 1960), 142: "The first postclassical vistas essentially derived from visual experience rather than from tradition, memory, and imagination." See also Uta Feldges, *Landschaft als topographisches Porträt* (Bern, 1980), esp. 53-65, for the topographical aspects of this and related Trecento landscapes.

11. Nicolai Rubinstein, "Political Ideas in Sienese Art: The Frescoes by Ambrogio Lorenzetti and Taddeo di Bartolo in the Palazzo Pubblico," *JWCI* 21 (1958), 179-89; for a recent, cautionary look at the frescoes with less confidence in their clear interpretation, Michael Baxandall, "Art, Society, and the Bouguer Principle," *Representations* 12 (1985), 32-43.

12. Millard Meiss, *Painting in the Time of Jean de Berry III. The Limbourgs and their Contemporaries* (New York, 1974); Pearsall and Salter, 142-46, 152-56; Eberle, 122-51; see also the analogous images from the same time, ca. 1400, in Otto Pächt, "Early Italian Nature Studies and the Early Calendar Landscape," *JWCI* 13 (1950), 13-47.

13. This is a confusion, particularly in Alpers's discussions of topography in later Dutch painting, and in 17th-century Dutch art in general (as well as in 19th-century French "Realism") to an inexperienced viewer, for the analytical separation of formal means and depicted objects is often difficult to make when an artist wishes to convince us, illusionistically, unless we can somehow make direct reference to the object allegedly represented, the referent. This was the strategy of John Walsh at a lecture in Boston in 1987 (College Art Assn. meetings), when he compared the convincing renditions of clouds within Dutch pictures with their counterparts in meteorological photographs and demonstrated the high degree to which artists freely invented their pictorial cloud forms, despite their seeming veracity.

14. A good overview of this material is Raimond van Marle, *L'iconographie de l'art profane au Moyen Age et à la Renaissance* (The Hague, 1931) I, 197-278; also W. A. Baillie-Grohman, *Sport in Art* (London, 1925). Useful background to the later Rubens images of the hunt in Arnout Balis, *Rubens Hunting Scenes* (Corpus Rubenianum Ludwig Burchard. XVIII, no. 2) (New York, 1986), esp. 50-69. For late medieval tapestries of the hunt, G.W. Digby, *The Devonshire Hunting Tapestries* (London, 1971).

15. Elisabeth Dhanens, *Hubert and Jan van Eyck* (New York, 1980), 155-68, fig. 113 (Louvre, Cabinet des Dessins). An *Otter Hunt* is documented in Padua, Italy, in the early 16th century as the work of "John of Bruges" by Marcantonio Michiel. See also Otto Kurz, "A Fishing Party at the Court of William VI," *Oud Holland* 71 (1956), 117-31; Paul Post, "Ein verschollenes Jagdbild Jan van Eycks," *Jahrbuch der Preuszischen Kunstsammlungen* 52 (1931), 120-32. Both of these copied works have been associated with marriages, so that hunt scenes here, too, may have had an allegorical sense, akin to many of the texts on the hunt of the "stag of love" (Marcel Thiebaux, *The Stag of Love,* Ithaca, 1977).

16. Fos.22v-23r, ca. 1480. J. P. Filedt Kok, ed., *Livelier than Life. The*

Master of the Amsterdam Cabinet or the Housebook Master (Amsterdam, 1985), 218ff., plate III. The same master also made drypoint prints of a *Stag Hunt*, 165, no. 67, as well as a courtly *Departure for the Chase*, 169, no. 72, with ladies. He also made numerous images of courtly lovers: nos. 66, 73, 75, 121-22, 133, and the Castle of Love from the Housebook, fos. 23v-24.

17. See Werner Gundersheimer, *Ferrara; The Style of a Renaissance Despotism* (Princeton, 1973), 229-71; see also Michael Levey, *Painting at Court* (New York, 1971), 56-76.

18. On Botticelli's Mythologies and their audience, see Ernst Gombrich, "Botticelli's Mythologies," *Symbolic Images* (London, 1972), 31-81.

19. The classic interpretive study of the Palazzo Schifanoia frescoes remains Aby Warburg, "Italienische Kunst und internationale Astrologie im Palazzo Schifanoja zu Ferrara (1912/22)," reprinted in Dieter Wuttke, ed., *Aby M. Warburg Ausgewählte Schriften und Würdigungen,* (Baden-Baden, 1980), 173-98. Also, Jean Seznec, *Survival of the Pagan Gods* (New York, 1953), 74-76, 203-09.

20. The earliest painting with a topographically accurate image of Jerusalem as a setting for a religious picture is by Jan van Scorel of Utrecht (1495-1562). See *Kunst voor de Beeldenstorm,* exh. cat. (Amsterdam, 1986), 180-82, no. 61, for that work, the Lokhorst Triptych, ca. 1526. On early topographic views of Jerusalem, C. H. Krinsky, "Representations of the Temple of Jerusalem before 1500," *JWCI* 33 (1970), 1-19.

21. Vienna, Kunsthistorisches Museum, and Paris, Louvre. See Ronald Lightbown, *Mantegna* (Berkeley/Los Angeles, 1986), 78-80, 408, no. 10 (Vienna, dated ca. 1458/59); 420-21, no. 22 (Paris, dated ca. 1482/85, though other authorities place it earlier).

22. A vivid, later evocation of this kind of landscape as a setting for spiritual trials is Bellini's *St. Francis*, which is discussed in this general context by Millard Meiss, *Giovanni Bellini's St. Francis in the Frick Collection* (Princeton, 1964). See also the Lehman drawing, no. 3, ascribed to Bellini, for a related theme. For the German context of "Wilderness" with a more local, Alpine form, see Larry Silver, "Forest Primeval: Albrecht Altdorfer and the Early German Wilderness Landscape," *Simiolus* 13 (1983), 4-43.

23. Pochat, 326-30, quoting the earlier formulation by Ludwig Heydenreich: "For the effect of this presentation rests on its visionary content. Not a reality, but an appearance is presented, which the beholder experiences equally." Leonardo's *sfumato* and *chiaroscuro* lighting create an atmosphere of transcendence in much the same effectiveness as Altdorfer's *chiaroscuro* drawing in tones. Pochat connects this mystic light with Neoplatonic light metaphysics; in any case, light as a symbol of the divine had long been a trope within medieval aesthetics (Wolfgang Schöne, *Uber das Licht in der Malerei,* Berlin, 1954).

24. Alte Pinakothek, ca. 1522/25. See Franz Winzinger, *Albrecht Altdorfer: Die Gemälde* (Munich/Zurich, 1975), 97-98, no. 45. The connection between heaven and earth is often conveyed through celestial portents or apparitions, such as the star above the manger at the Nativity or the comets above the cross at the Crucifixion. The author is currently completing a study of these religious subjects by Altdorfer, tentatively titled "Nature and Nature's God."

25. Walter Gibson is currently completing a book on the "world landscape" in Netherlandish tradition (in press, Princeton), for which see also H. G. Franz, *Niederländische Landschaftsmalerei im Zeitalter des Manierismus* (Graz, 1969). The best recent study of Patinir's landscapes interprets them within the Augustinian tradition, akin to Petrarch, of life as a pilgrimage and nature as a metaphorical *paysage moralisée,* with tempting, easy lowlands versus demanding but virtuous, isolated uplands: R. L. Falkenburg, *Joachim Patinir: het landschap als beeld van de levenspilgrimage,* diss. (U. of Amsterdam, 1985). A related discussion of landscape within an engraving by Lucas van Leyden is Werner Busch, "Lucas van Leydens 'Grosse Hagar' und die augustinische Typologieauffassung der Vorreformation," *Zeitschrift für Kunstgeschichte* 45 (1982), 97-129.

While to some extent, these interpretive schemas are both too learned and too rigid, they do capture the key elements of opposition within the structures of Patinir and Lucas landscapes and make clear the allegorical reading of nature that underlies such religious scenes.

26. For Bol as a draftsman and for further references, see *The Age of Bruegel; Netherlandish Drawings in the Sixteenth Century,* exh. cat. (Washington, 1986), 71-74, nos. 14-15.

27. Quoted in *Dutch Landscape: The Early Years,* 16.

28. On the relationship between Dutch Protestant theology and the "vernacular," human qualities in religious subjects that surrounded patrons of art (including prints and drawings as well as domestic stained glass) in the Low Countries, see Peter Parshall's lecture from the symposium, "Dutch Art before Iconoclasm," in *Bulletin van het Rijksmuseum* (in press).

29. Franz Winzinger, *Albrecht Altdorfer Graphik* (Munich, 1963), 43, 115-17, nos. 175-83. Also, *Prints and Drawings of the Danube School,* exh. cat. (New Haven, 1969), 55-59, nos. 56-60.

30. A comprehensive interpretation of Bruegel's landscape drawings that stresses a "stoic" world-view and a continuing image of the harmonious relationship or perversion of harmony between man and nature is given by Justus Müller Hofstede, "Zur Interpretation von Bruegels Landschaft, Ästhetischer Landschaftsbegriff und Stoische Weltbetrachtung," in Otto von Simson and Matthias Winner, eds., *Pieter Bruegel und seine Welt* (Berlin, 1979), 73-142. On the drawings, most recently, *The Age of Bruegel,* 91-94, 97-98, nos. 24-25, 27 (a landscape with St. Jerome! fig. 1).

31. On Coninxloo, *Dutch Landscape: The Early Years,* 20, 117-18, nos. 21-22.

32. Karl Arndt, "Pieter Bruegel d. Ae. und die Geschichte der 'Waldlandschaft,'" *Jahrbuch der Berliner Museen* 14 (1972), 69-121; H. G. Franz, "Das niederländische Waldbild und seine Entstehung im 16. Jahrhundert," *Bulletin Musées Royaux des Beaux-Arts de Belgique* 17 (1968), 39ff.

33. *Dutch Landscape: The Early Years,* 118, no. 22; Nicholaes de Bruyn after Gillis van Coninxloo. See also the cliche misconception on p. 14: "Although it is possible to place these Antwerp artists within a tradition of religious painting so that landscape can be considered simply as an element lending greater visual weight to religious subjects, it is important to stress that Patinir was thought of by contemporaries as a landscape painter. The religious subjects treated by him and his followers, such as the Rest on the Flight to Egypt, the Apostles on the Road to Emmaus and various hermit saints, were chosen because they required a landscape setting rather than because the landscape setting was demanded by the subject."

34. Pochat, 381-91. On the genre of pastoral, a vast topic, see Pearsall and Salter, 9-12, Ernst Robert Curtius, *European Literature and the Latin Middle Ages,* trans. W. Trask (New York, 1953), 183-200; and especially Thomas Rosenmeyer, *The Green Cabinet* (Berkeley/Los Angeles, 1969).

35. In the Dutch and English contexts of the following century, such pastoral subjects were often associated with the erotic and were quite definably the vogue of royalty and nobility. See especially Alison Kettering, *The Dutch Arcadia* (Montclair, N.J.; 1983) with reference to the court of Charles I in England and the House of Orange in Holland. For patronage of Giorgione and the poet Sannazaro in Venice, evidence points to the mainland court of Caterina Cornaro; see the recent Yale dissertation by Daniel Lettieri, soon to be published in book form, and Pochat, 383, plus Rudolph Wittkower, "L'Arcadio e il Giorgionismo," *Umanesimo Europeo e Umanesimo Veneziano* (Florence/Venice, 1963), 473-84, reprinted as "Giorgione and Arcady," in Wittkower, *Idea and Image* (London, 1978), 161-74.

36. Pochat, 415-26. From the vast literature on this picture: Patricia

Egan, *"Poesia and the Fête Champêtre," Art Bulletin* 41 (1959), 303-04; Philip Fehl, "The Hidden Genre: A Study of the *Concert Champêtre* in the Louvre," *Journal of Aesthetics and Art Criticism* 16 (1957), 153-68.

37. For the connotations of the lyrical instruments of viola da gamba or lira da braccio, see Emmanuel Winternitz, *Musical Instruments and their Symbolism in Western Art* (New Haven, 1967), 86-98. A similar outdoor party with music literally depicts the court of Caterina Cornaro in front of a typical Venetian pastoral landscape (anonymous, ca. 1500; Attingham Park, Shrewsbury; Pochat, fig. 117). On the amiable qualities of satyrs in Italian art, see Lynn Frier Kaufmann, *The Noble Savage. Satyrs and Satyr Families in Renaissance Art* (Ann Arbor, 1984), esp. 65ff.

38. *Early Italian Engravings from the National Gallery of Art,* exh. cat., Washington, 1973, 390-436.

39. On Giorgione's circle and landscape art, Pochat, 384-426 *(Venus,* 411-14). The pastoral effects of the Venus theme are further emphasized in Giulio Campagnola's engraving *Venus Reclining in a Landscape* (Washington, 1973, fig. 19-10), a work that reveals the general diffusion of *Giorgionismo* in the works of Giulio Campagnola. See also the *Young Shepherd* engraving (fig. 19-11), whose figure is quite close to the boyish *Shepherd with Flute* at Hampton Court.

40. See Washington, 1973, 410-13, no. 150, with comparative figs. of the Louvre drawing as well as the Rotterdam Giorgione.

41. Washington, 1973, fig. 19-18.

42. A quite similar pen drawing by Domenico is the Berlin-Dahlem *Landscape with Two Figures* (Kupferstichkabinett), a work that reveals not only similar, geometrically cubic, clustered buildings but also the emphatic parallel strokes revealing Domenico's technique for production of woodcuts after Titian designs.

43. Illustrated in Pochat, figs. 132, 146. See also Bellini's *Feast of the Gods* (1514, fig. 115), Lotto's *Dream of a Maid* (ca. 1500, fig. 118), Correggio's *Jupiter and Antiope* (1528, fig. 135), the related *Bacchanal of the Andrians* (ca. 1523-25, fig. 143), and the *Pardo Venus* (ca. 1535-40, fig. 149).

44. Pochat, 472, fig. 161. On the later associations of the pastoral with eroticism, see Kettering, esp. 33-62, 83-99 and her separate study, "Rembrandt's *Flute Player*: A Unique Treatment of Pastoral," *Simiolus* 9 (1977), 19-44.

45. Illustrated in Washington, 1973, 413, n. 6, fig. 19-21. For this drawing as well as the Lehman collection drawing, see the forthcoming study by Harold Wethey on Titian drawings (Princeton, in press).

46. See David Rosand and Michelangelo Muraro, *Titian and the Venetian Woodcut,* exh. cat. (Washington, 1976-77), esp. 120ff. for Domenico Campagnola, 138ff. for landscapes. A good comparison with the Lehman drawing is the woodcut "After Domenico Campagnola," 166, no. 30, of a landscape with couple gathering fruit, based on a Louvre drawing. See also *Landscape with Tree and River,* 174, no. 34.

47. See, for example, the Dutch emulation of Titian woodcuts by Hendrik Goltzius (1558-1617) in his drawings and woodcuts, e. g. *Arcadian Landscape with Figures* (1593; Chatsworth) or *Landscape with Seated Couple* in *Dutch Landscape: The Early Years,* 59, fig. 2; 143, no. 43. On the influence of Venetian woodcuts on Dutch landscapes, see p. 17, but for Goltzius's virtuoso ability to render his landscapes in the styles of various artistic predecessors, see the Bruegelian strain represented on p. 59, fig. 1: *Pass in the Rocky Mountains* (1594; Haarlem, Teylers Foundation).

48. Isolde Härth, "Zu den Landschaftszeichnungen Fra Bartolommeos und seines Kreises," *Mitteilungen des Kunsthistorischen Instituts in Florenz* 9 (1959), 125-30.

49. "Multifarum casularum ruriumque lineamenta curose ad vivum expressa" (14 prints). A larger edition was issued in 1561 (30 prints) under the title "Very fine images of properties, farms and country cottages rendered in copper from the life" (Praediorum villarum et rusticarum casularum icones elengantissimae ad vivum in aere deformatae). In later reprints, such as the 1612 C. J. Visscher edition, Bruegel is credited on the title page as having been the designer of these images. *Dutch Landscape: The Early Years,* 18-19, 110-11, no. 18; *The Age of Bruegel,* 228-30, no. 87. The Master of the Small Landscapes was identified as Joos van Lier by Egbert Haverkamp-Begemann, "Joos van Lier," *Pieter Bruegel und seine Welt. Colloquium* (Berlin, 1979), 17-28.

50. Berlin-Dahlem, Kupferstichkabinett. *The Age of Bruegel,* 251-59, nos. 97-100.

51. Chatsworth Collection; *The Age of Bruegel,* 95-96, no. 26.

52. This interest in local views was especially popular among the local printmakers of Haarlem, such as Jan van de Velde, after designs by artists such as Willem Buytewech. See David Freedberg, *Dutch Landscape Prints* (London, 1980), 28ff.; and *Dutch Landscapes: The Early Years,* 134, no. 36; 137-38, no. 38; 173-79, nos. 73-75, as well as Visscher's Amsterdam reprint of the Small Landscapes, 111, no. 18.

53. On Dutch landscapes as imaginary "walks," Freedberg, 15f., who stresses that these walks take place away from the pressures of city life in the pleasant, local countryside.

54. This is the opinion of Christopher Brown in his essay in *Dutch Landscape: The Early Years,* 26-30, where he singles out both "nostalgia for the countryside...of a society which was rapidly becoming urbanized" as well as an "intense local and national pride" during the truce in the Dutch War of Independence. See also Freedberg, 11-14, stressing the blend of the Dutch with the pastoral. For the economic realities of the Dutch rural economy in this period, see Jan de Vries, in *Dutch Landscape,* 79-86.

55. On the associations of the cow with Dutch pride, see the suggestive article by Joaneath Spicer, "'De Koe voor d'aerde statt': The Origins of the Dutch Cattle Piece," *Essays in Northern European Art Presented to Egbert Haverkamp-Begemann* (Doornspijk, 1983), 251-56. Also Freedberg, 35, on *The White Cow* by Jan van de Velde. For images of historic sites within Dutch scenery, see Wolfgang Stechow, *Dutch Landscape Painting of the Seventeenth Century* (London, 1966), 33-49. See related works by Aelbert Cuyp, such as his *View of Amersfoort* (fig. 65). Doomer is discussed by Wolfgang Schulz, "Lambert Doomer als Maler," *Oud Holland* 92 (1978), 93-94, with the prototype of the erotic pastoral couple as fig. 22, cat. xi; and by idem, *Lambert Doomer, sämtliche Zeichnungen* (Berlin, 1974), cat. 197, fig. 102, for the Lehman drawing. Doomer, a Rembrandt pupil, was noted primarily for his topographical drawings, into which he introduced a Rembrandt-based element of the picturesque and atmospheric. See also Werner Sumowski, *Drawings of the Rembrandt School,* vol. 2, ed. W. Strauss (New York, 1979), 783ff., with the Lehman drawing, 870, no. 10 and the copy after the Rembrandt Lehman drawing (see below), 994, no. 465x (Paris, Lugt Coll.).

56. I am grateful to Arthur Wheelock, curator of Dutch paintings at the National Gallery of Art, Washington, for information concerning his Cuyp picture and for general information concerning this site in Cleve. The Berlin drawing is inv. no. 6661; Groningen datt. no. 92), and both have been posited by van Gelder and Jost to come from a sketchbook of ca. 1651-52. For Jan van Goyen's sketchbook views of Elterberg, see Baer (as cited, n. 1), 200, no. 83 (Smith College Museum). The definitive study of Dutch views of this region of the lower Rhine is Heinrich Dattenberg, *Niederrhein Ansichten Holländischer Künstler des 17. Jahrhunderts* (Dusseldorf, 1967), with Monterberg as nos. 72-73, 79, 82, 90 (Cuyp); 109, 110 (the Lehman Doomer; on the artist, p. 83f.); 135 (Hendrik Feltman); 163 (van Goyen); 327 (Herman Saftleven); 355 (anonymous panorama).

57. See the views with shipping featured in Stechow by Cuyp (fig. 236-37) as well as related, earlier images (Vroom, fig. 223; Salomon

van Ruysdael, fig. 229). The other related drawings of Dordrecht by Cuyp are collected by J. G. van Gelder and Ingrid Jost, "Doorzagen op Aelbert Cuyp," *Nederlands Kunsthistorisch Jaarboek* 23 (1972), 223-39. In addition to the Lehman drawing, fig. 5 (there described as location unknown), the closest parallel is a larger image in horizontal format (Amsterdam, P. and N. de Boer; fig. 6); a different view of the city in the same format is in Rockport, Maine (coll. Eric Sexton; fig. 1). The painted version of this skyline is now in Leipzig (fig. 9), with its original left half in Los Angeles (fig. 7), making a broad panorama from 1647. Indeed, the Los Angeles half closely resembles the formula employed for a recognizable scenic spot in the Lehman Doomer drawing, for it features Cuyp's beloved large cows dominating the foreground with the edge of the city of Dordrecht, the Riedijkse Poort, visible at the horizon line behind them.

58. On the production of Dutch landscape panels in the studio, see the remarks by David Bomford in *Dutch Landscape: The Early Years,* 45-56. On artists' sketchbooks, see the published example by Jan van Goyen, published by H. U. Beck, *Ein Skizzenbuch von Jan van Goyen* (The Hague, 1966); others by van Goyen survive (Dresden, British Museum), while some were dispersed, even recently. On van Goyen's use of such sketchbook folios, including his own views of the Cleve region, see H. U. Beck, "Jan van Goyen's Handzeichnungen als Vorzeichnungen," *Oud Holland* 72 (1957), 241-50. We have seen similar evidence of Cuyp's use of topographic sketches, and sketchbooks by A. van Borssum and N. Berchem also survive in the British Museum. Of course, topographic concerns for the "portraits" of cities led to careful studies by artists for these mapmaking ventures, chiefly Braun and Hogenberg's *Civitates orbis terrarum* (1572-1618; facsimile: Amsterdam, 1965), in the second half of the 16th century. See the Joris Hoefnagel, *View of Linz* in *The Age of Bruegel,* 201-02, no. 74, a work copied after a previous study by Lucas van Valckenborch. In general on "painter cartographers," see M. Russell, *Visions of the Sea* (cited, n. 6), 24-50, including Hans Bol's *View of Antwerp* (fig. 52). Earlier in the 16th century, Dürer's sketchbook of the Netherlands includes views of particular buildings as well as a pen sketch of the port of Antwerp from its quai (Marlier-Goris, fig. 68); Dürer's contemporary, Hans Baldung of Strassburg, also produced a silverpoint sketchbook, now in Karlsruhe, which includes views from the tower of the cathedral.

59. Stechow, 50-64.

60. On Bol, see Sumowski, *Drawings of the Rembrandt School* (New York, 1979), 179ff., where the Lehman drawing, although signed at lower left, is unmentioned.

61. There is no comprehensive study of Rembrandt landscape paintings, although Cynthia Schneider is completing work on a book ms. I am grateful to Professor Schneider for sharing an early draft of that ms. with me as well as for sharing her general interest in landscape in numerous conversations. An overview is provided by Max Eisler, *Rembrandt als Landschafter* (Munich, 1918).

62. Egbert Haverkamp-Begemann, *Rembrandt After 300 Years*, exh. cat. (Chicago, 1969), 167-68, no. 117, points out that Doomer also sketched this same cottage, possibly at the same time (Paris, Lugt collection; see above). The other Lehman drawing is 166, no. 114, where it is compared to studies of farm buildings and trees in Vienna, Stockholm, and Chatsworth, as well as with the etchings of 1641 and 1645. In the corpus of Rembrandt drawings compiled by Otto Benesch, the two Lehman works are, respectively IV, no. 815, and II, no. 462a.

63. One could also compare the layout and motifs of Hendrik Goltzius's woodcut *Landscape With a Peasant Dwelling* from the late 1590s; *Dutch Landscape: The Early Years,* 144, no. 44. See also Stechow, 19-32.

64. A similar interpretation for some of Jacob van Ruisdael's *Grain Field* images was advanced by R. H. Fuchs, "Over het landschap. Een verslag naar aanleiding van Jacob van Ruisdael, 'Het Korenveld,'" *Tijdschrift voor Geschiedenis* 86 (1973), 281-92. Fuchs argues for oppositional structures within landscapes, such as life and beauty against death and decay.

65. On forests in general, Stechow, 64-81.

66. Seymour Slive and H. R. Hoetink, *Jacob van Ruisdael,* exh. cat. (The Hague/ Cambridge, Mass., 1982), 67-77, nos. 20-21.

67. See the essay by M. A. Schenkeveld-van der Dussen, "Nature and Landscape in Dutch Literature of the Golden Age," in *Dutch Landscape: The Early Years,* 72-78; also Freedberg, 14. See also the recent essay by Josua Bruyn, "Toward a Scriptural Reading of Seventeenth-Century Dutch Landscape Paintings," in Peter Sutton, ed., *Masters of 17th-Century Dutch Landscape Painting,* exh. cat. (Boston, 1987), 84-103.

68. H. Diane Russell, *Claude Lorrain 1600-1682,* exh. cat. (Washington, 1982). Marcel Roethlisberger, *Claude Lorrain: The Paintings* (New Haven, 1961).

69. Marcel Roethlisberger, *Claude Lorrain: The Drawings* (Berkeley/Los Angeles, 1968), nos. 570, 1064.

70. Russell, 231, no. 29; also nos. 8, 9a, 47. Marcel Roethlisberger, *The Claude Lorrain Album in the Norton Simon, Inc. Museum of Art* (Los Angeles, 1971).

71. Russell, 241, no. 38, stressing the fact that the pope at mid-century was a Pamphili, Innocent X, and that Claude made a view of St. Peter's from this same site.

72. For the Cleveland picture, datable to ca. 1645, Russell, 153, no. 33, which has a similar vertical format, background river landscape and figure disposition of angel and holy figures. For other Claude Rest images, Russell, 130, no. 21, and drawings, 263, no. 54; 297, no. 75. For the emphatic palm tree at the right in association with the holy figures and their warm, Mediterranean climate, see the related flora of the "Dragon tree," featured already in images of the Flight in German prints by Schongauer and Dürer. Götz Pochat, *Der Exotismus während des Mittelalters und der Renaissance* (Stockolm, 1970), 118-36.

73. See Larry J. Feinberg, "Claude's Patrons," in Russell, 450-64.

74. Exhibited and discussed by Russell, 286-88, no. 69; see also the related drawings, 289-94, nos. 70-73.

75. Linda Lee Boyer, "The 'Origin of Coral,' by Claude Lorrain," *Metropolitan Museum of Art Bulletin* 26 (May, 1968), 370-79; on Ovid in general, Leonard Barkan, *The Gods Made Flesh* (New Haven, 1986), 54-55 for this theme.

76. On Perseus, Barkan, 52-56; on coral, chiefly used as a cure for bleeding and as a talisman against the devil, Robert Koch, "The Salamander in van der Goes' *Garden of Eden,*" JWCI 28 (1965), 325-26.

77. See the evaluative remarks toward understanding this theme by Russell, 293-94, citing Natalis Comes's allegory of the tale of Perseus as noting the positive valuation of the hero as a symbol of the reason and prudence of the soul; in this respect, it is worth recalling that Pegasus eventually came to dwell with Apollo and the muses on Mount Parnassus, so his wings could symbolize the transcendence of mankind's natural limitations.

78. Russell, 71, n. 8, cites the 17th-century documentation by Baldinucci of Claude: "He took no displeasure in having figures in his landscapes or sea pieces added by another hand." See the discussion in terms of examination of individual pictures, 77-78.

79. Russell, 55-58, 81-96.

80. Stechow, 147-66; Albert Blankert, *Nederlandse 17e eeuwse italianiserende landschapschilders* (Soest, 1978).

81. For Claude's ongoing influence, see *Im Licht von Claude Lorrain,* exh. cat. (Munich, 1983), esp. 178ff.

TOPOGRAPHY AND THE IMAGINATION, MODERN LANDSCAPE DRAWINGS

Levi P. Smith III,
with the assistance of Martha Ward

TOPOGRAPHY AND THE IMAGINATION, MODERN LANDSCAPE DRAWINGS

In 1857 John Ruskin ended the preface to his book *The Elements of Drawing and Perspective* by reminding the reader that "the best drawing masters are the woods and the hills."[1] Ruskin's conviction, controversial in his day, climaxed more than a century of debate concerning the roles of drawing and nature in the generation of art.[2] The debate was symptomatic, for perhaps the broadest possible field for artistic expression in this period was to be found in the combination of the medium of drawing and the subject of landscape. The development of landscape and drawing up to and beyond the time of Ruskin was not linear, a discarding of old subjects and techniques for new ones. Rather, it involved a broadening of definitions, a multiplication and exploration of methods and motifs that mediated between opposed ideals of exact replication and imaginative creation.

Beginning in the sixteenth century, drawing served as a bridge between the producer and the patron of art. Baldassare Castiglione's *Il libro del cortegiano,* published in 1528, established drawing as an ability every gentleman should possess. Contemporary with Castiglione, Giorgio Vasari assembled a collection of drawings intended to illustrate the progress of the arts.[3] Until the middle of the nineteenth century, when photographs began to replace them, drawings were a primary medium by which works of art were reproduced and disseminated. As a result, the connotations of drawing as a medium could range from the didacticism of illustration to the cultured practices of gentlemen. The resulting tension between the functional illustration and the privileged creation constituted a dialectic of some importance to the identity of modern drawings.

The multi-layered, permeable structure of nineteenth-century bourgeois society succeeded a century in which class structures had become increasingly unstable. Historians have recently begun to set the development of modern landscape and drawing in relation to the bourgeoisie's growing involvement with the arts, both as consumers and as artists. Recent studies of eighteenth-century English, and nineteenth-century French, landscape painters have stressed the ideological perimeters their images deploy.[4] Thus Constable represented as one with the land the peasant who was so differentiated from him by class, and Monet excised the smokestacks of modern industrial France to construct idyllic visions of suburban Paris. The entrepreneurial business practices of the bourgeoisie shaped artistic production as well. Some artists, exploiting an independent and more anonymous market, turned to less expensive and faster media, capitalizing at the same time on the taste for intimacy presumably provided by drawings. The increased production and preservation of works on paper, with their connotations of informality and intimacy, reflect these market conditions.

Other products of bourgeois hegemony also affected drawing. The proliferation of mass-media journals and newspapers during the second half of the nineteenth century, with their often standardized styles of illustration, undoubtedly affected independent artists. This standardization stimulated some to react by working in increasingly idiosyncratic personal styles. For example, in the late 1860s and early 1870s, Paul Cézanne reworked fashion illustrations as he sought to arrive at a distinctive and distinguishing style.[5] In the 1880s and 1890s, Monet, Cézanne, and others seem often to have selected motifs in defiance of the mass-marketed familiar. These motifs are records of alienation from the dominant social discourse as well as agents in the formation of a personal identity. However, it is symptomatic of the circular nature of this process that caricature, inextricably linked in the nineteenth century to the mass media, became an important stylistic source for independent artists.

Caricature is perhaps the most aggressively alienated form of drawing and of representation; yet it too was a mainstay of the mass media. The distinction between dominant (mass, common) and subversive (original, individual) had constantly to be renegotiated during the nineteenth century.

A similar process, involving widespread standardization and increasingly individuated response, occurred in the depiction of landscapes. During the height of the craze for the grand tour, when completion of a gentleman's education required a ritualized visitation to the sites of culture, Goethe astutely observed that "All modern landscape comes from topography."[6] As a standard for acceptance or deviation, topography implied the measured delineation of a directly observed site, a mapping of the memorable. It required a submission to the actuality of the subject, a submission that upholders of the ideal in art abhorred. Heinrich Fuseli wrote at the beginning of the nineteenth century that topography was the norm to be dismissed: it was "the tame delineation of a given spot..."[7] The topographical view, Fuseli continued, could only delight the antiquary, the traveller, or the owners or inhabitants of a place. Thus Fuseli pejoratively associated the expectations of cultured travellers with those of property owners. "View-painters" represented estates in England with the same fidelity to the observed as the painters of *vedute* exercised in depicting famous sites in Italy. In both cases, the viewer's relationship to the image was one of familiarization, whether the viewer owned (or desired) the actual site or sought to acquire the cultural values that the site embodied.

The grand tour of the gentleman was succeeded in the nineteenth century by the recreational outing of the bourgeoisie. The lengthy pilgrimage by coach to a certified monument was replaced by the speedy suburban train ride to a newly discovered place. If, as Larry Silver suggests in his essay for this catalogue, many Renaissance landscapes suggest the meditative viewer, landscapes of the modern era suggest a transitory one. The hermit is succeeded by the tourist.

Tourists require itineraries with recommended stops. Guide books developed a format and language to answer this need. To ward off the disorienting experience of being in an unfamiliar place, guides organized a series of views, with suggestions of where to look and what to see. In similar fashion, the various motifs of landscapes mediated between the actual and the constructed. An artist's selection of motif might be as predictable as a postcard view, or in reaction to such familiarity, might be idiosyncratic and inscrutable. In either case, codification for the tourist set the standard for orientation.

Despite the differences in their destinations, activities, and ostensible motivations, the gentleman of the grand tour and the nineteenth-century tourist were actively engaged in creating themselves through the experience of travel. In similar fashion, landscapes offered artist and patron a space within which identity might be confirmed and authenticity reified. Rather than trace a comprehensive history of this development, a task uncongenial to the essay format, and one that would lead us away from the drawings selected for this exhibition, we can instead relate the motifs to the historically varied experience of travel, tracing through this period how structuring principles such as viewer location and mode of observation have evolved.

On the Road: Travel

Travel usually involves a dislocation from the familiar. At the beginning of the modern era, John Bunyan used travel as a metaphor to evoke the progress of the soul toward God. What drove Pilgrim was desire. If desire was a "moving toward," its opposite would seem to have been the stillness of contemplation, the fixity of possession. The possession a traveller took of the places he visited was imaginative. Many of the earlier landscape drawings of the modern period appeal to this act of imaginary possession, or to the desire which impelled the traveller.

In the watercolor *Travellers Entering a Town* (no. 46), by Paul Sandby (1725/6-1809), strong diagonal lighting, the inward curve of the road, and the travellers' general movement toward an arched gate suggest the approaching end of a journey at a suitably picturesque location. By contrast, in *Landscape with Ruined Arch* (no. 42), by a follower of Francesco Zuccarelli (1702-1788, a Venetian landscape artist popular in England during this time), the placement of the road parallel to the surface of the drawing and the planar composition enforce a separateness, assigning to the viewer a role as witness rather than participant. The planar composition of this work, a convention of the "classical landscape" popularized by Claude and Poussin in the seventhteenth century, suggests the stillness of possession. Movement is unnecessary, the traveller has "arrived."

The thematic contrasts of these images are further emphasized by differing techniques and imagery. The watercolor's effect of immediacy is apparent when compared with the soft, grainy surface of the Venetian drawing, meant to evoke for the connoisseur the subtle colorism of many eighteenth-century Venetian painters. The landscape elements and figures of this work compose an idealized, imaginary Italian landscape in which two zones, the left and right halves, are tied together by the serpentine garland of scenery and by the central group's carefully designed pyramidal form. It is difficult to be certain, but one of the figures beyond the arch appears nude, while the other, who carries a staff, appears to be wearing a cape. In any case, their garb contrasts with the modern dress of the central group. The image provides the contrast eighteenth-century visitors to Italy would have expected to experience, between a contemporary mundane reality (the encounter of the rider with a peasant woman) and a classical world (the arch and the antique figures beyond).

The "classical" landscapes created by Poussin and Claude working in Rome during the mid-seventeenth century stress a vision of man's constructed order reposing in nature's softer order. This type of landscape, with its planar composition conveying a sense of order and clarity, was extraordinarily influential. The paintings of Claude were, and still are, beloved in England, and Poussin's landscapes with mythological subjects constituted the

academic ideal of painting in France through the first half of the nineteenth century. Fuseli lumped together the traditionally opposed categories of classical and romantic landscapes, and contrasted their transformative art to topography, writing "The landscape of Titian, of Mola, of Salvator, of the Poussins, Claude, Rubens, Elzheimer, Rembrandt and Wilson, spurns all relation with this kind of mapwork."[8] In contrast to the replication of a specific place, the viewer is transported by these images into the field of art to "tread on classic or romantic ground."[9]

Informal sketches, such as the wonderful, scribbled *Landscape with Castle* (no. 39), by Giovanni Battista Tiepolo (1696-1770), suggest an encounter with a specific place, but the scene that is depicted may well have interested the artist because of its affinity with classical landscape. *Fantastic Landscape* (no. 41), by Zuccarelli, though including more landscape and several groups of stock figures, portrays an architecture surprisingly similar to that in the Tiepolo. Both drawings represent dappled light and both share a fascination with the juxtaposition of geometric architectural forms and lush nature.

John Varley (1778-1842) transposed Claude's ideal vision onto the vernacular of the English countryside in his *View of a Town with a Harbor* (no. 48), signed and dated 1836. The effect of luminous evening light is convincing, but the watercolor's conventional format is indicated by its close similarity to a work by Varley, dated 36 years earlier.[10] The two trees on the right, a personal variation on the framing *repoussoir* of the classical landscape, were, in addition, a leitmotif of his work.

In the watercolor *Landscape with Stagecoach* (no. 47), by Thomas Creswick (1811-1869), peculiarly feathery trees and soft forms express an almost Venetian tonal subtlety and preciousness through the medium of watercolor. The delicacy of treatment suggests that refinement of the environment the subjects inhabit. In this work the road is so broadened that its introductory force—the impetus it gives us to move into the scene—is subverted. Two zones, less obvious than in the Venetian image, establish the traveller's world, the road and coach, in an area separate from the stability of an older world: the ancient castle and grounds, seen through a gap in the roadside trees to the right. The mode of transportation is not saddled horses, as in the Sandby, but the more stately conveyance of a large coach with attendents. The horses appear to be turning toward the opening, and a vaguely indicated group of figures (a woman with a parasol and a child?) may form a welcoming committee at the substantial country estate. The distance Creswick establishes between the viewer and the scene by the expansive foreground suggests that distance by which the upper class distinguished itself.

As we move into the nineteenth century, changes in the classes and destinations of travellers begin increasingly to affect the appearance of landscapes. In works by two Barbizon artists, the watercolor *Landscape* (no. 54), by Henri Joseph Harpignies (1819-1916), and the crayon drawing *Landscape* (no. 53), by Charles François Daubigny (1817-1878), we depart from the directed passage or complete possession that earlier landscape images evoke. Rather, the passing of the traveller is prolonged in a series of incidents, the sheer multiplicity of which consititute the subject of the image. The anecdotal quality of the Harpignies is supported by an inscription in the upper left corner: "FAMARS 8 bre 63." The time, therefore, is autumn; the place, a location near the small town of Famars where the artist's father was part owner of a sugar factory. In both these works, the road is a narrow track, scored and rutted by local traffic. The motif of the Harpignies is a beautifully rendered puddle, which generates a narrative element as well. Beyond it, two figures have negotiated the mudhole, as have, apparently, many others, by taking the path in the immediate right foreground. The figures have started down the other side of the hill, but another in the distance suggests that this is only one hill of many.

The alienating force of urban anonymity is suggested in *Landscape with Road Approaching a City* (no. 62), by Jean-François Raffaeli (1850-1924). The strong diagonal of the fence on the left, the scoring of the road and its highlights, and the rapidly diminishing scale of the figures lead us into the image. But the highway broadens and dissolves any sense of destination as it nears the maze of the city. We are left stranded in the vague middle ground of the landscape, still distant from a few, minute, brilliant spots—windows winking in the dusk. A dark front of clouds hangs over the distant city, and, dimly visible, smokestacks add their palls of smoke.

The impact that urban life and increasingly fast travel had on the perception of the countryside is suggested by Maurice de Vlaminck (1876-1958) in a drawing titled *Village Street: Boissy-les-Perches* (no. 72). The village appears merely as a stop along a road which continues on into the distance. The town is anonymous, as secretive as the faceless peasant woman who stands on the street. The technique is swift and rough, and the sharp contrast of black and white suggests the light that follows a storm, when wet surfaces reflect the harsh, white light of a clearing sky. The velocity of this drawing—its vigorous execution, the steep perspective of the central road—convey the calculation of the driver, slowing for the clutter of a village, but already anticipating the open road ahead. In his youth Vlaminck was a professional bicycle racer, and later in life, as the owner of a collection of classic automobiles, he loved driving at high speeds on country roads. The conclusion of his autobiographical novel, *Dangerous Corners*, finds him reflecting on life, seated behind the wheel of his automobile, parked by the side of the road after a speedy drive.

The drawings we have surveyed reveal the increasing mobility of society and the nexus of this activity in the city. By the end of the nineteenth century, the rapidity of railroad and automotive travel helped to transform the experience of landscape into a blur—the perceptual correlative of physical disorientation. The experience of displacement increasingly overrode that of movement toward, or arrival at, a desired destination. At the same time, the possibility of mentally possessing a clearly ordered and valued site was increasingly denied.

By the Road: Views

From the time of the grand tour onwards, travel was

punctuated by varied points of interest – views, prized for their historic and cultural value, their beauty, and, increasingly in the nineteenth century, their novelty. To appreciate a view meant to make a stop, to pause, and to take account of one's surroundings. However, the modes of observation employed in landscapes, originally dominated by the classical structures of Claude and Poussin, were progressively linked with emergent scientific disciplines that generated new observational and historical criteria.

Vedute were produced in mass during the eighteenth century by Venetian artists, who capitalized on their location in a center of the grand tour and quickly developed a standardized syntax of line and perspective with which to order their inventories. *Vedute* often emphasize outline, in such a manner as suggests the use, or influence of the use, of an optical device such as a camera obscura.[11] These mechanical aids undoubtedly reinforced the association of line with the clarity and fidelity of the perfect copy. The Enlightenment attitude toward the classification of knowledge, as exemplified in Diderot's encyclopedia, with its endless lists, indices, and diagrams, is preserved in these visual catalogues of place. The artists' anxiety concerning the referentiality of the image is spelled out in titles and annotations that they added to their works. Faithfully recording the essential aspects of the site required the appraiser to suspend time. Accordingly, when human figures appear they must not distract from the set materials of the site by generating psychological interest. Their poses and gestures are stylized; for the observer they function as measuring sticks of scale and as a reminder of characteristic, but ultimately inconsequential, local color.

The eighteenth-century drawing titled *The Tower of Malghera* (no. 38), by a Venetian artist working in the style of perhaps the greatest producer of *vedute,* Canaletto (Giovanni Antonio Canal, 1697-1768), epitomizes the genre. It is a clear record of a memorable site. The tower, taken down early in the nineteenth century, was an old Venetian fortification on the shore of the lagoon. This drawing is probably a simplified copy of an etching by Canaletto.[12] Our artist removed the clouds, fishermen, and waves in the Canaletto, and drastically reduced the range of tonal values. He reduced or eliminated precisely those elements that were extraneous to the function of the *vedute* and that, if not manipulated with finesse, might threaten the unchanging specificity of the place.

A similar linear clarity appears in *Province of Milan* (no. 50), drawn by Jean-Baptiste-Camille Corot (1796-1875) during a visit to Italy in 1834. Corot inscribed the drawing with the location, date, and possibly the atmospheric conditions, annotations indicating its diaristic purpose. As a descendant of the popular *vedute,* this private drawing reminds us that the desire to recapture in memory the specifics of travel was common to both artist and patron.

Similarly, John Ruskin (1819-1900) inscribed his *Italian Landscape* (no. 49) with a description of the view ("Il Resegone di Lecco from San Stefano"), the date, and the names of various roads and buildings. Its linear style with cursory outlines is similar to that of the two works previously discussed. However, Ruskin appears to have begun work on the watercolor with perhaps the most

ephemeral yet specific indicator of temporality, the sky. For it seems Ruskin's aim was to create an elemental confrontation of clouds and stone, of the momentary with the millenial. Ruskin's knowledge of mountains was based on his study of geology, the causal history of present appearances. "Anatomical work on mountains," Ruskin believed, would aid his art.[13] Indeed there may have been an element of competition in the choice of the subject of snow-capped mountains; in 1878 Ruskin wrote that "[Turner] felt always that every power of art was vain among the upper snows. He might as well have set himself to paint opals, or rubies. The Alps are meant to be seen, as the stars and lightnings are, not painted."[14]

Ruskin's view recalls an eighteenth-century concern with the Sublime, the awe-inspiring forces of nature and history, which are represented in this exhibition by Giovanni Battista Piranesi (1720-1778). Italy's antique landscape, associated with the Ideal, was relocated within a scientific frame of reference with the discovery of Pompeii and Herculaneum in the mid-eighteenth century. Though he began his career in Venice as a painter and architect, Piranesi found success as a printmaker preparing views of Italy and, subsequently, of the ruins of antiquity. His drawings after 1760 related almost exclusively to prints, and his extremely cursory yet precise technique was partly dictated by technical concerns.[15] The dominant feature of his *View of Pompeii* (no. 37) is a rigorous goemetry of lines, ruled and measured rather than sketched, constructing the architecture of ruins. His cryptic numerical annotations, in this drawing from one to fifteen, may relate to his complex etching procedure, which involved up to twelve acid baths.[16] The connotations of objectivity associated with the measured quality of the drawing style are contradicted by the vertiginous perspective and the intentional underscaling of the human figures. Though those may have been conventions of architectural draughtsmanship with no expressive content intended, their effect in Piranesi's prints, in combination with the extraordinarily rich chiaroscuro, made them important elements in romantic artists' imaging of the Sublime. Piranesi's works form an important bridge between the view-painters' conventions of objective delineation and the subjective expression of Romanticism.

At Home: The Familiar Landscape

Home is the beginning and end of most journeys. In many of the present drawings it was the site of the familiar, often the locus of consciously displayed or closely guarded values. For these artists and their patrons, drawings of dwellings could disclose the value of the sites as material possessions and as psychological spaces, places by which one was possessed.

A drawing by Marco Ricci (1676-1730), *The House of Marco Ricci* (no. 35), bears an inscription on the verso stating that it is "The house of Sign.r Marco Ricci in the Bellunese among the mountains: with a view of an adjacent monastery. Taken by Sig.r Marco Ricci and given on the spot to Humphrey Mildmay, Esq.r. An. 1726.)

This drawing was thus a gift to an English patron from Ricci, who had lived in England almost continuously since 1708. The presentation to Mildmay occurred in the same year that Ricci moved back to Italy, and whether or not the drawing accurately depicts his Italian home, it exemplifies the Virgilian ideal of country living. The large farmhouse is set back on broad lands, on which figures busy themselves tending cattle and tilling soil, while in the foreground, in the shade of a tree, two men converse, as a woman attends them. The fecundity of nature and man's husbandry of it are stressed. The figures in the foreground suggest ordered nature's ability to generate intellectual reflection.

By contrast, the drawing by Jean-Baptiste Oudry (1686-1755), *Country Farmhouse* (no. 32), portrays the cluttered yard of a farmhouse. Here wealth is indicated not by the inclusion of peaceful, intellectual reflection, but by an accumulation of farm machinery and by the attraction of birds to the full silo. In the 1720s Henri Camille, Marquis de Beringhen, who had introduced Oudry to Louis XV in 1724, commissioned from the painter a series of six small rural landscapes, at least four of which were finished and dated 1727.[17] The following year the king ordered the artist to follow the royal hunts and make sketches, preparatory to creating a painting.[18] This drawing may or may not be directly related to these commissions, but its emphases concur with the concern of the French court to evaluate the prosperity and material wealth of their lands.

In the latter part of the nineteenth century, Eugène Louis Boudin (1824-1898) represented a French rural community in a highly finished drawing, *Landscape* (no. 58). Here country houses are almost completely obscured by brush and trees, a suggestion that farming and grazing animals have been replaced by industry and city occupations. Boudin, Claude Monet's first teacher, declared the middle class to be as worthy of representation as the poor and the aristocracy. This image seems to embody the silence of the landscape during the bourgeois workday and through its composition, the value of the bourgeois home as a space inaccessible to the external world.

A similar silence reigns in the background garden represented in *Landscape* (no. 71) by Maurice Utrillo (1883-1955). The drawing is enlivened by the great variety of scribbled lines used to construct the image. Its subject is similar to that of a painting (circa 1905) representing a view of the area near Montmagny, a town six miles from Paris.[19] Here Utrillo lived with his mother, the artist Suzanne Valadon and her future husband, Paul Mousis, a prosperous businessman.

Whereas the perimeter of the backyard circumscribes Utrillo's view, in the sketch by Pierre Bonnard (1867-1947), *Study with Window* (no. 73), a window frame constrains nature. The jumble of textures of the garden contrasts with lightly drawn, large, rounded shapes that seem to relax in the interior. The drawing style is as varied as Utrillo's, but looser, more casual in effect. In both these works, value resides in the artist's and viewer's comfortable participation in the closed and protected spaces of bourgeois dwellings. Within this environment,

however, there is still room for the aberrant and individual: Utrillo's alcoholism, Bonnard's reclusive wife.

Several images in this exhibition record public spaces as sites of the familiar, of recreation. In *View of the Pincio in Rome* (no. 33), by Jean-Honoré Fragonard (1732-1806), the villa recedes, cedar trees loom, and the figures gather, lilliputian beneath them. The shaded space the visitors share, rather than the famous building, is emphasized. Fragonard's art created a fashionable ambiance of antiquity for his aristocratic French patrons. In his drawing *La Fête à Saint-Cloud* (fig. 1), Fragonard uses a variety of media: black chalk, graphite, and brushed, colored washes to translate the dream-like dimensions—the sense of fecund, elegant nature overrunning man's monuments of the past—into the soft, cascading space and color of the garden of a royal French chateau.

An equally rich surface animates Boudin's pastel drawing of fashionably dressed women enjoying a day at the beach in his *Beach Scene* (no. 57). The pastel medium, associated with the ancien regime, had been generally out of favor with progressive artists since the revolution. The publication, in the mid-nineteenth century, of the Goncourts' study of eighteenth-century French artists, signaled a rehabilitation of that period's art, and several of the impressionists, notably Renoir and Degas, worked in the medium. Pastel preserves the separate touches of the draughtsman in brilliantly pigmented dust. Its softness allows alterations and is suggestive of sensuous perception rather than intellectual delineation. Boudin's bourgeois ladies, represented here in the same medium favored by eighteenth-century aristocrats, relax in a landscape of common prosperity, rather than in one of privileged wealth. Under their sun-shading umbrellas, on a breezy day, watching ships out on the water, the women sit on a Normandy beach, a coast popular both as a vacation spot and as a shipping center.

Pierre-Auguste Renoir (1841-1919) portrayed the casual delectation of the common landscape in his watercolor *Landscape with Girl* (no. 59). A woman sits with her back to us, facing a vignetted landscape. Renoir also included a caricatured artist on the right, below which he initialed his image. The artist wears a formless, broad-brimmed hat, and is hunched over, intent on his work, right arm outstretched. His slumped posture contrasts with the strong back and squared shoulders of his model, who may be holding a baby, a book, or sewing. The poses of these figures evoke a sense of leisure and informality, echoed by the light, sketched quality of the watercolor. Renoir suggests the familiarity of landscape painting in the latter part of the nineteenth century, but in the rumpled figure of the artist, he also conveys a sense of the intensity of artistic creation.

The Extraordinary Vision

In several of this exhibition's drawings, the human figure is completely subordinated to nature, or indeed, no figures are present to socialize the landscape. We have already noted the problematic nature of figures within *vedute*, but in the landscapes to be discussed here, the absence of human figures allows for the projection of human

sensibility into forms.

In a series of texts and images published in the mid-eighteenth century, the Englishman Alexander Cozens sought to demonstrate the expressive potential of landscape painting.[20] Significantly, Cozens illustrated his theory through drawings composed from blots. He identified various 'species' of landscape compositions found in nature and associated them with emotional and spiritual states. In effect, Cozens sought to elevate the artist's private world of observation and expression, embodied in unfinished drawings, to the status of history painting.

Drawings and landscapes that were products of the imagination rather than studies from nature had, of course, existed for at least a century before Cozens' publications. His emphasis on texture and materiality, and on tone rather than line, was new. His images were compounded not so much of imagined objects as of imagined surfaces and spaces. In the sixteenth century Leonardo had advised looking at a roughly textured wall to find compositional inspiration. What distinguished Cozens from his similarly inspired predecessor was the modern artist's willingness to leave forms ambiguous in the belief that their suggestive and emotional resonances would accordingly be enhanced.

Contemporary with Cozens, Thomas Gainsborough (1727-1788) sought for an alternative to academic theory and its emphasis on the depiction of human emotion in history painting, while attempting to create an art of civic value. Gainsborough may have drawn the two works in this exhibition employing miniature landscapes of charcoal, broccoli, and bits of glass, which he habitually composed to aid his imagination.[21] In any case, his drawing *Woodland Scene with Man and Dog Walking Over a Bridge* (no. 43) has been described as representing an old man accompanied by a small child climbing either over a bridge or up a flight of stairs. These descriptions ignore the compositional priority that Gainsborough gave to the rolling, hillocked woodlands splashed with light. The smudged, vague figures merge with the landscape.

Diminutive figures also seem to dissolve in the environment, in Corot's charcoal *Landscape* (no. 51). The sketched equivalent of the feathery, classical landscapes of his later paintings, this drawing approaches an abstract evocation of light and shade, with looming form and expanding space.

The obscurity of these scenes finds its equivalent in nocturnal perception. Night is inimical to traditional

Fig. 1. Jean-Honoré Fragonard, (French, 1732-1806), *La Fête à Saint-Cloud*. The Robert Lehman Collection, 1975.1.628. Metropolitan Museum of Art, New York.

drawing; line and definition disappear, leaving unbounded fields of shifting tones. Popular during the baroque era as a background for striking light effects, often in the service of dramatic narratives, the obscurity of night comes into its own as a subject in the nineteenth century, when the correlation of nature and human sensibility was sought through appeals to perceptual equivalents. Three works in the exhibition indicate the general development of this motif.

In his *Moonlit Landscape* (no. 55), Harpignies shows a large field bounded by a distant horizon of trees and the roofs of a town, dominated by one huge, scraggly tree. Two indistinct figures stand on a thin, luminous path which cuts diagonally across the field. The moon glows, half-hidden behind lowering clouds. The image conveys a romantic sense of mystery through a record of nocturnal observation—the curious tonal reversal characteristic of nighttime, in which the foreground is lighter than the horizon.

Obscurity in the presence of illumination structures *The Lighthouse at Honfleur* (no. 61), by Georges Seurat (1859-1891). As in so many of the artist's drawings done in conté crayon, Seurat explores here an effect of intangibility. He extends the frustrations of night vision to daytime sight, creating on rough Ingres paper a haze of granular particles that refuses to coalesce into distinctly modelled forms.

A follower of neo-impressionist theory, Henri Edmond Cross (1856-1910) created a visionary image of the star-filled night sky in his watercolor *Landscape with Stars* (no. 67). Cozens' blot technique could have been used to produce the horizon line of trees rising above a line of lighter wash, as though out of a low-lying mist. Three textures compose the image: the incorporeal wash, the thick blot, and the crystalline network of the sky. This image is about the eye's ability to fill darkness with color and tangibility.

Patrons, Possession, and Fantasy

Two-thirds of the drawings in this exhibition, from the eighteenth century on, are either initialed, signed, or signed and annotated, an indication that they were created or valued as independent works of art at the time of their production. None of the exhibited modern drawings can be definitely connected with a painting. An example of one drawing in the Lehman collection that is related to a painting is Fragonard's *Fête à Saint-Cloud* (fig. 1), which is a preliminary study, a "première pensée" for part of a painting with the same title commissioned by the duc de Penthiere about 1755.[22] Drawings that were made as studies for prints are uncommon as well; the Piranesi *View of Pompeii* (no. 37) is the only certain example.

One drawing in the show, *The House of Marco Ricci* (no. 35), an eighteenth-century work discussed above, bears an inscription indicating it was a presentation piece to a patron. The inscription of another work in the Lehman collection, *Pastoral with Two Sailing Boats* (fig. 2) by Armand Guillaumin (1841-1927), suggests the evolving artist/patron relationship. Guillaumin apparently dedicated the drawing to Eugene Blot on Easter of 1909.

A brief history of the artist and patron helps elucidate their close relationship. Blot was first introduced to the art of Guillaumin, and to collecting as well, in 1882, by a Docteur Filleau, who took him to the gallery of Père Portier in the rue Lepic, in Paris. Blot purchased three paintings on that first visit: a Boudin, a Guillaumin, and a Pissarro, all for three hundred and fifty francs.[23] By 1907, Blot had emerged as an important dealer and had handled works by Guillaumin. This same year, Blot arranged a very successful exhibition of Guillaumin's paintings and pastels at the Galerie Druot in Paris. In May of 1909, Guillaumin exhibited there again, and again his art sold well. Perhaps he dedicated this drawing to Blot in thanks for arranging the upcoming 1909 show. In any case, Blot's progression from collector to dealer to co-founder of the Society of Friends of the Luxembourg Museum, an organization that distributed funds to needy artists and their families exemplifies the close relations that often existed between artists and patrons during this time, and the proximity of collectors and dealers as well.

The provenance of Seurat's *The Lighthouse at Honfleur* (no. 61), charts its passage through collections belonging to painters, art critics, and art historians, including Maximilien Luce, Félix Fénéon, and John Rewald. Highly finished, the work rivals Seurat's paintings as a fully characteristic piece.[24] In both media we find the ordinary transformed into a hauntingly suggestive visual paradox: an image of strong formal design yet vague form, based on observation.

We can compare Seurat's drawing with another much earlier work, also probably conceived as an independent work of ar t. *Landscape with a Horse Held by a Page* (no. 40), by Giandomenico Tiepolo (1727-1804), combines a dramatic mountain landscape, perhaps based on the artist's travels in Spain, with a fancifully costumed page who has dropped his banner to tend a beautiful, thoroughbred horse.[25] The page looks toward an elegant dog, and these three symbols of extravagant and whimsical luxury are juxtaposed with a hay wagon drawn by oxen, climbing the steep slope in the background. The horse, page, and dog exist in a brilliant foreground light that defines their solidity in opposition to the gray wash of the background and substantiates the whimsical over the mundane.

Tiepolo's drawing makes fantasy tangible, while Seurat's reveals the transformation of reality into the suggestive intangibility of drawing. In the difference between these two depictions, we witness the artists' transfer of allegiance and ambition from extravagant objects of possession to what cannot be owned but can only be seen. Individualized acts of perception become the locus of imaginary and the creative. The landscape has correspondingly shifted, from a place in which to exist, to a protean field, informed by the viewer's emotion. The mobility of the traveller has been internalized.

The descendant of the eighteenth-century traveller is the mid-nineteenth century "flaneur," as described by Charles Baudelaire: the man who moved "into the crowd as though into an enormous reservoir of electricity,"[26] a blur among other blurs in the "landscape of stone."[27] Baudelaire's description occurred in his essay on the "Painter of Modern Life." Significantly, the artist celebrated in this

essay, Constantin Guys, embodied Baudelaire's ideal of art not through finished paintings, but through informal sketches and unsigned drawings. They were the only media responsive enough to catch that half of art which Baudelaire defined as modernity: "the transient, the fleeting, the contingent."[28]

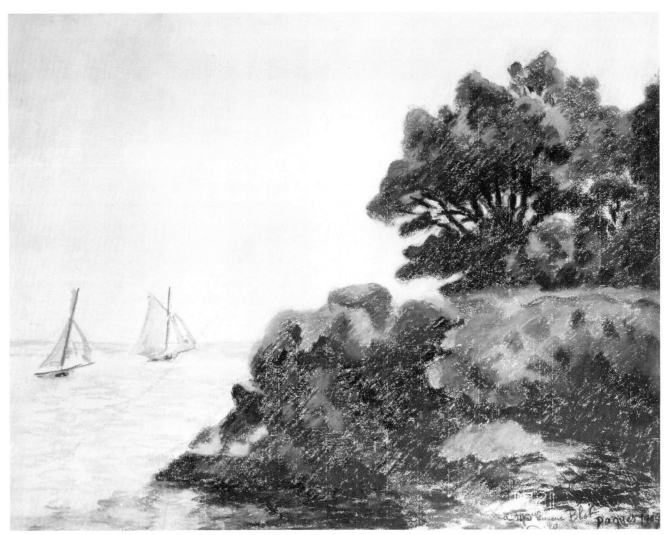

Fig. 2. Armand Guillaumin, (French, 1841-1927), *Pastoral with Two Sailing Boats,* The Robert Lehman Collection, 1975.1.635. Metropolitan Museum of Art, New York.

NOTES

1. John Ruskin, *The Elements of Drawing and Perspective* (London/New York, 1907), xxii.

2. This debate is further complicated by the enormous variety of meanings that "nature" has enjoyed. Kenneth Clark counts sixty-eight in *English Romantic Poets and Landscape Painting* (London, 1945), 2.

3. Joseph Alsop, *The Rare Art Traditions* (New York, 1982), 114-15.

4. Concerning English landscapists, see, for example, John Barrell, *The Dark Side of Landscape* (Cambridge, 1980) and Ann C. Birmingham, *The Ideology of Landscape: Gainsborough, Constable and the English Rustic Tradition* (Ann Arbor, 1984). The new approach to impressionism is exemplified by Paul Tucker, *Monet at Argenteuil* (New Haven, 1982) and summarized in *Day in the Country: Impressionism and the French Landscape*, exh. cat. (Los Angeles County Museum of Art, 1984).

5. For example, Cézanne's oil-painting *La Promenade*, c. 1871 (Venturi *ffl*119), reworks a fashion print published in *La Mode Illustré* in 1871, transforming an anonymous and ephemeral image into a monumental one.

6. Quoted by Charles Rosen, "Now, Voyager," *New York Review of Books* (11/6/86), 56.

7. Excerpted from Fuseli's *Lectures on Painting* (1820), 185; as quoted and discussed by Conal Shields in her introduction to Leslie Parris, *Landscape in Britain c. 1750-1850*, exh. cat. (The Tate Gallery, 1973), 10.

8. Ibid.

9. Ibid.

10. The similar work in the Leeds Art Gallery, is titled *View of Chester* (a town in the county of Cheshire, England), and is reproduced in Adrian Bury, *John Varley of the "Old Society,"* (Leigh-on-Sea, 1946), plate B.

11. On the use of camera obscura by view-painters, see, for example, Decio Gioseffi, *Canaletto: Il quaderno delle gallerie veneziane e l'impiegno della camera ottica* (Trieste, 1959).

12. Reproduced in Burr Wallen, *The William A. Gumberts Collection of Canaletto Etchings*, exh. cat. (Santa Barbara Museum of Art, 1979), no. 24.

13. Quoted in Arts Council of Great Britain, *John Ruskin*, exh. cat. (London, 1983), 27.

14. Ibid, 25.

15. As discussed in Jonathan Scott, *Piranesi* (London/New York, 1975), 293.

16. Piranesi's paintings procedure is described in Scott's *Piranesi* on page 297. However, Scott doesn't discuss Piranesi's numbering system, and there has apparently been no investigation of the meaning of these numbers.

17. As discussed in Hal Opperman, *J.-B. Oudry,* (Fort Worth, 1983), 128-29.

18. Ibid.

19. The work, *Paysage à Pierrefitte, is reproduced in Paul Petrides, L'oeuvre complet de Maurice Utrillo* (Paris, 1959), no. 11. The drawing is also close to a drawing, *Restaurant Campagnard*, dated 1912, reproduced as no. D93 in Petrides.

20. For a succinct discussion of Cozens' theories and recent publications concerning them, see Michael Rosenthal, "An Expressive Topography," *Times Literary Supplement* (12/5/86), 1376.

21. Gainsborough's contemporaries Solomon Gessner and Sir Joshua Reynolds describe his use of these aids; see John Hayes, *The Drawings of Thomas Gainsborough* (New Haven, 1971), 33.

22. As noted by George Szabo, *Seventeenth and Eighteenth Century French Drawings* (New York, 1980), no. 13a. The painting is in the collection of the Banque de France, Paris.

23. Blot's relationship with Guillaumin is detailed in the essay by Raymond Schmit, "Armand Guillaumin dans son temps," in G. Serret and D. Fabiani, *Armand Guillaumin, Catalogue raisonée de l'oeuvre peint* (Paris, 1971), 70-76.

24. Concerning the problematic relationship between Seurat's drawings and paintings, see Robert Herbert, *Seurat's Drawings* (New York, 1962), passim; and, most recently, Erich Frantz and Bernd Growe, *Georges Seurat, Drawings* (Boston, 1983), 7-49, passim.

25. The possible connection with Tiepolo's travels is made by George Szabo, *Eighteenth Century Italian Drawings* (New York, 1981), no. 117.

26. Charles Baudelaire, *Baudelaire: Selected Writings on Art and Artists*, trans. P.E. Charvet (Harmondsworth, Sussex, 1972), 400.

27. Ibid.

28. Ibid, 403.

COLORPLATES

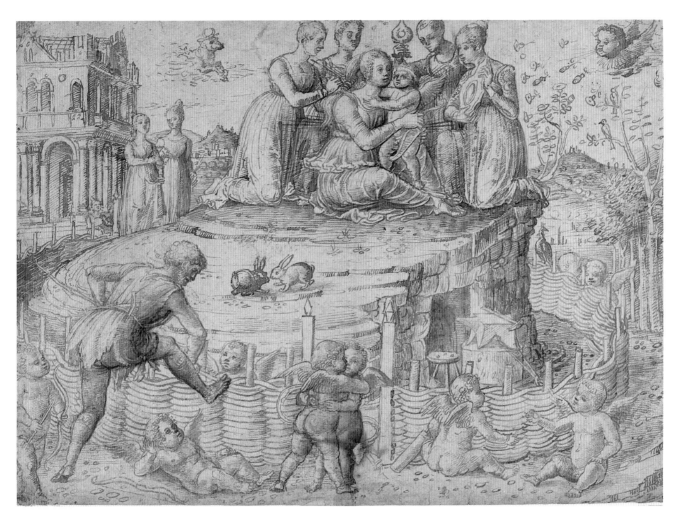

Francesco del Cossa
Italian, c. 1436-1478
Venus Embracing Cupid at the Forge of Vulcan
Pen and brown ink on paper

Colorplate I
Catalogue No. 4

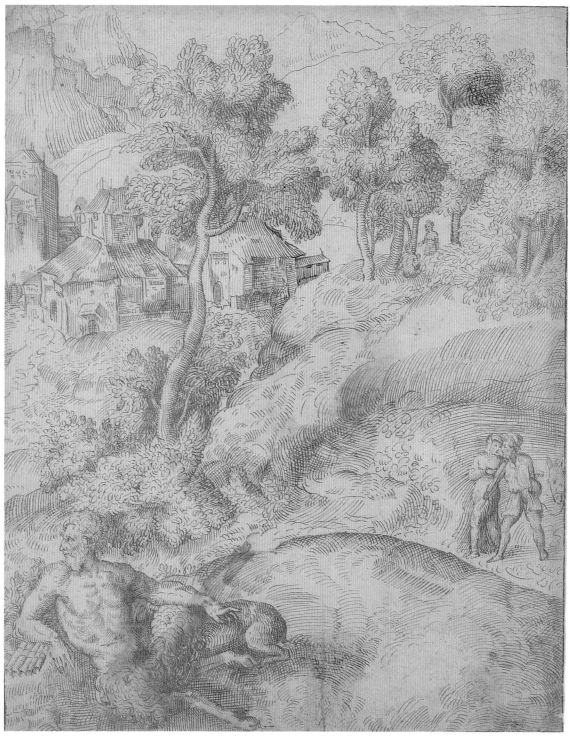

Colorplate II
Catalogue No. 7

Domenico Campagnola
Italian, 1500-1564
Landscape with Satyr
Pen and brown ink on paper

34

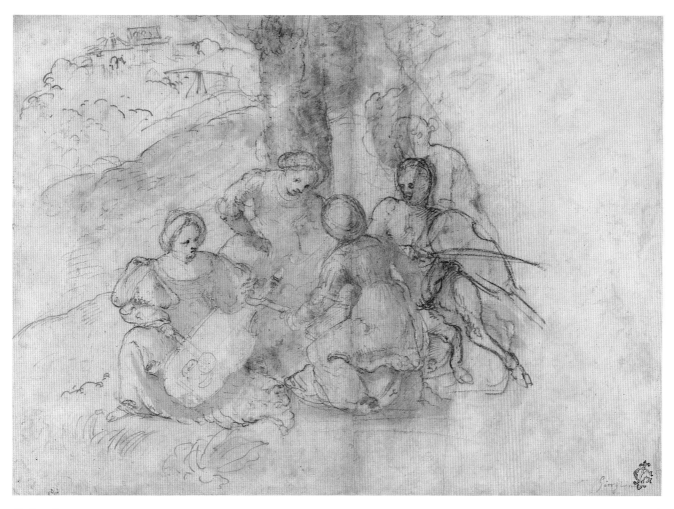

Girolamo Romanino
Italian, 1484/87-1559
Pastoral Concert
Pen and brown ink and brown wash over black chalk on paper

Colorplate III
Catalogue No. 8

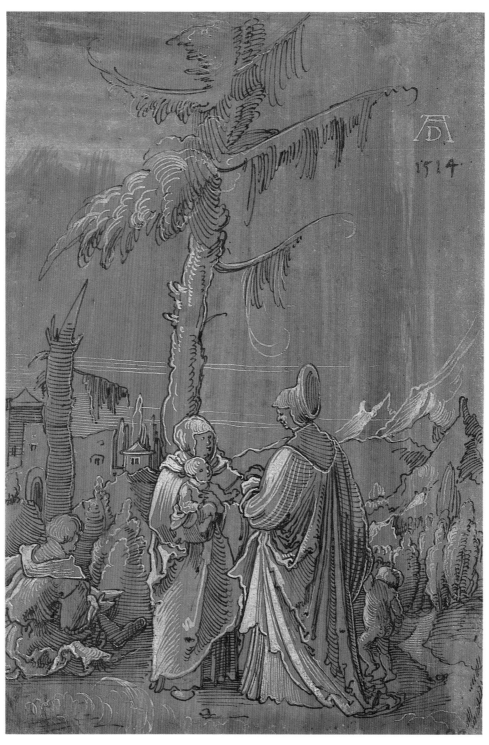

Colorplate IV
Catalogue No. 11

Follower of Albrecht Altdorfer
German, 1480-1538
The Holy Family
Pen and ink, heightened with white on light yellow-brown prepared paper

German Artist
Nürnberg, 1543
Fantastic Landscape
Pen and ink with white highlights, blue and green wash on paper

<div align="right">

Colorplate V
Catalogue No. 13

</div>

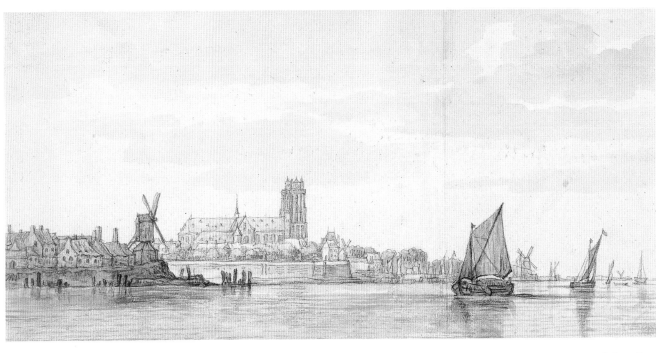

Colorplate VI
Catalogue No. 20

Aelbert Cuyp
Dutch, 1620-1691
View of Dordrecht with the "Grote Kerk"
Black chalk and watercolor on paper

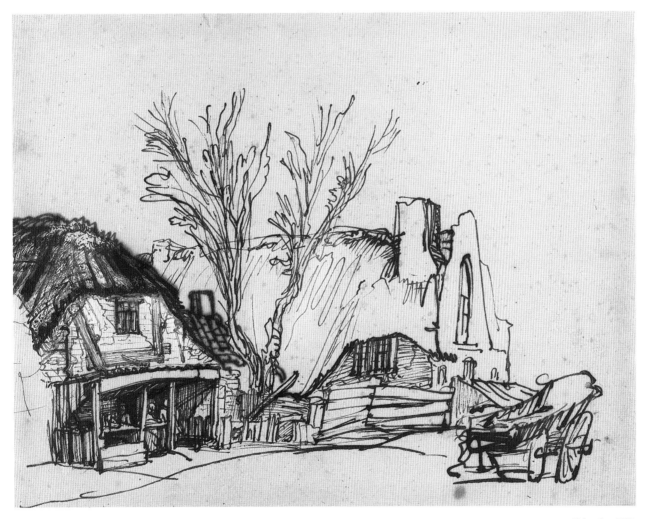

Rembrandt Harmensz van Rijn
Dutch, 1606-1669
Two Cottages
Pen and dark brown ink with white paint and gallnut ink on paper

Colorplate VII
Catalogue No. 22

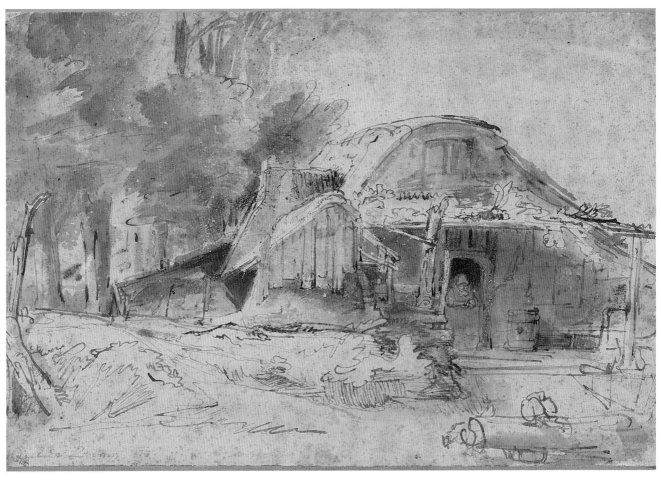

Colorplate VIII
Catalogue No. 23

Rembrandt Harmensz van Rijn
Dutch, 1606-1669
Cottage near the Entrance to a Wood
Pen and brown ink with brown wash over black chalk on paper

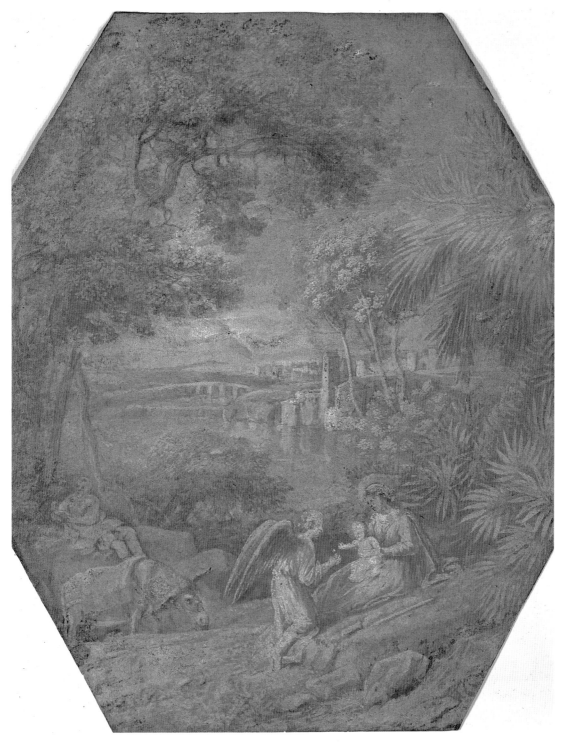

Claude Lorrain (Claude Gellée)
French, 1600-1682
Landscape with the Rest on the Flight into Egypt
Point of brush in brown wash heightened with white paint on blue paper

Colorplate X
Catalogue No. 36

Giovanni Paolo Pannini
Italian, 1691-1765
Landscape with Statue and Ruins
Pen and brush with tinted ink washes and watercolor on paper

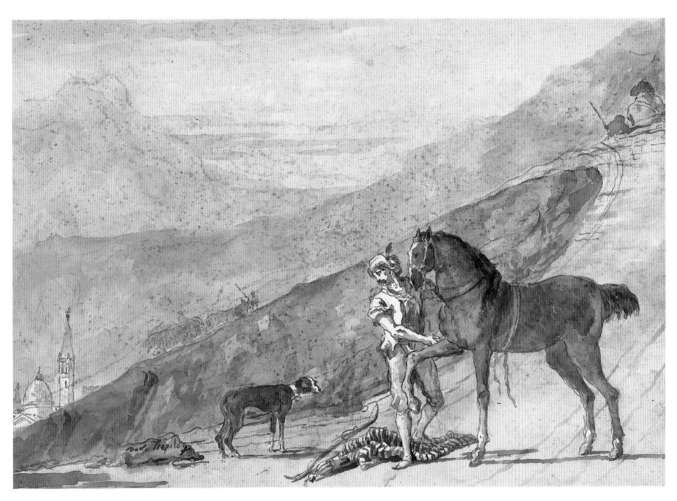

Giandomenico Tiepolo
Italian, 1727-1804
Landscape with a Horse Held by a Page
Pen and ink with wash over black chalk preliminary drawing on paper

Colorplate XI
Catalogue No. 40

Colorplate XII
Catalogue No. 54

Henri-Joseph Harpignies
French, 1818-1916
Landscape
Watercolor over pencil drawing on paper

Pierre-Auguste Renoir
French, 1841-1919
Landscape with Girl
Watercolor on paper

Colorplate XIII
Catalogue No. 59

Colorplate XIV
Catalogue No. 60

Vincent Van Gogh
Dutch, 1853-1890
Road Near Nuenen
Chalk, pencil, pastel and watercolor on paper

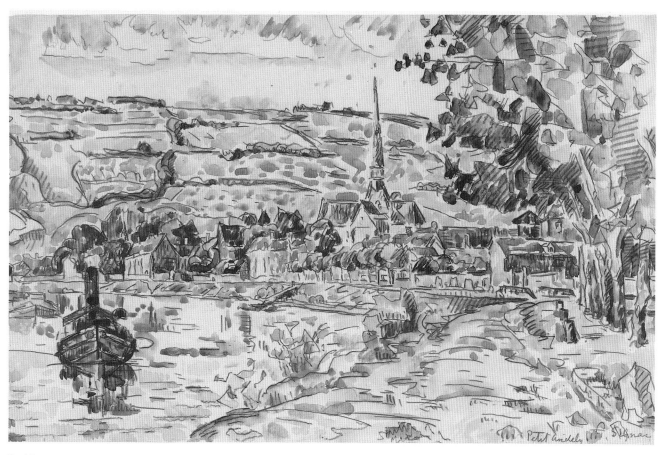

Paul Signac
French, 1863-1935
Petit Andelys: The Barge
Watercolor over pencil on paper

Colorplate XVI
Catalogue 67

Henri-Edmond Cross
French, 1856-1910
Landscape with Stars
Watercolor over pencil on paper

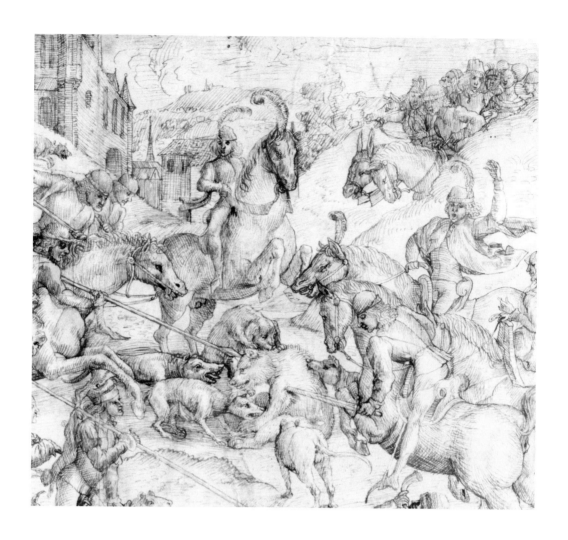

CATALOGUE

George Szabo

No. 1

Frank van der Beecke or François à Becke
Flemish, Bruges, about 1470

The Bear Hunt

Pen and sepia ink over black chalk on paper, 29.9 x 42.6 cm. The sheet is cut along all four sides. Inscribed on verso in an early sixteenth-century hand: *François à Becke*.

Provenance: Mrs. Chauncey J. Blair, Chicago.

Bibliography: *Master Drawings*, 1935, no. 10; Orangerie Cat., 1957, no. 110; Cincinnati Cat., 1959, no. 238; *The Waning Middle Ages*, The University of Kansas Museum of Art, Lawrence, Kansas, 1969, no. 37; Szabo, 1978, no. 4.

This unusually large and rich drawing represents a bear hunt set in a hilly and partly wooded landscape with a large castle and other buildings looming in the background. The participants of the courtly hunt number close to thirty. Some are mounted, while others are on foot and, together with ten hunting dogs, they seem to congregate around a large bear — the victim of the hunt, who is placed just right of the composition's center.

The hunters are divided into well-defined and composed lively groups. On the left, a party of mounted participants is dominated by two elegantly dressed young women wearing hennins: the one in the mid-ground is seated sideways behind a young nobleman with a flat hat, her face is round and her dress is decolletée; the other young woman in the back is also seated sideways on the saddle, but she has her own mount led by a young attendant. In the center, hunters, both on horseback and on foot, are carrying lances, leading hunting dogs or attacking the bear.

On the right there are also groups of courtly participants. In the center another young woman on horseback and a young courtier with a long feather in his cap. On the top right, a larger group of ladies and men, seemingly all mounted on horses, except for a court-jester wearing an eared fool's cap and riding a long-eared donkey or mule.

Judging from the cut-off figures on the bottom and on the right, the drawing was originally larger on these two sides. Thus, the hub of the composition with the bear must have constituted the original true center of the whole.

Only a few early Netherlandish drawings can be compared to this large composition. The sheet representing a *King with his Entourage before an Ossuary* in Hamburg, usually attributed to a follower of Hugo van der Goes and dated c. 1470, contains similar figures to those found on *The Bear Hunt*: a young prince, two elegantly dressed young ladies, courtiers and a fool. The young prince is even identified sometimes as Maximilian of Hapsburg who as the consort of Charles the Bold's daughter, Mary of Burgundy, was in Flanders onward from 1477 (F. Winkler, *Das Werk der Hugo van der Goes*, Berlin, 1964, pp. 242-243, fig. B5). Another comparable but later composition by Bernard van Orley, now in a Private Collection, depicts a *Hawking Party* with a young lady on horseback, surrounded by other hunters and again by a fool. It is connected to a series of drawings in the Louvre that represent the *Hunts of Maximilian* and dated to c.

1535 (A. E. Popham, "Bernard van Orley (?1490-1542), Hawking Scene," *Old Master Drawings*, I, 1926, pp. 22-23, pl. 31).

The elaborate garments and head-dresses of the figures roughly date this unusual drawing to the 1470s. This dating is strengthened by the mention of several members of the van der Beecke family, who were employed as artists to execute certain festive decorations for the wedding celebration of Charles the Bold and Margaret of York in 1468.

The elaborate composition and design of the bear hunt suggest that it could have been made as a preliminary drawing for such a festive decoration or tapestry. The Dukes of Burgundy and their courtiers greatly favored representations of ceremonial hunting and fishing scenes on paintings, manuscript illuminations and on tapestries. Some are still preserved and recent scholarly studies have successfully tied them to certain historical events and have identified the principal figures and exact locations represented on them (O. Kurz, "A Fishing Party at the Court of William VI, Count of Holland, Zeeland and Hainault. Notes on a Drawing in the Louvre," *Oud-Holland*, LXXI, 1956, pp. 117-131; R. Mullally, "The So-called Hawking Party at the Court of Philip the Good," *Gazette des Beaux Arts*, VIe per., XC, 1977, pp. 109-112; A. van Buren Hagopian, "La Revue de Louvre et des Musées de France, XXXV, 1985, pp. 185-192; for the Devonshire Hunting Tapestries see G.W. Digby, Victoria and Albert Museum, *The Tapestry Collection, Medieval and Renaissance*, London, 1980, pp. 12-14, figs. 2-11).

It is quite plausible, therefore, to assume that this drawing was commissioned to record a similar occasion. Furthermore, the hunt depicted could easily have included both Margaret of York and Mary of Burgundy; images of the two ladies wearing hennins are probably portraits and the young man in front of Mary of Burgundy could be identified as Maximilian of Hapsburg. Consequently, the whole composition may be a record of a specific historical event and place of importance yet to be identified.

Considering the above, the landscape with the castle and the town in the background may also have some importance that has been overlooked until now. The architectural details of the castle with crenellated walls, turrets and tall windows seem to indicate specific components of an existing building complex, not an imaginary one.

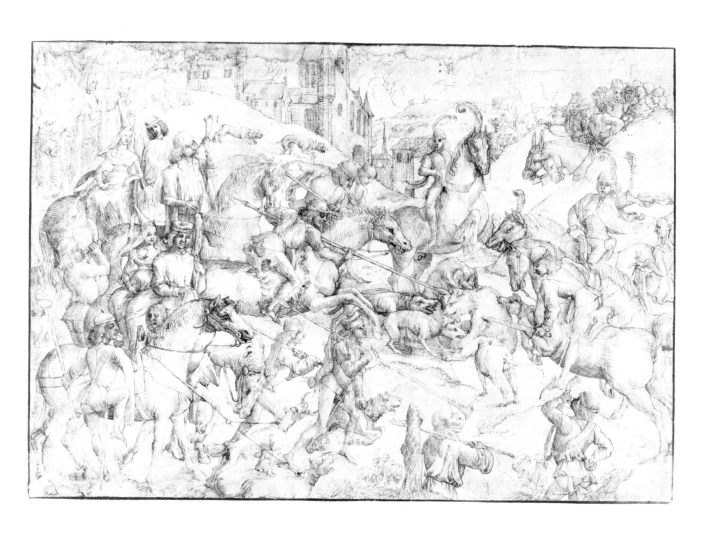

No. 2

Baccio della Porta called Fra Bartolommeo
Italian, Florence, 1472-1517

Horsemen Approaching a Mountain Village

Pen and brown ink on paper, 29.8 x 20.6 cm.

Provenance: Fra Paolino da Pistoia, Florence; Suor Plautilla Nelli, Convent of Saint Catherine, Piazza San Marco, Florence; Cavaliere Francesco Maria Nicolò' Gabburri, Florence; William Kent; Private collection, Ireland.

Bibliography: Fleming, 1958, p. 227; Kennedy, 1959, pp. 1-12; Bean-Stampfle, 1965, no. 30; Szabo, 1978, no. 34; Szabo, 1982, no. 21; Szabo, 1983, no. 21.

This fleeting and wide-ranging landscape was once part of an album with forty other landscape studies that was assembled in 1730, bound in sheepskin, and provided with a frontispiece bearing the arms of Cavaliere Gabburri (1675-1742). The title page attributed the landscape studies to Andrea del Sarto, but now they are safely tied to the autograph oeuvre of Fra Bartolommeo and are considered to be "among the earliest pure landscape studies in European art" (Bean-Stampfle, 1965, p. 33).

The exact place represented here and the date of the drawing are both unknown. In some of the other drawings the topography is easily identifiable, among them the buildings of the Convent of Santa Maria Maddelena in Pian di Mugnone near Caldine on a sheet now in the Museum at Smith College (Kennedy, 1959, pp. 4-7). Approximate dating for this drawing is provided by the watermarks on a number of other sheets from the Gabburri Album, for the paper can be identified as Florentine of 1507 and 1508 (Kennedy, 1959, pp. 8-9). Various speculations also connect some of the landscape drawings with Fra Bartolommeo's trip to Venice in March and April of 1508.

An interesting aspect of this drawing is that another one in the Gabburri Album, closely related to it, shows the same landscape but from "a more distant and slightly different vantage point" (Collection of Count A. Seilern, Prince's Gate, London). The Seilern drawing "was used for the landscape in Giuliano Bugiardini's *Rape of Dinah* which, as described by Vasari, was begun by Fra Bartolommeo and finished by Bugiardini," the only instance in which one of the Gabburri landscapes is directly connected with a painting (I. Härth, "Zu Landschaftzeichnungen Fra Bartolommeos und seines Kreises," *Mitteilungen des Kunsthistorischen Institutes in Florenz*, IX, 1959, pp. 125-30).

No. 3

Italian Artist
Venice, First Quarter of Sixteenth Century

Saint Jerome in a Landscape

Pen and brown ink on paper, 17.8 x 21.6 cm.

Provenance: Luigi Grassi, Florence (Lugt Supplement, 1171b).

Bibliography: Berenson, 1938, no. 1589J; Langton Douglas, 1946, p. 128, plate LXXX; Orangerie Cat., 1957, no. 112; Cincinnati Cat., 1959, no. 201; Bean, 1960, discussed in no. 1010; Berenson, 1961, no. 1859J; Heinenmann, 1962, p. 286; Puppi, 1962, p. 148, fig. 107; Bean-Stampfle, 1965, no. 4; Wazbinski, 1968, p. 8, fig. 8; Ragghianti, 1972, p. 132, fig. 28; Pignatti, 1974, no. 7; Szabo, 1979, no. 26; Szabo, 1982, no. 40; Szabo, 1983, no. 40.

This sheet is one of the earliest examples of Italian landscape drawing. The free-flowing lines become lighter and lighter as the watery landscape recedes into the distance and the dense, but playfully drawn, timbered buildings in the center exude an exotic but still familiar ambiance and feeling. The qualities of this "little masterpiece" have elicited constant praise but no consistency of attribution since it surfaced at the Grassi sale in 1924. Berenson ascribed it to Pietro di Cosimo and noted the "Flemish" and "Japanese" feeling. His attribution was accepted by Langton Douglas. In contrast, the Venetian character was strongly stressed by other connoisseurs and commentators. Robert Lehman preferred an association with Giovanni Bellini; others mention the influence of Alvise Vivarini, Giorgione, and Bartolomeo Montagna (for a summary of opinions see Bean-Stampfle, 1965, p. 20). Pignatti's reaffirmation of the Giorgione connections is noteworthy. Inconclusive as these attributions are, together with the presence of the Northern half-timbered buildings (borrowed from Dürer?), they nevertheless suggest a dating to the first decades of the sixteenth century.

The importance and the beauty of the landscape have overshadowed the figure of Saint Jerome and the iconographic problems of this complex drawing. For instance, it was suggested that the writing saint before the opening of a cavelike cell could also be Saint John on Patmos. However, as Wazbinski also noted, the saint is definitely Saint Jerome, and the drawing is a remarkable illustration of humanistic ideas popular in Northern Italy during the fifteenth century which represent this saint as an example of the *Vita Solitaria* or *Vir Melancholicus*. This cult of Saint Jerome reaches back as far as Petrarch and was rekindled by later writers such as Angelo Decembrio and Pietro Bembo. They all emphasize the solitary meditation of the saint sitting before his cell as his mind wanders through the savage and magnificent forests, the snow-covered mountains, the cool valleys, and the far-reaching rivers (Wazbinski, 1968, pp. 6-8, 16). In this sense, the freely drawn figure of Saint Jerome seems to be a deliberate contrast to the compressed, dense group of half-timbered buildings that are also antipodes of nature, adding another artistic and poetic dimension to this celebrated drawing.

Francesco del Cossa
Italian, c. 1436-1478

Venus Embracing Cupid at the Forge of Vulcan

Pen and brown ink on paper 28 x 40.7 cm.

Provenance: Jan Pietersz, Zoomer (Lugt 1511); John Skippe; Descendants of John Skippe; the Martin Family, including Mrs. A. C. Rayner Wood; Edward Holland Martin.

Bibliography: Fry, 1906-7, no. 14; Parker, 1927, no. 24; Popham, 1930, no. 147; Ruhmer, 1958, pp. 40-41; Columbia Exh., 1959, no. 6; Bean-Stampfle, 1965, no. 8; Szabo, 1975, pl. 196; Images of Love and Death, 1975, no. 59; Szabo, 1977, no. 3; Szabo, 1978, no. 17; Szabo, 1982, no. 11; Szabo, 1983, no. 11.

This exceptionally large and magisterial sheet is unquestionably North Italian. But the complex iconography, its purpose, as well as any precise attribution still present a great variety of problems and at best only tentative solutions.

The central focus of the composition is Venus, seated on a rocky mount, holding the winged Cupid who stands between her legs crossed at the ankles and embraces her. His blindfold is raised to his forehead. Venus and Cupid are surrounded by four attendant maidens, possibly the Hours; the two on the left seem to arrange Venus's hair, the third holds a perfume vial, and the fourth an elaborately framed mirror. As if in antithesis to their refinement, the rocky mount under them has a dark opening before which are the rude tools of the blacksmith, hammer on the anvil, tongs against the stock, and a sturdy three-legged stool. Vulcan himself is weaving a fence around the mount. In contrast to the graceful garments of Venus and her group, he is raggedy, with a hammer stuck in his belt. Inside and outside the fence are nine winged putti in various poses, some with bow and arrow, some with only a quiver. The two who embrace at the gate in the center may be Eros and Anteros. In the upper left, from the direction of a palazzo with elaborate architectural details, three young women, perhaps the Graces, approach the enclosure through a rear gate. Each is holding an unidentified object. In the sky above them is a half-figure of a bull, the sign of Taurus. In the upper right corner, a winged, cherub-like figure is blowing flowers toward Venus's group. In the distant background, cities and castles on hilltops complete the composition. In addition, various animals further embellish the rich iconography: two rabbits are playing on the mount, a peacock is perched on the fence, and there are songbirds on the branches of the trees.

Ever since Fry first published the drawing in 1906, the richly inventive and involved iconography has been connected with the elaborate allergories of the cycle of frescoes by Ercole de'Roberti, Cosimo Tura, and, between 1469 and 1470, Francesco Cossa. It further has been suggested that the drawing may be "a model for a counterpart to the Mars-Venus fresco" (Columbia Exh., 1959, no. 9). The symbolism seems to confirm this theory; the enclosure with the fence probably represents a bond of marriage, further underlined by the presence of the peacock, a bird of Juno, the guardian of marital fidelity. The embracing Eros and Anteros may signify the emphasis on mutual love. The flower-blowing cherub may be Zephyrus and, together with the zodiacal bull, would imply that the scene represents the month of April, which is governed by the planet Venus.

Whether the virtuoso drawing is by Cossa or by one of his associates is hard to ascertain, because no documented drawings are known (Bean-Stampfle, 1965, p. 23). The complicated cross references of the allegorical representations seem to indicate careful planning and also reveal that the theme of the drawing was partially inspired by Pellegrino Prisciano, the probable author of the Schifanoia cycle. Besides the thematic variety, the excellence in drawing, the elegant figures, and the playful putti strongly imply that if the drawing is not an autograph work of Cossa, it is by another major master and not by a somewhat lackluster follower like Parentino, as suggested by Ruhmer. A careful analysis and comparison with other Ferrarese drawings of the period, such as the *Orpheus* in the Uffizi, might shed a new light on this and other drawings attributed to Cossa (A. F. Tempesti-Tofani, *I grandi disegni italiani degli Uffizi di Firenze*, Milan, 1974, no. 32).

No. 5

Ercole de'Roberti
Italian, Ferrara, c. 1456-1496

Saint Sebastian

Pen and brown ink on prepared paper, 30.2 x 21 cm.

Provenance: Unknown; acquired in the 1920s.

Bibliography: Master Drawings, 1935, no. 12; Cincinnati Cat., 1959, no. 204; E. Ruhmer, "Ergänzendes zur Zeichenkunst des Ercole Roberti," *Pantheon*, XX, 1962, pp. 243-244, 247; Szabo, 1978, no. 25; Szabo, 1982, fig. 43; Szabo, 1983, fig. 43.

The body of the martyred saint pierced by arrows is tied to a dry tree-trunk that halves the composition and the landscape behind him. On Saint Sebastian's right, a harsh, forbidding and bare rocky mountain formation continues the rocks of the foreground. Its ragged, geometric shapes are strong contrasts to the gently rolling, soft hills on the left, enlivened with clusters of trees and vistas of buildings and a faraway castle. The tension in the landscape, the agony of the saint and the nervous, scratchy lines of the reed pen imbue the drawing with a feeling of drama.

The rather large sheet for a long time was attributed to Francesco Cossa and considered a preliminary drawing for a panel painting similar to his well-known *Orpheus* in the Uffizi (E. Ruhmer, *Francesco del Cossa*, München, 1959, p. 86). However, Ruhmer convincingly placed it into the oeuvre of Ercole de'Roberti by comparing it to other drawings of this younger follower of Cossa. Emphasizing the nervous character of the drawing style, he states this sheet may be one of the earliest drawings by Roberti and dates it to the first years of the 1480s.

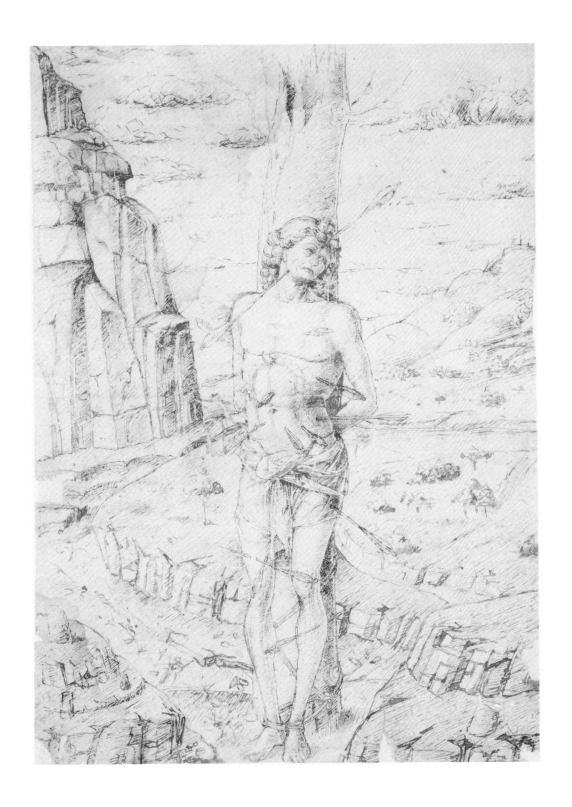

Domenico Campagnola
Italian, Padua, 1500-1564

Landscape with a Rock and Buildings

Pen and brown ink on paper, 17.3 x 14.8 cm.

Provenance: Collection of John Skippe; Collection of Edward Holland Martin, London.

Bibliography: *Catalogue of the Well-known Collection of Old Master Drawings, Principally of the Italian School formed in the 18th century by John Skippe*, London, Christie, Manson & Woods, November 20, 1958, Lot 47; Szabo, 1979, no. 22; Szabo, 1982, p. 41; Szabo, 1983, p. 41, fig. 52.

A pure landscape is created here by Domenico Campagnola, who was born of a German father and adopted by the Italian artist Giulio Campagnola. Two traditions are reflected in this composition: the Italian preoccupation with nature is seen in the representation of the large rock and tree in the foreground; the northern trait is the elaborate minutia of the buildings occupying the middle and affect the sketchy, distant view of the mountains. The refined penwork, the masterful recreation of space and distance imbue the drawing with qualities that once tempted the well-known connoisseur and scholar of Italian drawings, A. E. Popham (verbal communication) to attribute this sheet to Titian.

However, recent comprehensive studies convincingly tie the drawing to Domenico Campagnola's oeuvre. E. Saccomani, through documentation, reveals that this combination of large rock, tree and distant buildings is frequent in his other drawings. She cites the landscapes in the Uffizi, in the Louvre, in the British Museum, as well as those in Amsterdam and Berlin to constitute a well-defined group ("Domenico Campagnola disegnatore di 'paesi':degli esordi alla prima maturità," *Arte Veneta*, XXXVI, 1982, figs. 1, 4, 7, 9, 12, 13, 14, 19, ...). Although she did not include this drawing, it is quite evident that by its characteristics it certainly belongs to her assembly of Domenico Campagnola's landscape drawings.

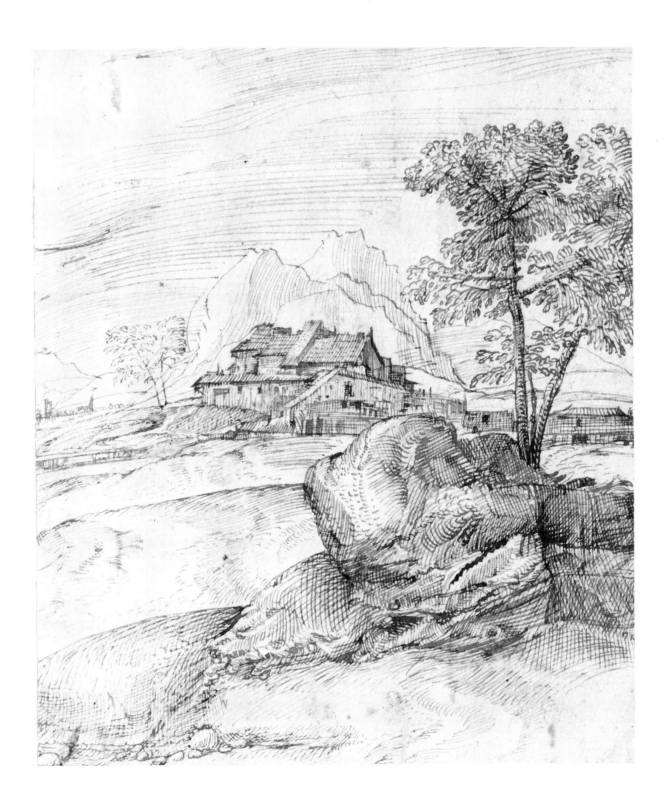

No. 7

Domenico Campagnola
Italian, Padua, 1500-1564

Landscape with Satyr

Pen and brown ink on paper, 26.2 x 20.8 cm. Watermark: Anchor in a circle, similar to Briquet 587.

Provenance: Unknown; acquired from W. H. Schab, New York, 1959.

Bibliography: *Graphic Arts of Five Centuries: Prints and Drawings*, W. H. Schab Gallery, New York, 1959, no. 127; Szabo, 1979, no. 23; Szabo, 1982, no. 37; Szabo, 1983, no. 37.

This lively sheet contains an almost complete inventory of the subjects, draughtsmanship, and style that made Domenico Campagnola so influential, not only among his Italian and Northern contemporaries but also with later artists, such as the Carracci and even Watteau. The hilly ridge that runs diagonal from the lower left to the upper right divides the composition into two almost equal halves. A recumbent satyr is in the left foreground, his right forearm on a syrinx and his left resting on the head of a sleeping dog. The satyr points markedly toward the right of the composition where a man and woman approach leading a mule. Among the trees in the upper reaches of the pictorial field are two nude female figures (no doubt wood nymphs), one sitting and one standing. The other half of the drawing is filled with another well-known motif of Campagnola's: a small town or village consisting of various buildings, some rustic and others more elaborate, that cling to the foot of a mountain range.

The penwork is very fine and dense, especially in the satyr, his dog and the trees; in contrast, the nymphs and the surrounding trees are drawn with a delightful lightness and apparent enjoyment of line. All these charateristics indicate that the drawing is from the artist's later period, for which a more detailed chronology of his activity is still wanted. The thoughtfully arranged composition, the deliberate actions and movements of the figures, such as the satyr's pointing finger, the couple with the mule, and the nymphs all suggest that the artist probably had a definite subject in mind rather than just a random assembly of genre or mythological characters. Unfortunately, as with many other works by Domenico Campagnola, the exact meaning still escapes us.

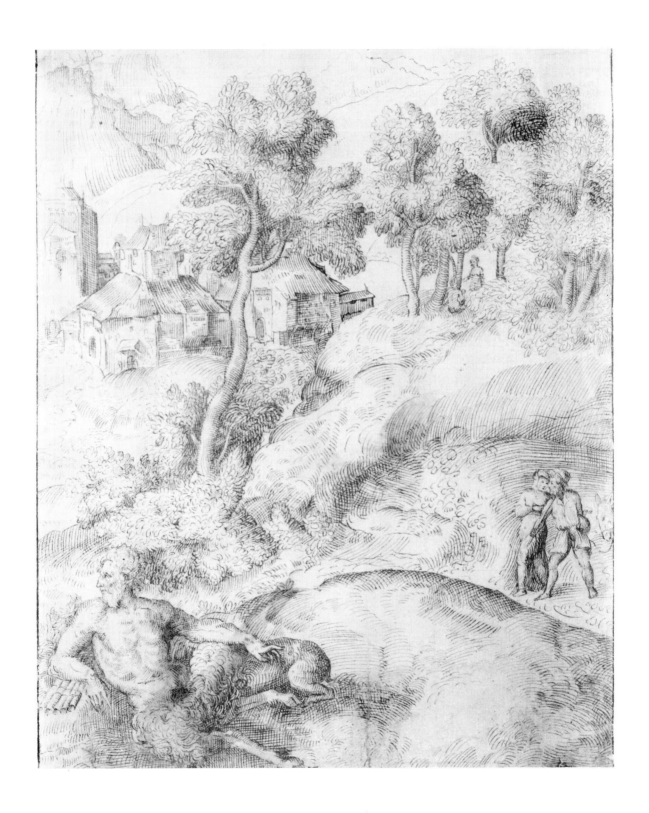

Girolamo Romanino
Italian, Brescia, Cremona, 1484/87-1559

Pastoral Concert

Pen and brown ink and brown wash over black chalk on paper, 29.3 x 41 cm. Inscribed in pencil at lower right: *Giorgione*

Provenance: Collection of the Moscardo Family; Conte Lodovico Moscardo, Verona; Marquis de Calceolari (until 1920); Luigi Grassi, Florence (Lugt Supplement 1171b).

Bibliography: Orangerie Cat., 1957, no. 124; Cincinnati Cat., 1959, no. 216; Bean-Stampfle, 1965, no. 54; Oberhuber-Walker, 1973, p. 93; Szabo, 1979, no. 7; Szabo, 1982, no. 30; Szabo, 1983, no. 30.

Large and ambitious in composition, this is the most elaborate of three Romanino drawings of musical groups including a faun. Although these drawings are grouped together, they still represent distinct variations of the *concert champêtre*, both technically and iconographically. The lute players on a sheet of studies in the Uffizi is a pen drawing (*Mostra di strumenti musicali in disegni degli Uffizi*, Florence, 1952, fig. 12). The pastoral concert in the Janos Scholz Collection, New York, is a fleeting and spontaneous red chalk drawing with four figures - two women playing a flute and a lute, the faun with a flute, and a young gentleman in a plumed hat holding a sword. This, the third, is more controlled and deliberately composed. The five figures are all gathered in the center under a tree. Three richly dressed young women and the faun are all playing string instruments; the fifth figure, probably also a young woman, is behind the faun and seems to listen intently to the music. The composition is further tightened by the fact that all four players gaze attentively toward the center of the group as if reading music. In the background to the left, behind rolling hills, there are sketchy outlines of buildings; the right side of the drawing is empty or unfinished. In contrast to the two others, this drawing has an air of purpose and a feeling of completeness in spite of the partially unfinished figures, instruments, and setting.

The three drawings are thought to be early ideas for or associated with the frescoed lunettes of musicians in the loggia of the Castello del Buon Consiglio in Trento that were painted by Romanino in 1531-32 (Maria Luisa Ferrari, *Il Romanino*, Milan, 1961, pl. 65). The connection is very distant and the contrived frescoes are a far cry from the immediacy of the drawings. It has also been pointed out that all share a dependency on the *Fête Champêtre* in the Louvre, variously attributed to Giorgione or to the young Titian (Philip Fehl, "The Hidden Genre: A Study of the *Concert Champêtre* in the Louvre," *Journal of Aesthetics and Art Criticism*, XVI, 1957, pp. 153-168; Patricia Egan, "*Poesia* and the *Fete Champêtre*," *Art Bulletin*, XLI, 1959, pp. 303-313). Of the three, however, only this drawing approximates the mythic, poetic level of its famed predecessor or has a comparable structure, including the tree and the distant buildings. It is not hard to imagine that the artist could have planned to fill the void on the right side with a shepherd and his flock similar to the small group in the right background of his *Nativity with Four Saints* (National Gallery, London; Ferrari, pl. 49), thus completing not only the composition but also the metamorphosis of the mythological and allegorical theme into the pastoral genre.

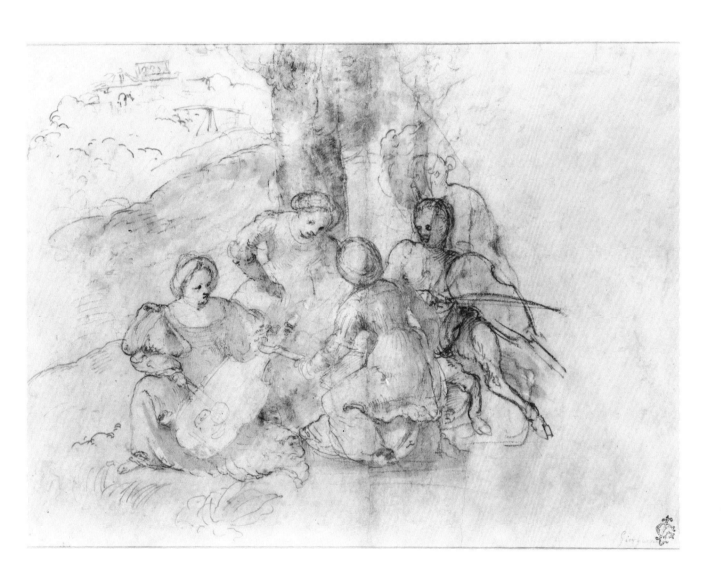

No. 9

Tiziano Vecellio called Titian
Italian, Venice, 1487-1576

Landscape with Seated Figures

Pen and ink on paper, 18.5 x 23.8 cm.

Provenance: Private collection, Germany; acquired from Reinhardt Galleries (R. Ederheimer), 1927.

Bibliography: D. von Hadeln, "Two Drawings by Titian," *Art in America*, 15, 1927, pp. 127-131; *Master Drawings*, 1935, no. 28; Cincinnati Cat., 1959, no. 214; Szabo, 1979, no. 10.

The landscape composition with a male and female figure sitting among a cluster of trees, the distant buildings and mountains behind them certainly evoke the spirit of Titian. This feeling probably prompted Detlev von Hadeln, in 1927, to characterize it as "not merely an unusually fine product of one of Titian's followers but an original by the master ... conclusively proven on technical and graphic grounds." However, this illustrious scholar and connoisseur of Titian's drawings could not ignore the possibility that the drawing could be "associated with ... hundreds of landscape drawings which are clearly the work of his imitators particularly Domenico Campagnola." In fact, several motifs in this drawing are very close to those found in woodcuts attributed to Campagnola. The couple is quite similar to the figures in the *Landscape with a Hurdy-Gurdy Player and a Girl* of c. 1540, or in the *Landscape with a Couple Gathering Fruit* of c. 1540-1545 (D. Rosand and M. Muraro, *Titian and the Venetian Woodcuts*, Washington, D.C., 1976, nos. 29, 30). Other elements, such as the cluster of trees and the buildings in the distance, seem to correspond as well. The drawing technique, however, is entirely different from those securely attributed to Campagnola; and based on evidence provided by recent scholarship on Titian, it can be suggested that this landscape may have been made in the master's workshop, probably as a preparatory drawing for a woodcut.

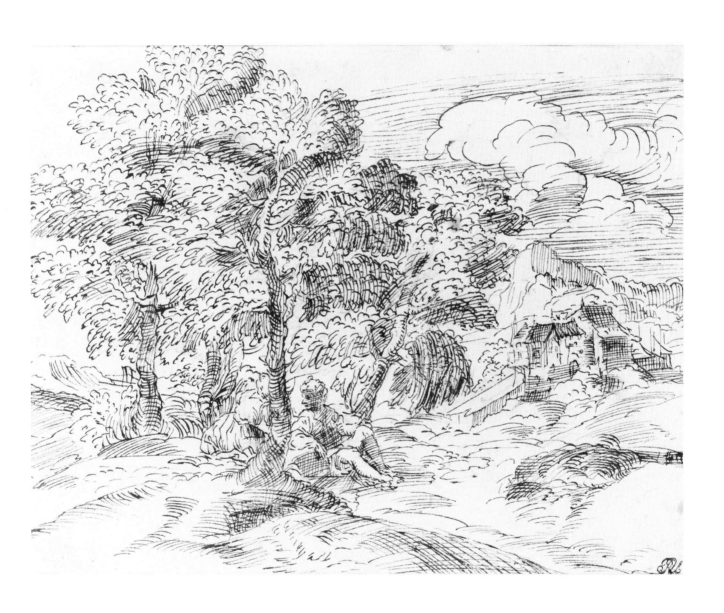

No. 10

Italian artist
Venice, First Quarter of Sixteenth Century

Shepherd Resting Under a Tree

Pen and ink over traces of black chalk on paper, 25.3 x 20.2 cm. Inscribed in lower left corner in a sixteenth-century hand: *ZORZON*. On verso: studies for ornamental designs.

Provenance: Collection of the Moscardo Family, Verona; Conte Lodovico Moscardo, Verona; Marquis de Calceolari; Luigi Grassi, Florence.

Bibliography: Grassi Sale Cat., 1924, Lot 115; Szabo, 1979, no. 28a; Szabo, 1982, p. 41, fig. 53; Szabo, 1983, p. 41, fig. 53.

The young shepherd, asleep under a tree, is accompanied by his faithful dog. In the background with a cluster of buildings and trees, a figure with raised arms seems to be running out of the door of the house closest to the sleeping figure. Recumbent and sleeping females, dressed and in the nude, were quite common in Venetian art at the beginning of the sixteenth century. As M. Meiss pointed out, they represent Venus, naiads, nymphs and other mythological figures (M. Meiss, "Sleep in Venice: Ancient Myths and Renaissance Proclivities," *Proceedings of the American Philosophical Society*, vol. 110, no. 5, 1966, pp. 348-382). In addition, courtesans and other women of easy virtue were often depicted in the disguise of sleeping beauties (L. Lawner, *Lives of the*

Courtesans: Portraits of the Renaissance, New York, 1987). In contrast to this profusion, there are only a few known male counterparts. Well-known are Cima da Conegliano's *Endymion* in Parma or the small bronze in Berlin attributed to Bellano (F. Gandalto, *Il "Dolce Tempo," Mistica, Ermetismo e Sogno nel Cinquecento*, Roma, 1978, pp.43-75, fig. 9; W. Bode, *Die italienischen Bronze statuetten der Renaissance*, Berlin, n.d., p. 16). Both represent sleeping shepherds accompanied by their dog; Cima's figure is in a rich landscape.

It is quite possible, therefore, that this drawing could reflect or copy a lost composition by Giorgione - whose name was written on it in the Venetian dialect still in the first half of the sixteenth century.

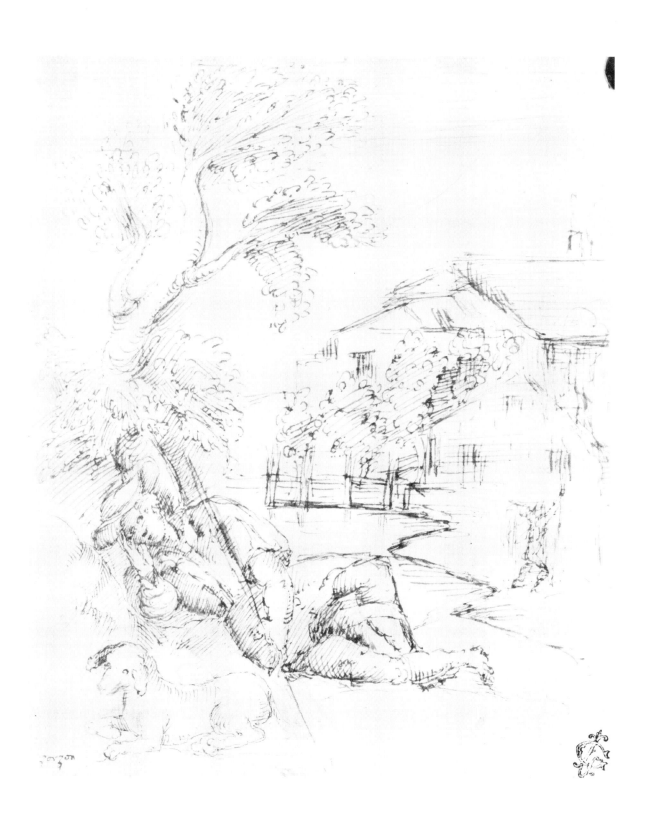

No. 11

Follower of Albrecht Altdorfer
German, 1480-1538

The Holy Family

Pen and ink heightened with white on light yellow-brown prepared paper, 21.5 x 14.8 cm. Dated by the artist (upper right): *1514*. (A. D. monogram above date is a later addition.) Inscribed in ink in lower right: *129*.

Provenance: Collection of J. P. Heseltine, London; Collection of Henry Oppenheimer, London.

Bibliography: J. P. Heseltine, *German Drawings*, London, 1912, no. 1; *Catalogue of the Famous Collection of Master Drawings Formed by the late Henry Oppenheimer, Esq., F.S.A.*, London, Christie, Manson & Woods, July 24, 1936, Lot. 352: F. Winzinger, *Albrecht Altdorfer, Zeichnungen*, Munich, 1952, no. 125; K. Oettinger, *Altdorfer-Studien*, Nürnberg, 1959, p. 111, fig. 30; L. Oehler, "Das Dürermonogramm auf Werken der Dürerzeit," *Städel Jahrbuch*, n.s. vol. 3, 1971, pp. 79-108; Szabo, Northern Drawings, 1978, no. 29.

In the center the Virgin holding the infant Christ is conversing with St. Elizabeth leading by hand the young and naked St. John the Baptist. Behind the seated and reading St. Joseph, the landscape background includes a cluster of buildings on the left contrasted by the ragged mountains on the right.

The appealing composition is enhanced by the use of prepared paper and contrasting highlights, so characteristic of the Danube School of German artists in the first decades of the sixteenth century. These qualities apparently prompted a sixteenth century connoisseur to add the monogram of Albrecht Durer and led to an attribution to Albrecht Altdorfer by Heseltine.

More recently Oettinger considered the drawing to be a copy by Hans Leu the Younger (c. 1490-1531) or drawn by another Altdorfer imitator - the so-called "Master of the Berlin Lamentation."

As on many Northern compositions of this period, the trees carry symbolic meanings. The large verdant tree behind the Virgin and Child is not only the axial line of the drawing, but symbolic of the New Testament and the new branch on the Tree of Jesse, the infant Jesus. In turn, the broken dry-trunk behind the reading St. Joseph represents the Old Testament and could refer also to St. Joseph's age.

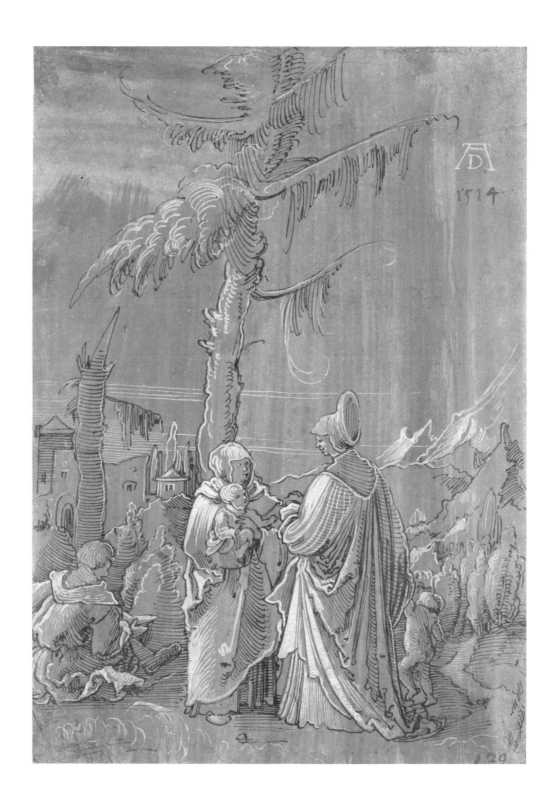

No. 12

Hans Brosamer
German, Fulda, Erfurt, 1480/1490-1552

Venus and Cupid on a Large Snail

Pen and ink with grayish wash on paper, 20.8 x 35.9 cm. Signed and dated by the artist on tree at right: *HB 1538.*

Provenance: Dr. Walter Gernsheim, London; Philip Hofer, Cambridge, Mass.

Bibliography: "Old Master Drawings," *Burlington Magazine*, 70, 1937, pp. 137-138; Szabo, Northern Drawings, 1978, no. 31.

In the center of the drawing, Venus and Cupid are on the back of a large snail fording an extensive body of water (sea?). She is almost nude, seated and holding the left arm of Cupid, armed with an arrow and quiver. The composition is dominated by the wide vista of the water and the distant castles and towns on its shores. The foreground is framed by cut-off tree trunks on the left and a large tree bearing the intertwined initials of the artist and the date.

Hans Brosamer, a minor artist, was greatly influenced by Lucas Cranach the Elder. This is reflected not only in the style of the drawing but, also, in the placement of his monogram. Several drawings by him, identical in style and bearing the same signature, are in the Kupferstichkabinett in Berlin (M. Friedlander and E. Bock, *Handzeichnungen Deutscher Meister im Kupferstichkabinett*, Berlin, 1923, esp. no. 509).

The significance of the theme - Venus and Cupid transported by a snail - is puzzling. There are no similar scenes represented in the profuse graphic arts of the period or in Brosamer's oeuvre. However, it is well-known that in the symbolism of Venus, Cupid, and Love, the snail played an important role since classical antiquity and especially in the Northern Renaissance (L. Hausmann and L. Kriss-Rettenbeck, *Amulett und Talisman. Erscheinungsform und Geschichte*, München, 1966, pp. 109ff). The snail symbolized rebirth and rejuvenation and was sometimes allegorical of the female genitalia and of the uterus (A. A. Barb, "Diva Matrix," *Journal of the Warburg and Courtauld Institutes*, 16, 1953, pp. 204-205). Also, as today, the snail is proverbial for slowness. Thus it is quite possible that the drawing could also symbolize the slow progress of love.

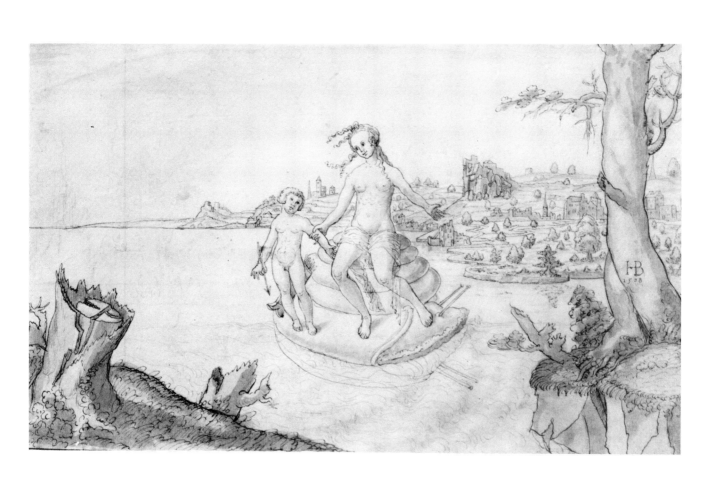

No. 13

German Artist
Nürnberg, 1543

Fantastic Landscape

Pen and ink with white highlights, blue and green wash on cream paper, 14.4 x 21.3 cm. Dated in white in lower left corner: *1543*.

Provenance: Collection of the Princes of Lichtenstein, Vaduz.

Bibliography: Cincinnati Cat., 1959, no. 254; P. Holm and A. Schmitt, Hanns Lautensack, Nurnberg, 1957, p. 111, no. 129; Szabo, Northern Drawings, 1978, no. 33.

The rich content and pleasing colors of this small drawing imbue it with a feeling of preciousness. The elements of landscape, fortified manor houses, distant castles and walled cities are carefully placed and accentuated with large singular trees, clusters of bushes, and forests. In the center a small pool reflects outlines of the buildings next to it. The autograph date 1543 is in the same white paint as the highlights of the drawing and is consistent with the overall style.

While in the Collection of the Princes of Lichtenstein, it was variously attributed to Augustin Hirschvogel (1503-1553) and Hanns Lautensack (1520-1566?), both from Nürnberg. With careful consideration of stylistic traits, Holm and Schmitt separated this and similar drawings from the oeuvre of these two and attributed them to a "Master of 1544," a Nürnberg artist whose name is still not known, but who apparently was influenced by Netherlandish artists. This attribution is now widely accepted and the colorful little drawings are considered examples "of the wide sharing of style and motifs in landscapes throughout Northern Europe at this time" (*Prints and Drawings of the Danube School*, Yale University Art Gallery, New Haven, 1969, pp. 97-99).

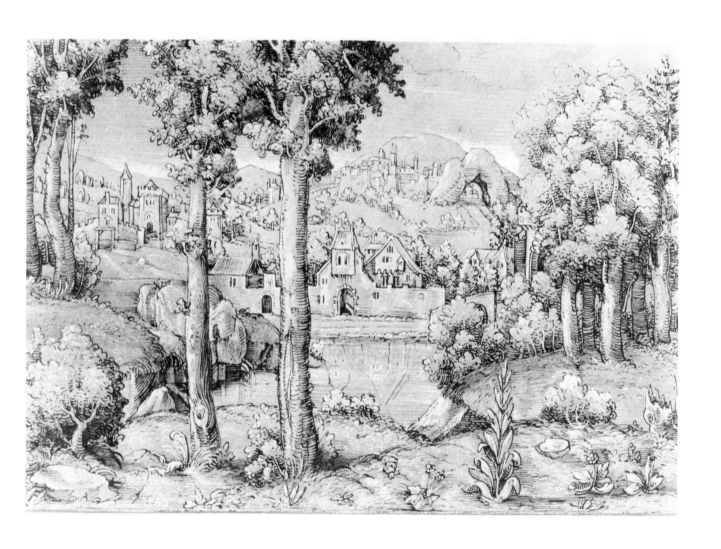

Attributed to Peter Bruegel the Elder
Flemish, Antwerp, Brussels, c. 1526-1569

Castle in Flanders

Pen and ink on paper, 13.4 x 22.5 cm. Inscribed (along the bottom in two lines, only the second of which is deciperable): *Anno 1564 30 Julius.* On verso: male figures pointing to a tree.

Provenance: Collection W. Argoutinski-Dolgoroukoff, St. Petersburg; Collection de M. N., The Hague.

Bibliography: *Catalogue d'une belle collection des dessins anciens, eaux-fortes et gravures 15e au 18e siècles,* Amsterdam, Houthakker, February 21, 1939, Lot 15; Cincinnati Cat., 1959, no. 240; Szabo, 1978, no. 6.

This appealing drawing represents a large, fortified and moated castle probably in Flanders. In spite of the elaborate architectural details and the character of the buildings, the sheet still does not provide enough information for positive identification. The inscription is of no aid in this respect. The first line defies reading. The second line is ambiguous; some words are in French, while there is still a controversy whether the date should be read as 1564 or 1604. Julius Held (in conversation) indicated his preference for the latter, however admitting that the style of the writing is rather late sixteenth century.

The attribution is also riddled with questions. Undeniably there is a noticeable tendency to imitate the exacting style of Bruegel's drawings, especially in the details of the gabled turreted buildings. However the rather superficial representation of the bushes and vegetation growing on the walls seems to indicate a later time, possibly after 1600. The existence of sketches on the verso might be an indication that this sheet originally belonged to the sketchbook of a travelling artist, possibly a Fleming who carefully noted the physical appearance of this castle, since disappeared or so changed that it is unrecognizable today.

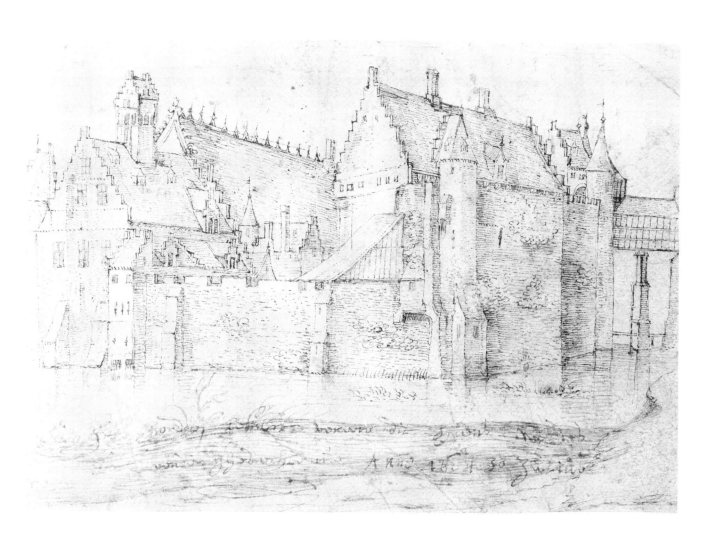

No. 15

Attributed to Peter Bruegel the Elder
Flemish, Antwerp, Brussels, c. 1526-1569

River Landscape

Pen and brown ink on paper, 9.2 x 19 cm.

Provenance: Collection of Dr. Fröhlich, Vienna; Collection of Le Roy Backus, Seattle.

Bibliography: L. H. Tietze, *European Drawings in the United States*, New York, 1947, no. 44; Ch. de Tolnay, *The Drawings of Pieter Brueghel*, New York, 1952, p. 89, no. A16; Orangerie Cat., 1957, no. 88; Cincinnati Cat., 1959, no. 241; Szabo, Northern Drawings, 1978, no. 7.

The illusion and representation of the far-reaching vista is certainly reminiscent of drawings by Peter Bruegel. This resemblance and fine penmanship probably contributed to its acceptance as an autograph work of Bruegel by Max Friedländer (verbal communication) and by Hans Tietze. However, Charles de Tolnay, in 1952 and later, strongly advocated an attribution to Jacques Savery. Recent scholarship, while admitting the general affinities of the subject to some of Bruegel's drawings, strongly emphasizes that Jacques Savery and his followers created similar works in the style of Bruegel. L. Munz states, "their starting point is frequently Brueghel's rendering of landscape, such as the small landscape drawings of the sixties, with their somewhat erratic and glimmering line. Jacques Savery's style is especially important in this context and is easy to identify by means of his signed etchings" (*Bruegel, The Drawings*, London, 1961, pp. 17, 20).

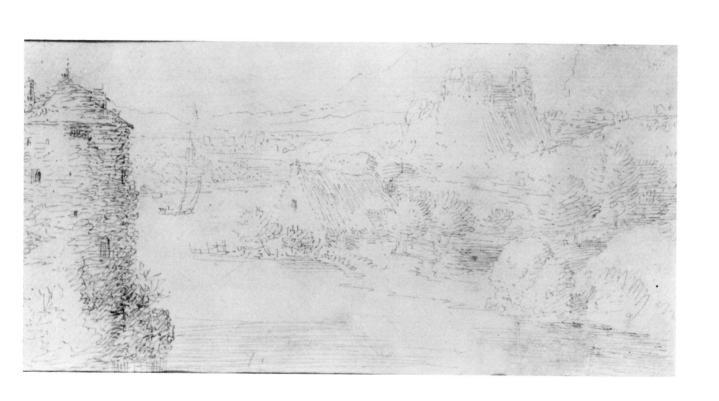

No. 16

Hans Bol
Flemish, Malines, Amsterdam, 1534-1593

Landscape with Abraham and the Angels

Pen and ink with brown gouache on paper, 18.4 x 28.6 cm.

Provenance: Unknown.

Bibliography: Orangerie Cat., 1957, no. 87; Cincinnati Cat., 1959, no. 242; Szabo, Northern Drawings, 1978, no. 8.

Hans Bol is one of the most productive landscape artists of his time. This important drawing is a characteristic example of Bol's mature period. It is an excellent example of the combination of old religious themes and the new naturalism developing in Netherlandish art in the second half of the sixteenth century. The composition is divided in half by the diagonal line created by the outlines of the buildings and of the rocky plateau on which they are located. The lower left half is the stage for the biblical story, with timbered buildings serving as the proper and immediate setting. The upper right half with the far-reaching vista of a valley with town, distant fields, castles and mountains in the rich backdrop is in the new spirit, clearly emulating Bruegel.

The richly textured drawing contains the most characteristic signs of Bol's style: a low vantage point, tall leafy trees and far-reaching views. As always, these are embellished with animated figures in the foreground as well as in the landscape, which further enliven the drawing. Bol's assured mastery of landscape is underscored by the deft use of the gouache creating an illusion of color.

The drawing is neither signed nor dated. However, comparisons can be made with similar compositions dating to between 1570-1585 (H. G. Franz, "Hans Bol als Landschaftszeichner," *Jahrbuch der Kunsthistorischen Instituts*, I, 1965, 19-67). It is especially close to two other drawings representing the same subject, one in the Albertina in Vienna and the other in an Amsterdam private collection.

Gillis van Coninxloo III
Flemish, Antwerp, Amsterdam, 1544-1607

Wooded Landscape

Pen and ink with brown and green wash, 19.7 x 29.8 cm.

Provenance: Unknown; acquired from Delius Giese, New York, 1948.

Bibliography: Szabo, Northern Drawings, 1978, no. 9.

Gillis van Coninxloo had an eventful life that took him from his native Antwerp to France, to Zeeland and to Frankenthal, now Mannheim in the Palatinate, where he remained from 1587 to 1595. Finally, he returned not to his homeland, but to Amsterdam to spend the rest of his life (A. Laes, "Gillis van Coninxloo, rénovateur du paysage flamand au XVIe siècle," *Annuaire des Musées Royaux des Beaux-Arts*, Bruxelles, I, 1939, pp. 99-119).

From a rather large oeuvre, it is evident that he became absorbed in studies of nature and trees as early as his exile in Frankenthal and extended it through his Amsterdam years, both in painting and drawings. He had several pupils as well as followers making it very hard to separate his works from those of imitators. This is further aggravated by the fact that his known drawings lack both signature and date, just as does this one.

However, it seems that many drawings are characterized by "nervous handling, in which vertical hatching with a fine, almost scratchy pen is employed to describe shadows. A vigorous combination of multi-directional banding and hooked strokes indicates volume, texture and direction of growth of trunks and principal limbs of trees, while ragged, looped and scalloped contours delineate leaf clusters" (D. Farr and W. Bradford, *The Northern Landscape, Flemish, Dutch and British Drawings from the Courtauld Collections*, London, 1986, p. 40).

This drawing contains almost every element of the above described vocabulary and, with the restricted use of palette - mostly brown, green and blue - creates a naturalistic, as well as mystic, landscape for which he was justly called "a poet of forests."

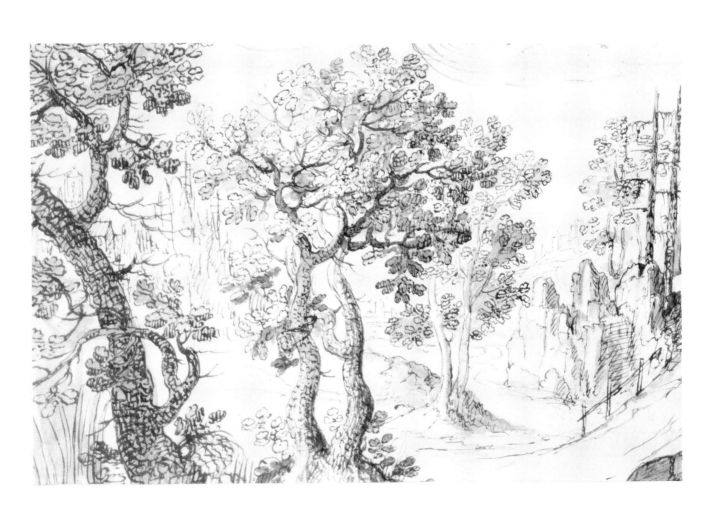

David Vinckboons
Flemish-Dutch, Mechelen, Amsterdam, 1576-1632

The Triumphal Entry of Frederik Hendrik of Orange into The Hague

Pen and brown ink with gray, blue and brown washes on paper, 37 x 53 cm. Signed in pen and brown ink at lower left: *Vinkebons.*

Provenance: Henry S. Reitlinger, London.

Bibliography: K. Goossens, *David Vinckeboons, Antwerpen s'Gravenhage,* 1954, p. 5; J. S. Held, "Notes on David Vinckeboons, Mededelingen von het Rijksbureau voor Kunsthistorische Documentatie," *Oud-Holland,* 6, 1961, pp. 41-44; Szabo, Dutch and Flemish Drawings, 1979, no. 49; H. B. Mules, *Dutch Drawings of the Seventeenth Century in the Metropolitan Museum of Art,* New York, 1985, pp. 12-13.

This ambitious drawing represents the triumphal entry of Prince Frederik Hendrik of Orange into The Hague after successful sieges of Wesel and s'Hertogenbosch in 1629. The procession is surrounded by four distinct elements of the landscape. On the right, the Prince's chariot is coming out of the woods. Then, the pageant passes before the view of the Buitenhof, the residence of the Counts of Holland, and the distant houses of the city. Finally, it passes through the artificial triumphal arch topped by the figure of Justice-Fortune and embellished with the coat-of-arms of the Prince's lands. The three earthy elements of the landscape are united under the broad sky above where the deceased members of the House of Nassau are ensconced in the clouds.

The richness of details, coupled with the sensitivity and virtuoso technique, ranks this large sheet as probably one of the most elaborate drawings known by the artist. Furthermore, as the event took place after September 14, 1629, the fall of s'Hertogenbosch, and Vinckboons was dead by January 12, 1633, this is probably the artist's last drawing.

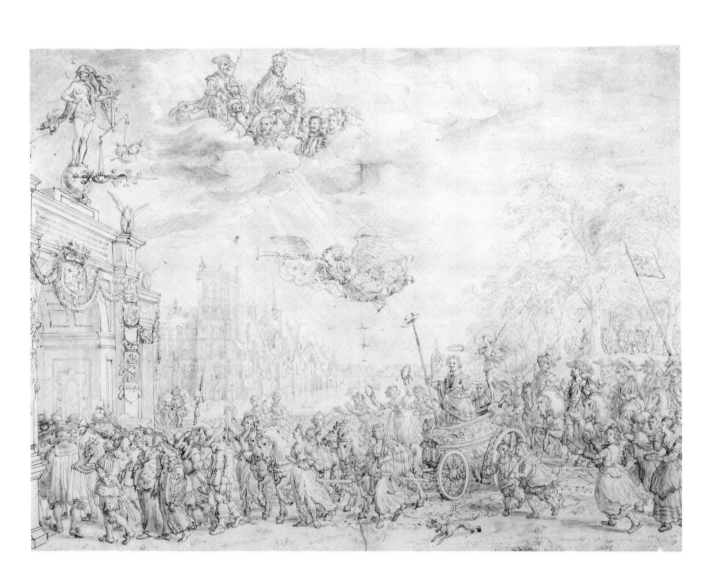

❧ No. 19

Jan Josephsz van Goyen
Dutch, Leyden, The Hague, 1596-1656

Boating Party on a River

Black chalk with watercolor on paper, 11.5 x 19.5 cm. Signed with initials and dated on the stern of the boat in the foreground: *VG 1651*. Watermark: crowned double-headed eagle with the arms of Basel in a heart.

Provenance: Collection of Mme. E. Warneck, Paris; Private collection, Paris; acquired from Lock Galleries, New York, 1961.

Bibliography: H. U. Beck, *Jan van Goyen 1596-1656. Ein Oeuvreverzeichnis*, I, Amsterdam, 1972, no. 281; Szabo, Dutch and Flemish Drawings, 1979, no. 10.

Jan van Goyen first studied in Leyden with a number of different masters, some landscape painters, some working on glass. After travelling in France in 1631, he moved to The Hague but also was active in Haarlem. Successfully uniting the many traditions, he probably became the most renowned proponent of naturalism of Dutch landscape painting and drawing in his time. His art as a prodigious draughtsman is thoroughly explored in H. U. Beck's recent monograph, which strongly emphasized that van Goyen's landscape drawings "were intended as works of art in their own right."

This delightful composition fully illustrates the artist's achievements. It belongs to the more than 30 drawings he produced between 1651-1653. It is carefully drawn with black chalk and enlivened with the deft touches of watercolor. In contrast to many of the landscapes composed of various elements, this drawing seems to represent a canal landing next to an actual village. The busy life is depicted in lively vignettes: a covered coach on the bridge, a couple in a small boat at the shore. The larger ferry boat in the foreground however steals all the attention; its passengers are merrily consuming their drink drawn from a large barrel, engaging in amorous pursuits as well as contributing more liquid to the canal in a very explicit manner. The importance of the boat is further emphasized because it carries the artist's initials and date. This fact, coupled with the elaborate technique and the lively composition, clearly suggests that the artist created it as an independent work of art and quite possibly for immediate sale.

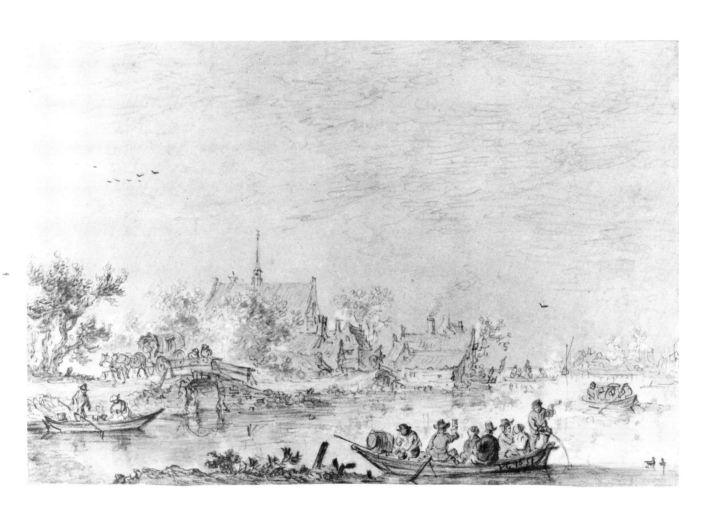

No. 20

Aelbert Cuyp
Dutch, Dordrecht, 1620-1691

View of Dordrecht with the "Grote Kerk"

Black chalk and watercolor on paper, 17.4 x 36 cm.

Provenance: Private collection, Paris (?); The Misses Alexander, England.

Bibliography: J. G. van Gelder and I. Jost, "Doorzagen op Aelbert Cuyp," *Nederlands Kunsthistorisch Jaarboek*, 23, 1972, pp. 227-238, fig. 5; Szabo, Dutch and Flemish Drawings, 1979, no. 5.

A sweeping panoramic view of the artist's native town, the architectural structures are all placed in a narrow strip at the bottom third of the sheet, while the vast sky is represented with only a few light patches of clouds. In spite of its distance, the view is dominated by the bulk of the great church "Grote Kerk," successfully framed by the windmill and cluster of old buildings, as well as the sailboats on the right. The composition is closely related to several paintings and drawings by the artist that are all conveniently and thoroughly listed by van Gelder and Jost. Their comparisons to the dated works suggest a tentative date of about 1650 for this drawing.

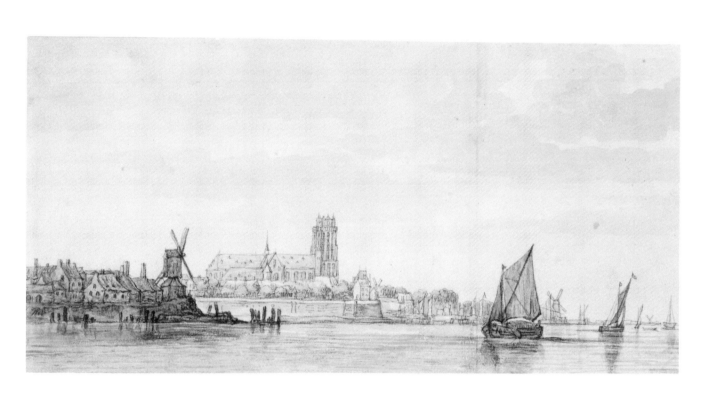

No. 21

Lambert Doomer
Dutch, Amsterdam, Alkmaar, 1622/23-1700

View of Monterberg with the Ruined Castle of the Counts of Cleve

Pen and ink with watercolor on paper, 23.5 x 40.5 cm. Inscribed on verso by a later (XVIII century?) hand: *De Monterenbergh van Kalker af te zein.* Watermark: pigeon.

Provenance: Collection of J. Tonneman, Amsterdam; Collection of H. Busserus, Amsterdam; Collection of J. Gildemeester, Amsterdam; Collection of H. Duval, Amsterdam; Collection of C. Hofstede de Groot, The Hague; Collection of H. Reitlinger, London.

Bibliography: W. Spiess, "Lambert Doomer, Rheinlandschaften, Zweite Folge," *Wallraf-Richartz Jahrbuch*, I, 1931, pp. 241-243, fig. 229; W. Schulz, *Lambert Doomer, Sämtliche Zeichnungen*, Berlin, 1974, no. 197, fig. 102; W. Schulz, "Lambert Doomer als Maler," *Oud-Holland*, 92, 1978, pp. 90, 91, 96, 99, fig. 23; Szabo, Dutch and Flemish Drawings, 1979, no. 6.

This highly finished and carefully elaborated drawing is based on a sketch the artist made during his travels through the Rhine region of Germany in 1663. The ruins represented here are near Calcar; the castle was destroyed in 1635. According to W. Schulz, the careful reworking and the introduction of the pastoral scene were done probably in the early 1670s.

The addition of the pastoral scene is also an indication of Doomer's constant tendency to introduce fashionable, allegorical meanings into his paintings and drawings. Schulz compares the three figures to his oil painting in Oldenburg that contains similar amorous-symbolic elements, such as the oboe-like instrument that the seated man holds to the mouth of the young woman.

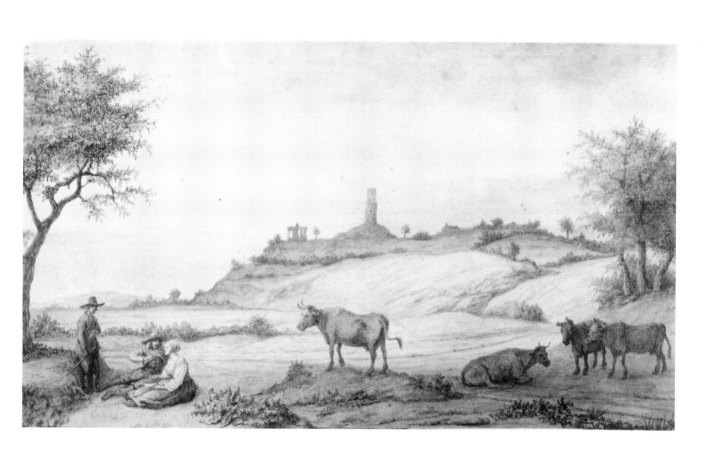

✒ No. 22

Rembrandt Harmensz van Rijn
Dutch, Leyden, Amsterdam, 1606-1669

Two Cottages

Pen and dark brown ink with white paint on paper, with the addition of heavy lines of gallnut ink, 14.9 x 19.2 cm.

Provenance: Private collection, London; Colnaghi and Co., London; Hanns Schaeffer, New York.

Bibliography: O. Benesch, *The Drawings of Rembrandt*, II, 1954, no. 462a; *Rembrandt After Three Hundred Years*, The Art Institute of Chicago, Chicago, Illinois, 1969, no. 114; O. Benesch, *The Drawings of Rembrandt*, II, 1973, no. 462a; Szabo, Dutch and Flemish Drawings, 1979, no. 28.

The powerful drawing is one of the many sketches that Rembrandt made around Amsterdam. His observations of the various components of the landscape are recorded with great variation of line and density of ink. The near cottage is depicted in almost minute detail; even the three figures in front of it are clearly discernible. The building in the back is characterized only by a few nervous lines and finally the carriage on the right is recorded with a few almost calligraphic characters.

It is very difficult to date this and the numerous related landscape sketches by Rembrandt. Otto Benesch suggested a date of around 1632-1633. Recent scholarship considers this too early and strongly suggests a later dating to betwen 1640-1645 on the basis of comparison to landscape etchings, bearing the date of 1641, by Rembrandt.

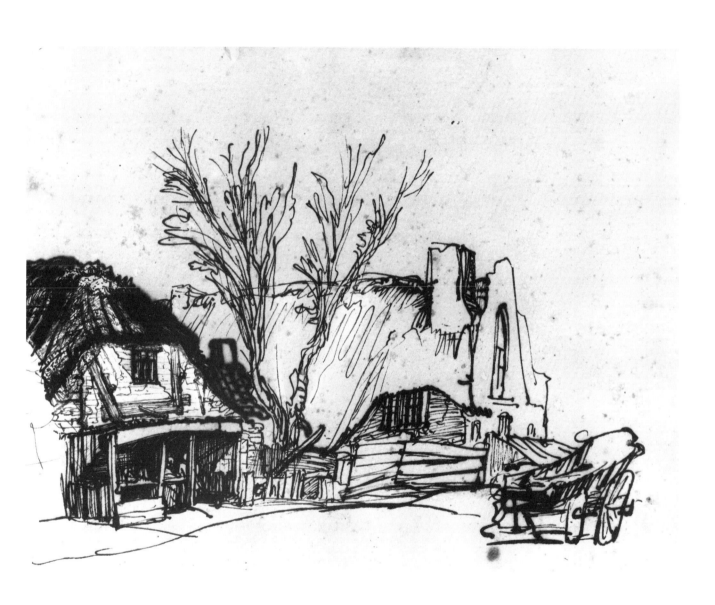

No. 23

Rembrandt Harmensz van Rijn
Dutch, Leyden, Amsterdam, 1606-1669

Cottage near the Entrance to a Wood

Pen and brown ink with brown wash over black chalk on paper, 29.8 x 45.2 cm. Signed and dated in pen and brown ink in lower left corner: *Rembrandt f. 1644.*

Provenance: Collections of Jonathan Richardson, Sr.; A. Pond; J. Barnard; Benjamin West; W. Esdaile; Sir Thomas Lawrence; B. Grahame; J. B. Heseltine; F. Müller; O. Gutekunst; J. Hirsch.

Bibliography: C. Lippman and C. Hofstede de Groot, *Original Drawings by Rembrandt*, Series I-IV, Berlin, 1881-1911, no. 186; J. P. Heseltine, *Original Drawings by Rembrandt in the Collection of J. P. H.*, London, 1907; M. Eisler, *Rembrandt als Landschafter*, Munich, 1918, p. 65; Ch. de Tolnay, *History and Technique of Old Master Drawings*, New York, 1943, no. 197; O. Benesch, *The Drawings of Rembrandt*, IV, 1955, NO. 815; Orangerie Cat., 1957, no. 123; Cincinnati Cat., 1959, no. 26; *Rembrandt After Three Hundred Years*, 1969, no. 117; O. Benesch, *The Drawings of Rembrandt*, IV, 1973, no. 815; Szabo, Dutch and Flemish Drawings, 1979, no. 29; H. B. Mules, *Dutch Drawings of the Seventeenth Century in the Metropolitan Museum of Art*, New York, 1985, pp. 32-33.

This is one of the most important landscape drawings by Rembrandt. It is his largest and one of the very few signed and dated by him. More importantly as Otto Benesch remarked, "it is a drawing as its own end drawn from nature." The composition combines and unites bold strokes of the pen and sweeping brushstrokes with a masterful juxtaposition of dense dark areas with light voids. This vibrancy and vigor is counterbalanced by the statue-like stillness of the bearded occupant of the cottage, who is observing the artist as intently as Rembrandt did the scenery.

Two copies of this drawing by Lambert Doomer exist (Paris, Cabinet des Dessins, and Fritz Lugt Collection, Fondation Custodia). Since Doomer was Rembrandt's pupil in the 1640s, it has been suggested that the two artists may have done these drawings at the same time (J. Q. van Regteren Altena, *Mostra di incisioni e disegni di Rembrandt*, Rome, 1951, no. 77). However, recent scholarship tends to suggest that Doomer made the copies in the late 1650s when he purchased a considerable number of Rembrandt drawings.

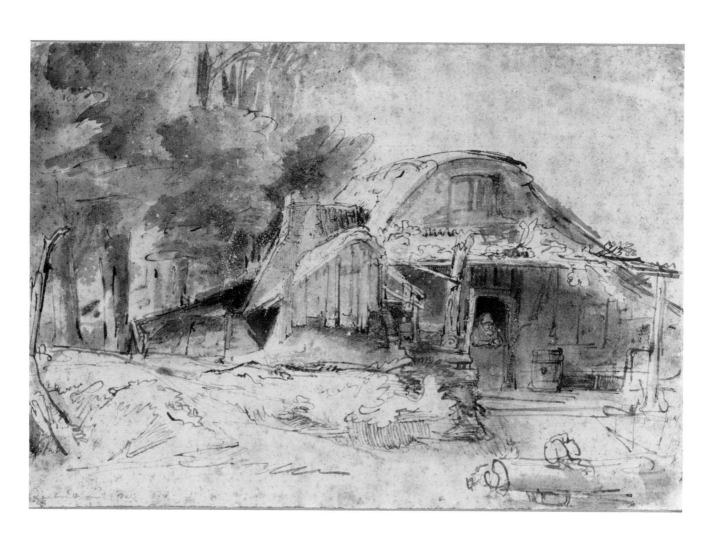

No. 24

Roeland Roghman
Dutch, Amsterdam, c. 1620-after 1686

Mountainous River Landscape with Figures

Pen and ink with gray wash over black chalk on paper, 15.6 x 23.5 cm. Signed in ink and pen in lower left: *R. Roghman*.

Provenance: Collection of W. Esdaile, London; Collection of Lady Bentinel, Brussels (?); Collection of W. J. Brie; Collection of C. Hofstede de Groot, The Hague; Collection of H. S. Reitlinger, London.

Bibliography: *Handzeichnungs - Sammlung des im Haag verstorbenen Dr. C. Hofstede de Groot*, C. G. Boerner, Leipzig, November 4, 1931, Lot 204; *The H. S. Reitlinger Collection*, Part VII, Sotheby's, London, June 22, 1954, Lot 694; Szabo, Dutch and Flemish Drawings, 1979, no. 40.

Roghman painted mostly landscapes of rocky mountains with strong contrasts of dark and light areas. This preference for mountains might be due to a trip to Italy around 1640 or shortly thereafter. However, his best known works are the more than 241 drawings representing castles of Holland, Utrecht and Guelders and painted between 1646-1647.

This landscape is signed but not dated. The rather romantic tone, the far-reaching and sketchy mountains and the few figures seem to echo his Italian sojourn, thus suggesting a date shortly after 1640. The marked absence of castles or fortifications is also an indication that this landscape was painted before his intensive topographic works of 1646-1647.

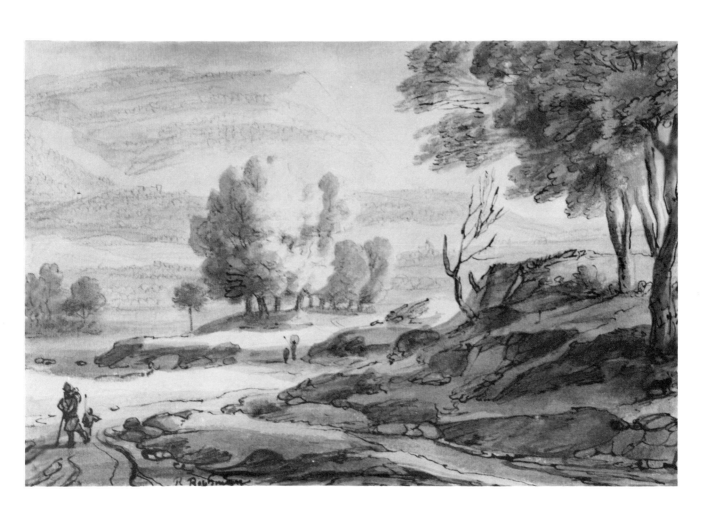

❧ No. 25

Antoine Waterloo
Dutch, Utrecht, Amsterdam, c. 1610-1690

Wooded Landscape

Black chalk with gray wash, heightened with white, on paper, 32.7 x 17.8 cm. Inscribed in ink in upper right: *Waterlon*. On verso: black ink and pen drawing, a design for an elaborate frame and faint traces of pencil drawings.

Provenance: Collection of H. S. Reitlinger, London.

Bibliography: *The H. S. Reitlinger Collection*, Part VII, Sotheby's, London, June 22, 1954, Lot 743; Szabo, Dutch and Flemish Drawings, 1979, nos. 52 a, b; D. Farr and W. Bradford, *The Northern Landscape, Flemish, Dutch and British Drawings from the Courtauld Collection*, London, 1986, p. 162.

Waterloo was one of the most peripatetic of the seventeenth-century Dutch draughtsmen. He was born in Lille, where he probably received his artistic training. After working in Utrecht, he was registered in Amsterdam as a painter in 1640. Shortly after, he married Catharyn Stevens van der Dorpe, the widow of the painter Elias Homis, who was known as a dealer in paintings. Although Waterloo settled in Amsterdam, he made occasional trips to Leuwarden, Utrecht and possibly further away to Holstein, Hamburg, Luxemburg and even to Italy. His sketchbook in Hamburg contains drawings made in some of these locations.

Most of his drawings display the same technique as this one, black chalk with black ink and china ink washes. The landscapes are dense, wooded compositions in which the contrasts between the dark and light areas are sharp due to the use of heavy chalk. Although this drawing bears the artist's signature, dating is difficult. Only the drawing on the verso offers a slight clue. It is possible that Waterloo composed the elaborate design for a frame on the verso at the request of his wife, possibly to be used in her business, after 1640, thus providing a date post quem. As Catharyn Waterloo died in 1674, it can be assumed that designs for picture frames for her business were not needed after that date, allowing a rough dating for the drawing between 1640-1674.

No. 26

Ferdinand Bol (?)
Dutch, Dordrecht, Amsterdam, 1616-1680

Travellers at a Village

Pen and brown ink with light wash on paper, 15.3 x 21 cm. Signed in ink in lower left corner: *Bol.*

Provenance: Unknown.

Bibliography: Szabo, Dutch and Flemish Drawings, 1979, no. 1.

The main feature of this landscape composition is the roadside village with rather simple, thatched houses and possibly an inn at the far left. Two travellers, one mounted and the other on foot, accompanied by their dog, are approaching in a somewhat agitated manner. The buildings and trees are represented in detail and in a rather meticulous manner. This is in marked contrast to the landscape compositions attributed to Ferdinand Bol that were assembled in the *Corpus* and in other recent scholarly works (W. Sumawski, *Drawings of the Rembrandt School*, New York, 1979, I, nos. 278x-282x; A. Blankert, *Ferdinand Bol [1616-1680]: Rembrandt's Pupil*, Dornspijk, 1982, pls. 199-204).

The signature, which is contemporaneous with the drawing, provides no initial or further clue as to the identity of the artist. Other attributions should also be considered. During the late sixteenth and early seventeenth centuries, several artists named Bol were active in both the Northern and Southern Netherlands, many of whom were known as landscape painters. However, the most likely candidate for the authorship of this drawing is Cornelius Bol. Born in Antwerp in 1599, he was active in Haarlem, Amsterdam, and problably in London in 1666 where he even painted the Great Fire. As landscape engravings by Cornelius Bol are known, it can be proposed that the present drawing might also be by him.

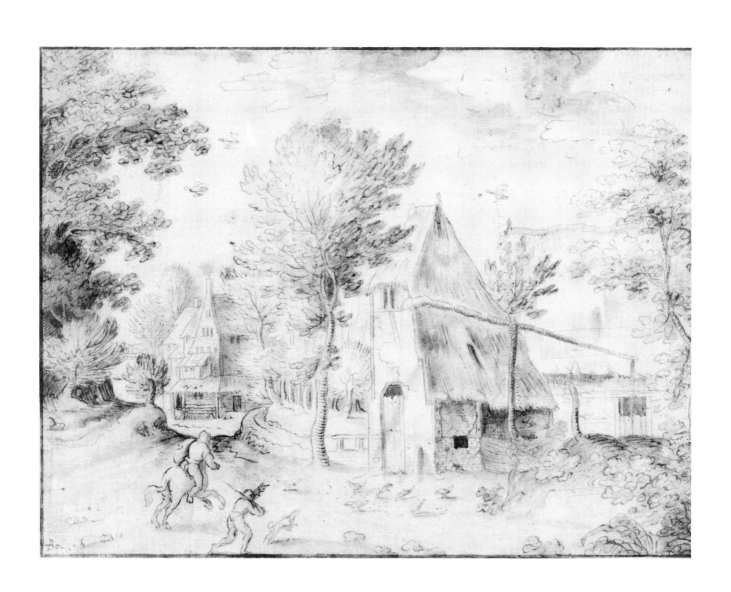

Jan van Kessel
Dutch, Antwerp, 1641-1680

Landscape with Bridge

Pen and ink with bluish gray wash on paper, 15.5 x 26.6 cm. Signed in pen and ink in lower left corner with joined initials: *JFK (ecit)*. On verso: an abandoned study for a "Garden Scene with Figures."

Provenance: Unknown.

Bibliography: Szabo, Dutch and Flemish Drawings, 1979, no. 63a-b.

Jan van Kessel spent his whole life in Antwerp. He was the son of Hieronymus van Kessel and Paschasia Bruegel, the daughter of Jan Bruegel the Elder. Kessel learned the craft of painting and drawing in the workshops of Simon de Vos, and his uncle Jan Bruegel the Younger. In 1644-45, he became a member of the painter's guild and worked as a successful painter of birds, flowers and fruit still-lifes. Kessel is also well-known for his series of allegorical paintings representing the continents.

Very few of Kessel's drawings survive and none seem to be related to this landscape. However, the whole spirit of this drawing is still closely related to seventeenth-century Netherlandish compositions. The trees, the close observation, the meticulous depiction of the foot-bridge and the shored-up canal clearly date it to the middle of the seventeenth century.

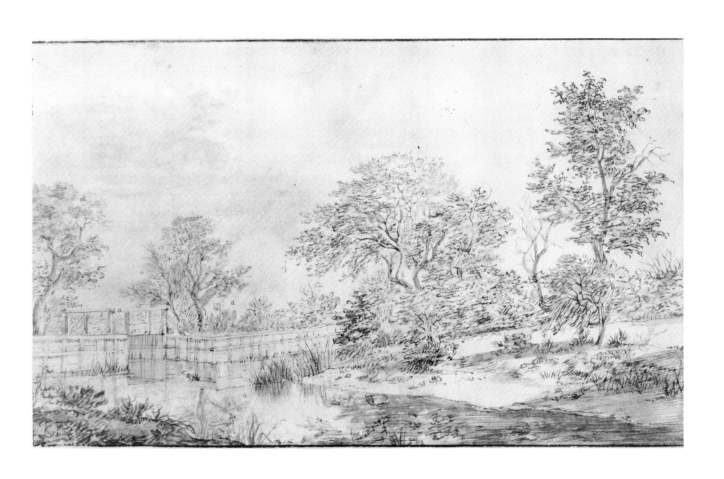

Valentin Klotz
Dutch, active 1667-1718

Roadside Shrine and Cross

Pen and black and brown ink with gray wash on paper, 15.7 x 19.3 cm. Signed with joined initials and dated in lower right corner: *VKf(ecit) 12/29 1699.*

Provenance: Collection of Sir Robert Witt, London.

Bibliography: J. Byam-Shaw, "Valentine Klotz," *Old Master Drawings*, III, 1928, p. 55; Szabo, Dutch and Flemish Drawings, 1979, no. 15.

Valentin Klotz served as a military engineer between 1672-1678 in the campaigns of William III of Orange against Louis XIV of France. Another Dutch artist, Josua de Grave, was part of this army and apparently exerted a considerable influence on Klotz, as both of them made records of the towns destroyed (D. Farr and W. Bradford, *The Northern Landscape, Flemish, Dutch and British Drawings from the Courtauld Collections*, London, 1986, pp. 120-121).

The quiet, rather unambitious landscape faithfully records the roadside shrine and the battered cross. The figure of a saint in the niche is unidentifiable as is the mountain-top castle in the far distance. In an honest and naturalistic manner, the roadside trees, bushes and puddle are all clearly depicted, thus representing the character of the artist, both as an acute observer and well-trained craftsman.

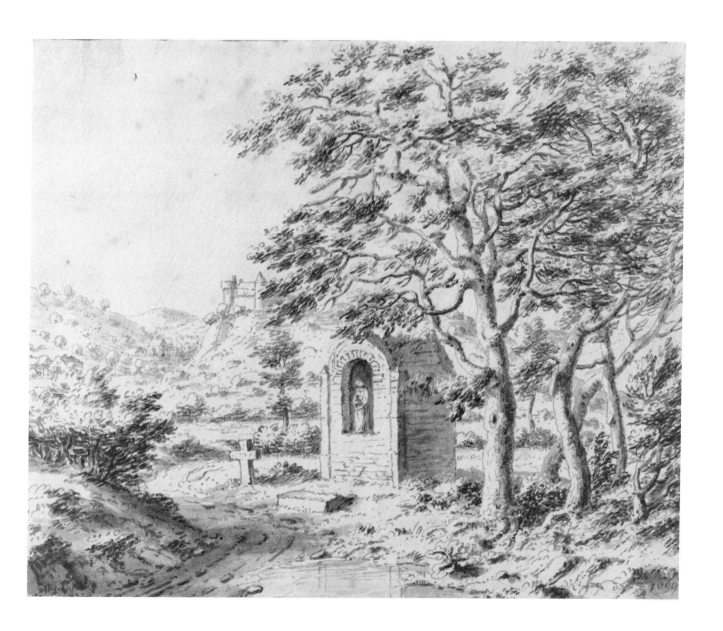

Claude Gellée, called Le Lorrain
French, Nancy, Rome, Naples, 1600-1682

Landscape with the Rest on the Flight into Egypt

Point of brush in brown wash heightened with white paint on blue paper, 23.8 x 19 cm.

Provenance: Lord Northwick; Collection of Henry Oppenheimer, London.

Bibliography: H. S. Francis, "Claude Gellée, Landscape with Rest on the Flight into Egypt," *Cleveland Museum of Art Bulletin*, 49, 1962, p. 234; M. Roethlisberger, *Claude Lorrain, The Drawings,* Catalog, Berkeley and Los Angeles, 1968, no. 570; Szabo, 1980, no. 20; *Profile du Metropolitan Museum of Art de New York*, Bordeaux, 1981, no. 157.

The colorful sheet is a reduced copy of Claude Lorrain's canvas of the same title, now in the Cleveland Museum of Art, that he painted in 1645 in Rome for Count Crescenzi. Besides the exact reduction in the artist's record-book, called "Liber Veritatis," this is the only known copy of the celebrated painting (H. D. Russel, *Claude Lorrain, 1600-1682*, New York, 1982, no. 33). It was observed that the essential elements are taken from the painting, but were reduced to the smaller scale of the drawing. However, prominence is given here to the trees, especially to the palm trees which effectively frame the group in the foreground and emphasize an independence for this sheet. This is further enhanced by the use of the blue paper and the profuse white of the heightening. In spite of these differences, the proximity to the painting still suggests a dating of about 1645 for this painting on paper.

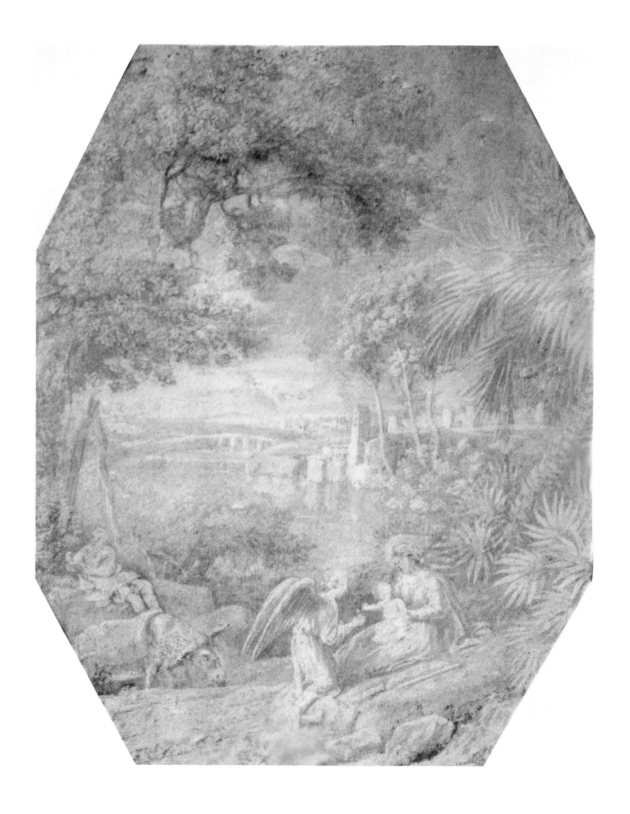

No. 30

Claude Gellée, called Le Lorrain
French, Nancy, Rome, Naples, 1600-1682

The Origin of Coral

Chalk, pen and ink with brown wash on paper, 25.4 x 33.3 cm. Inscribed by the artist at bottom left, in ink: *CLAUDIO fecit pensier de Ill*moil *Cardinalle di massim(o)*.

Provenance: Collection of Richard Houlditch, London; Viscountess Churchill.

Bibliography: Ch. de Tolnay, *History and Technique of Old Master Drawings*, New York, 1943, no. 233; L. L. Boyer, "The Origin of Coral by Claude Lorrain," *The Metropolitan Museum of Art, Bulletin*, 26, 1968, pp. 372-379; M. Roethlisberger, *Claude Lorrain, The Drawings*, Catalog, Berkeley and Los Angeles, 1968, no. 1064; Szabo, 1980, no. 22; H. D. Russel, *Claude Lorrain, 1600-1682*, New York, 1982, no. 69.

The large sheet is one of the six known preparatory drawings for the painting of the same subject that was commissioned from Claude by Cardinal Camillo Massimi in 1674, now in the Collection of Viscount Lobe. Three of these preliminary drawings are studies for figures; the three others are compositional studies of which the present drawing is the earliest.

As it was observed by the previous commentators, "all of the essential parts of the final composition are already in place here." The story of Perseus and the Origin of Coral probably was taken from Book IV of Ovid's *Metamorphoses*, translated into Italian by Giovanni Andrea dell'Anguillara (1561), and used by Claude. This scene shows Perseus washing his hand after killing the sea monster and freeing Andromeda. In the center Pegasus is tied to a palm tree, while on the left the groups of sea-nymphs are mixing Medusa's blood with sea-weed, turning them into coral.

That this drawing was the first full composition is conclusively proven by the inscription in the lower left corner. H. Diana Russel believes that the wording: "*CLAUDIO fecit pensier de Ill*moil *Cardinale di massim(o)*" indicates that the image is the thought, or *concetto*, of the cardinal; that he requested the subject and described to Claude how he wanted the image to look. This is a unique instance of such wording on a drawing by Claude" (Russel, 1982, p. 287). On a later drawing (now in the Louvre, Paris), Claude explored the "coloristic and luministic properties of the scene" and on the third "sumptuous and highly finished drawing" (now also in the Metropolitan Museum of Art), he created the *modello* for the painting, which was presented to Cardinal Massimi, before proceeding with work on the canvas (Boyer, 1968, p. 379).

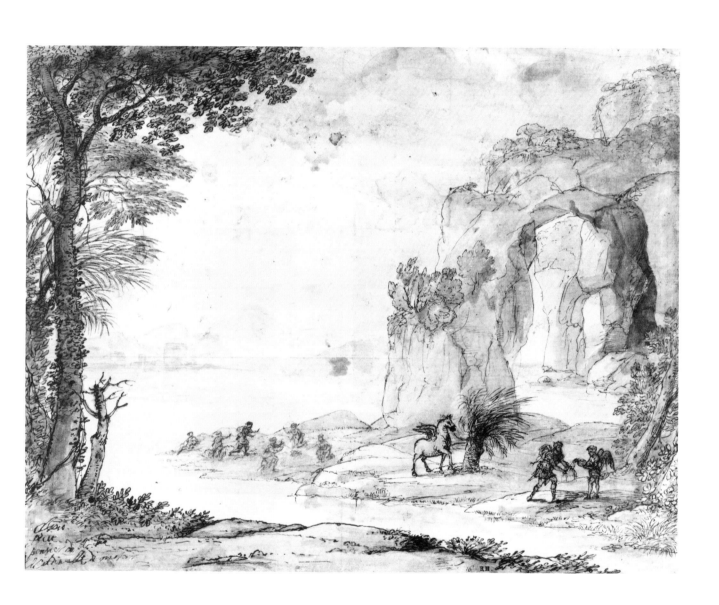

Claude Gellée, called Le Lorrain
French, Nancy, Rome, Naples, 1600-1682

Roman Landscape

Pen and bistre with wash on paper, 16.2 x 28.8 cm.

Provenance: Collection of R. Johnson; Collection of William Bateson, London (Lugt Supplement 2604a); Collection of Philip Hofer, Cambridge, Mass.

Bibliography: *Master Drawings*, 1935, no. 45; Ch. de Tolnay, *History and Technique of Old Master Drawings*, New York, 1943, no. 322; A. Mongan, *One Hundred Master Drawings*, Cambridge, Mass., 1949, p. 80; Orangerie Cat., 1957, no. 99; *French Drawings from American Collections, Clouet to Matisse*, New York, 1959, no. 24; Cincinnati Cat., 1959, no. 259; Szabo, 1980, no. 24.

The subject of this landscape, that floats like a mirage in the center of the sheet, has been described variously as a view of the Villa Doria Pamphili or the Villa Ludovisi. Richard Krautheimer, the great scholar of Rome's topography and architecture, however, identified it as that of the Villa Borghese. According to him, "the site was drawn by Claude from a position in the Villa Ludovisi about where the Palazzo Margherita now is, looking up the Via Veneto toward the Villa Borghese. The walls would then be the Mura Aureliane and the Mura di Belisario. A stand of pines still exists around the Villa Borghese" (*French Drawings from American Collections,*

Clouet to Matisse, p. 40).

It is known from contemporary sources that Claude explored various parts of Rome, wandering about the streets and the hills of Campagna. His impressions are recorded in drawings like this, with rapid strokes of the pen and a deft application of light and dense washes with brush. The combination of topographic truth, the vibrant textures and the luminous character seem to propose it as the perfect illustration for Goethe's remark about Claude's drawings, "We find here a beautiful union of nature and art at the highest level."

Jean-Baptiste Oudry
French, Paris, Beauvais, 1686-1755

Country Farmhouse

Black chalk on paper, 19.4 x 23.5 cm. Signed and dated in lower left corner: *J. B. Oudry 1728.*

Provenance: Private collection, New York.

Bibliography: Szabo, 1980, no. 27.

The farmhouse, the round building on the left, and the cluttered farmyard are all represented in a crisp manner that resembles seventeenth-century Flemish drawings. This may be an indication of the artist's early schooling under his father, who was a pupil of Teniers the Younger.

Oudry was a prolific draughtsman whose surviving oeuvre includes more than one thousand drawings (H. N. Opperman, *Jean-Baptiste Oudry*, I-II, New York, 1977). However, there are only a handful of landscape compositions among them and the present drawing escaped the attention of the oeuvre-catalog's compiler. In concept and in its details, it is close to the large composition called *Une ferme,* now in the Kunsthaus, Zürich, that is dated to 1750; and according to the inscription, it is the design for a canvas painted by Oudry for the Dauphin (J. B. Oudry, *Catalogue par H. Opperman*, Grand Palais, Paris, 1982-1983, no. 143). However, the present earlier composition is more lively as it includes human figures and birds flying around the round tower. These seem to be the tell-tale marks of a drawing done from nature, one of the important contributions Oudry made to eighteenth-century French art.

No. 33

Jean-Honoré Fragonard
French, Grasse, Paris, 1732-1806

View of the Pincio in Rome

Pen and brown ink with brown wash on paper, 29.5 x 39.1 cm.

Provenance: Collection Maingot, Paris; Collection of Pierre Defer, Paris; Collection of Edmond and Jules de Goncourt, Paris; Collection of Camille Groult, Paris; Collection of Philip Hofer, Cambridge, Mass.

Bibliography: *Dessins français du XVIII siècle*, École des Beaux Arts, Paris, 1879, no. 594; A. Ananoff, *L'oeuvre dessinée de Jean-Honoré Fragonard (1732-1806)*, Catalogue raisonné, II-IV, 1963, no. 1441, p. 425; Orangerie Cat., 1957, no. 96; Cincinnati Cat., 1959, no. 264; Szabo, 1980, no. 11.

Fragonard apparently was greatly fascinated by the intricate shapes of horizontal branches of parasol pines. On this large sheet, this interest is combined with another preoccupation of his whole artistic career, the depiction of garden scenes with *fêtes galantes*. These elements are combined perfectly; the vibrant play of shadows and light among the tree branches is matched by movement of the figures underneath them. The shapes of these gallants are hardly discernible; some are men, but most of them are women in the company of children playing, eating, or just sitting on the grass. It is interesting to note that the parasol pines are very similar to those depicted on Claude Lorrain's sheet in this exhibition (no. 31).

As Fragonard rarely inscribed his drawings with dates, dating is difficult. However, the location and primarily the preoccupation with the parasol pines strongly suggest that the drawing must have been done during his second voyage to Italy, in 1773-1774.

The most outstanding feature of this drawing is certainly the virtuoso use of the brush in applying the wash. There is a full scale of concentrations from the dense dark to the fleeting opaque. This is accompanied by an appropriate variety of brushstrokes, from broad and nebulous to short and dry, rendering the delicate textures of sky and uniting pines and people into a harmonious whole.

No. 34

Jean-Honoré Fragonard
French, Grasse, Paris, 1732-1806

Landscape with Road and Monument

Pen and ink over chalk with gray washes on paper, 15.6 x 22.2 cm.

Provenance: Collection of Edmond and Jules de Goncourt, Paris; Collection of Paul Cailleux, Paris.

Bibliography: R. Portalis, *Fragonard, Sa vie, son oeuvre*, Paris, 1889, p. 293; A. Ananoff, *L'oeuvre dessinée de Jean-Honoré Fragonard (1732-1806)*, Catalogue raisonné, I-II, Paris, 1963, no. 800; Szabo, 1980, no. 15.

The traditional titles attached to this drawing, such as "La Fontaine" or "Life in the Park at Fontainebleau," do not seem to correspond to the subject represented. The landscape does not resemble any part of the famous park, neither is a fountain discernible in it. The composition rather shows the crossing of a long, wide alley lined with tall trees with another, lesser road. In the center, the columnar monument is surmounted by a statue of the Virgin and Child. The landscape is enlivened on the left by a one-horse carriage, by a figure sitting on one of the stones surrounding the monument in the center and by several walking figures on the right. In the background, sketchy and misty outlines of a lake are also discernible.

The same elements are represented on another drawing, this one of pure chalk, formerly in the collection of A. Beurdeley in Paris, that seems to be a study preceeding the present more elaborate composition (Ananoff, 1963, p. 799). This relationship and the contradictory opinions about the true location notwithstanding, the remarkable qualities in the drawing were appealing enough for the Goncourt brothers to have included it in their famed collection of drawings.

Marco Ricci
Italian, Belluno, Venice, 1676-1730

The House of Marco Ricci

Pen and ink with sepia wash on paper, 37 x 49.6 cm. On verso: an inscription from 1726 (see below).

Provenance: Collection of Humphrey Mildmay, Esq., England; Collection of the Mildmay Family; Collection of Paul Wallraf, London.

Bibliography: Morassi, 1959, no. 51; Szabo, 1981, no. 22; Szabo, 1982, no. 26; Szabo, 1983, no. 26; Szabo, *Eighteenth Century Italian Drawings*, 1983, no. 22.

On the verso, the incription states: *The house of Sign.r Marco Ricci in the Bellunese among the mountains: with a view of an adjacent monastery. Taken by Sig.r Marco Ricci and given on the spot to Humphrey Mildmay, Esq. An. 1726.* Accordingly, the drawing was made on the spot and given to the visiting Mildmay. Ricci's connection and meeting with the Englishman at this time is not surprising since he had stayed in England twice, first from 1708 to 1711 and later with his uncle, Sebastiano Ricci, from 1712 to about 1726.

The drawing, despite its somewhat damaged state, is a precious document especially because the latter years of the artist's life are ill-documented. Also interesting and in contrast to Ricci's other later works which were mostly *capricci* in a light style, this landscape was drawn from life. Morassi points out that the composition, with the lively figures in the foreground, is related to Ricci's *View of Belluno* in the Royal Collection at Windsor Castle (A. Blunt and E. Croft-Murray, *Venetian Drawings at Windsor Castle*, London, 1957, figs. 3-4).

With its genre-like depiction of country-life around Ricci's house, this drawing throws an interesting light on the everyday life of Venetian artists in the first half of the eighteenth century. In addition, it provides an interesting document for the ways and means of collecting; in this case, collected as a souvenir rather than a drawing.

No. 36

Giovanni Paolo Pannini
Italian, Piacenza, Rome, 1691-1765

Landscape with Statue and Ruins

Pen and brush with tinted ink washes and watercolor on paper, 18.4 x 26.2 cm. On verso: ruins with a statue in tondo form, in pen and brush with tinted washes.

Provenance: Collection of Edward Fatio, Geneva.

Bibliography: Szabo, 1981, figs. 66a, b; Szabo, 1982, figs. 63 and 66; Szabo, 1983, figs. 63 and 66.

Pannini received his training in architecture and perspective painting in his native Piacenza. He settled in Rome in 1711. Pannini's incorporation of elements from the landscapes of Locatelli and those of the Roman-Dutch school, such as Vanvitelli (Gaspar von Wittel) and Pieter van Bloemen, further enriched his already successful and accomplished style. This drawing displays Pannini's mature style: a pleasing combination of elaborate ruins, a classical statue and a discreet presence of trees and bushes. The application of tinted ink washes and watercolors further enhance its romantic-melancholic atmosphere.

Through his paintings and many drawings, Pannini transmitted this tradition to artists working in the second half of the eighteenth century. Echoes of his compositions and manner can be found in the drawings of Piranesi, Canaletto and Fragonard, all of whom are represented in this exhibition.

♔ No. 37

Giovanni Battista Piranesi
Italian, Mogliano (near Mestre), Venice, Rome, 1720-1778

View of Pompeii

Pen and ink on paper, 27.6 x 41.9 cm. Inscribed with numerals 1 through 6 by the artist.

Provenance: Collection of H. L. Philippi, Hamburg; Collection of Colonel N. Calville, Penheale Manor, Launceston, Cornwall; acquired from Stephen Spector, New York, 1961.

Bibliography: H. A. Thomas, "Piranesi and Pompeii," *Kunstmuseets* Årsskrift, XXXIX-XLII, 1952-1956, pp. 20-21, 27; Szabo, 1981, no. 68; Szabo, 1982, no. 67; Szabo, 1983, no. 67.

Giovanni Battista Piranesi, one of the foremost vedutists of the eighteenth century, visited the recently excavated ruins of Herculaneum and Pompeii between 1770 and 1778. During these stays, he made a large number of drawings furnished with numerical notations. Apparently, he planned to transpose them into etchings for a publication on the ruins and views of Pompeii. As of today, at least thirteen of these drawn views of the excavated city survive (H. A. Thomas, p. 15; A. Bettagno, *Disegni di Giambattista Piranesi*, Venice, 1978, pp. 68-70, nos. 82-83). A number of these preliminary drawings were used by the artist's son, Francesco Piranesi. He completed his father's initial plans and published a three volume series devoted to Pompeii entitled "Antiquités de la grande Grèce" between 1804 and 1807.

This drawing shows a view through the Herculaneum Gate and corresponds to the engraving on Plate VI in Volume I. Therefore, it offers an interesting comparison between landscape drawing sketched on the site and its copy in the engraver's workshop. Piranesi's method and style are relatively simple: pen and ink provide a medium for the fast topographic depictions that are embellished with rapid sketches of figures, visitors as well as workmen. However as Thomas remarks, "He could nevertheless create enormously ponderous forms with it, and enliven their surfaces with a vivid play of light and shadow," while etchings by Francesco "...have...become very much darker, and have lost the luminosity of atmosphere and the weightiness and clarity of shapes." In addition, the almost empty final prints lack the liveliness provided by the human figures on the drawings.

This sheet is especially rich with such figures, like the two gentlemen in tri-cornered hats. They are similar to ones on Piranesi's sheet that represents the *Tomb of the Istanidi*, now in Copenhagen (E. Fischer, "G. B. Piranesi, 3 Tegniger - 3 Drawings," Statens Museum for Konst, København, 1978). These little vignettes on Piranesi's late drawings betray the artist's Venetian origins and recall the figures and caricatures of the Tiepolos.

No. 38

Italian Artist
Venice, Eighteenth Century

The Tower of Malghera

Pen and ink with gray wash on paper, 29.5 x 40.5 cm. Inscribed in lower center: *La Torre di Malghera.*

Provenance: Collection of Paul Wallraf, London.

Bibliography: Morassi, 1959, no. 13; Szabo, 1981, no. 23; Szabo, 1983, no. 6; Szabo, 1985, no. 5.

This drawing is based on an engraving of the same title by Antonio Canal, called Canaletto (1697-1768) (R. Pallucchini and D. Guarnati, *Le acqueforti del Canaletto*, Venice, 1958, pl. 8). The picturesque tower was a favorite subject of paintings by both Canaletto and Francesco Guardi; a small panel by Guardi with a colorful depiction of it is also in the Robert Lehman Collection (Szabo, 1982, fig. 15).

A considerable number of similar copies after Canaletto's graphic works survive; a dozen are in the Robert Lehman Collection (Szabo, 1981, nos. 12-24). They all clearly demonstrate the mechanical, repetitious character of such copies. Still, these replicas must have been popular with those collectors and travelers who could not afford the master's originals.

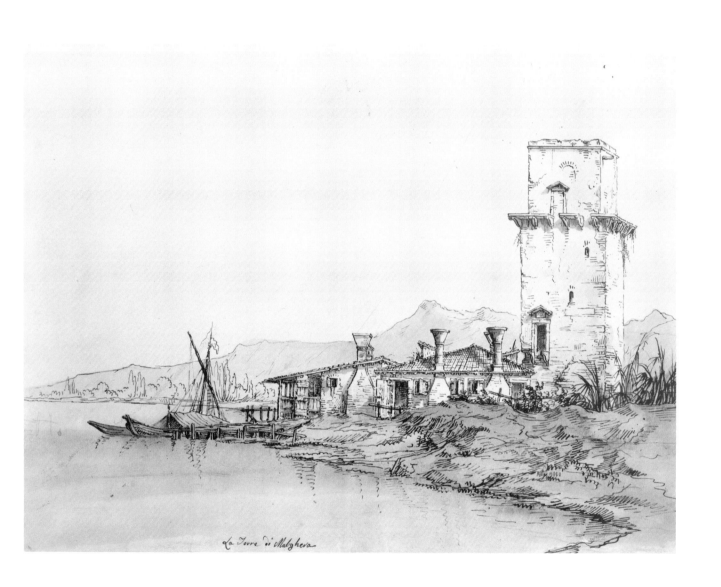

La Torre di Malghera

No. 39

Giambattista Tiepolo
Italian, Venice, Madrid, 1696-1770

Landscape with Castle

Pen and ink with brown wash on paper, 5.5 x 17.4 cm.

Provenance: Unknown.

Bibliography: Szabo, 1981, no. 112; Szabo, 1985, no. 33.

Giambattista Tiepolo did a considerable number of views from nature around the Veneto, before moving to Spain in 1762. These drawings with their powerful lines and strongly contrasting fields of dark wash and white paper constitute an interesting and still unexplored facet of his oeuvre. T. Pignatti lists similar drawings in the British Museum, the Berlin Printroom and the Rotterdam Museum, and suggests they were once part of an album acquired by Edward Cheney, an English collector, in Venice during the nineteenth century (*Venetian Drawings from American Collections,* Washington, 1975, p. 41).

Many of these horizontal landscape studies are on large papers, sometimes two to a sheet, that approximate the width of this drawing. The narrowness of the sheet and the cutting off of the house in the lower right corner might be further indication that this drawing was originally part of such a sheet, perhaps in Cheney's album.

Giandomenico Tiepolo
Italian, Venice, 1727-1804

Landscape with a Horse Held by a Page

Pen and ink with wash over black chalk preliminary drawing on paper, 29 x 42 cm. Signed on the rock in the lower left: *Dom. Tiepolo.*

Provenance: Collection of Paul Wallraf, London.

Bibliography: Morassi, 1959, no. 112; Szabo, 1981, no. 117; Szabo, 1985, no. 35.

This landscape composition combines careful observation with artistic fantasy. The page's Oriental-style costume is imaginary, while the arid, mountainous landscape and the sketchy buildings in the distant background on the left are reminiscent of Spain. It is possible that the drawing contains some memories of Giandomenico's travels in the company of his father, Giambattista Tiepolo. The calm composition with its down-to-earth, cool observation of nature is an interesting and revealing contrast to some of the romantic and exaggerated landscapes found in Giandomenico's religious compositions (Szabo, 1983, no. 39).

Morassi dates this drawing to the 1790s and remarks that the figures in the upper right corner "like many others in Tiepolo's drawings are only" a few steps away from Goya.

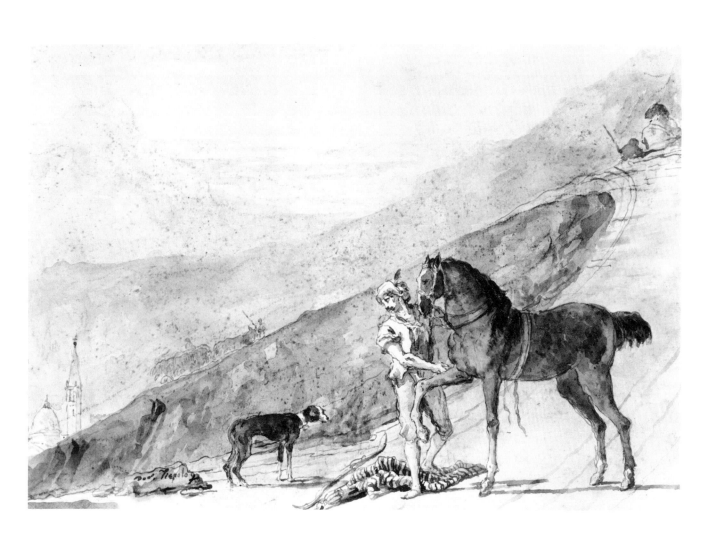

No. 41

Francesco Zuccarelli
Italian, Venice, 1702-1788

Fantastic Landscape

Pen and ink with wash and white highlights on paper, 30.5 x 46.8 cm.

Provenance: Collection of Villiers David, Friar Park, Henley; Collection of Paul Wallraf, London.

Bibliography: Morassi, 1959, no. 127; Szabo, 1981, no. 182; Szabo, 1985, no. 58.

The pleasant landscape is composed of various pictorial elements. Some, like the peasant houses or the villas, are probably taken from reality. Others, such as the ruins, hilltop castle and far-reaching seascape are clearly from the imagination. There is a pleasing arcadian feeling in this drawing as Zuccarelli harmoniously blends these elements in a manner similar to that found in Claude Lorrain's landscape compositions. This and similar compositions are the first heralds of Romanticism probably the reason for their popularity in England.

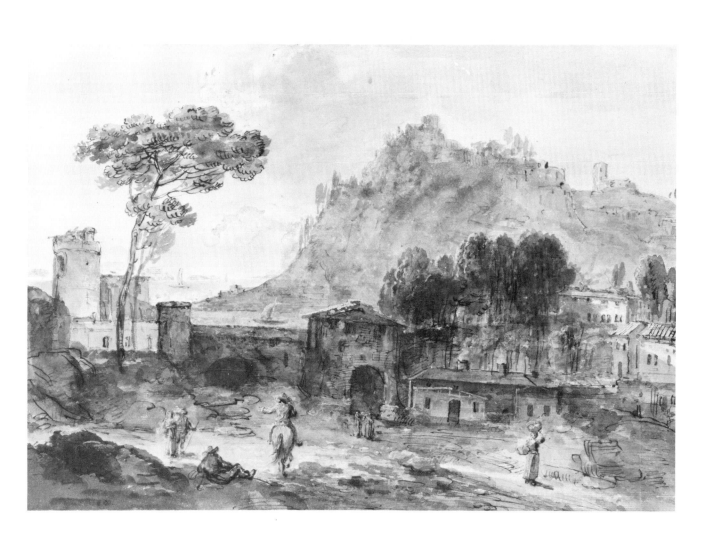

No. 42

Follower of Zuccarelli
Italian or English, Late Eighteenth Century

Landscape with Ruined Arch

Black chalk on paper, 23.5 x 33.7 cm.

Provenance: Unknown.

Bibliography: Unpublished.

The dry, belabored technique and mechanical style clearly indicate this drawing as the work of a copyist. Whether the minor artist was Italian or English cannot be ascertained, but an English attribution is suggested due to certain affinities with later English landscape drawings in this exhibition.

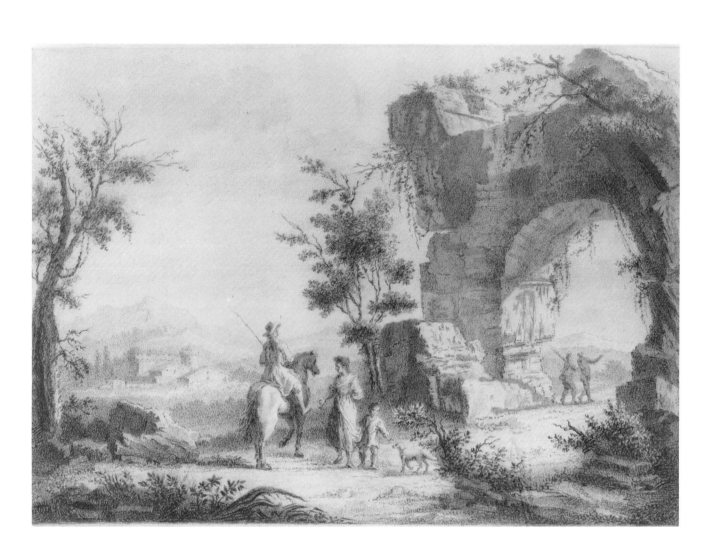

Thomas Gainsborough
English, Sudbury, Suffolk, London, 1727-1788

Woodland Scene with Man and Dog Walking over a Bridge

Black and white chalk with some ink wash on brown paper, 28 x 36.8 cm.

Provenance: Collection of Henry J. Pfungst, London; Collection of Victor Koch, New York.

Bibliography: Unpublished.

Although this drawing is neither signed nor dated, it is securely attributed to Gainsborough and may be dated to the later years of his career. In the 1770-1780s, he made a large number of romantic landscape drawings with the same strongly contrasting tonalities of black and white, some probably to be reproduced as engravings. The introduction of the man and his dog crossing the bridge enliven this composition; his bent figure and windswept coat deepen the romantic drama in nature, already expressed by the bold strokes.

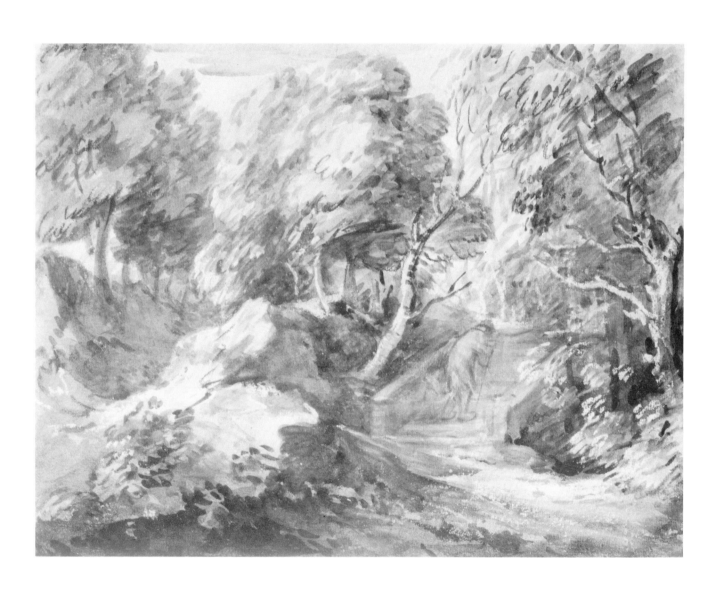

Thomas Gainsborough(?)
English, Sudbury, Suffolk, London, 1727-1788

Stormy Landscape

Black and white chalk on brown paper, 31.1 x 26 cm. Inscribed in lower left corner with initials and date: *T.G 1769.*

Provenance: "Grecian" Williams Collection(?); Collection of Hugh W. Williams, London; Collection of Victor Koch, New York.

Bibliography: Unpublished.

The black and white chalk composition is in the manner of Gainsborough. However, a comparison to his other drawing in this exhibition (no. 43) reveals certain weaknesses: the shape of the trees and foreground are rather undefined; and the romantic density of trees and foliage and the artist's bold strokes cannot be recognized here. For these and many other reasons, this drawing should be considered the work of an imitator of Gainsborough's style. John Hayes, the well-known scholar and connoisseur of the artist's drawings, suggested that this sheet is "in fact a drawing by John Hoppner, who imitated Gainsborough's style." He further quotes Sir George Beaumont's note from 1806 concerning Hoppner, "He is all imitative...he is in portrait an imitator of Sir Joshua Reynolds & in Landscape of Gainsborough" (Letter from 1961 in the Files of the Robert Lehman Collection).

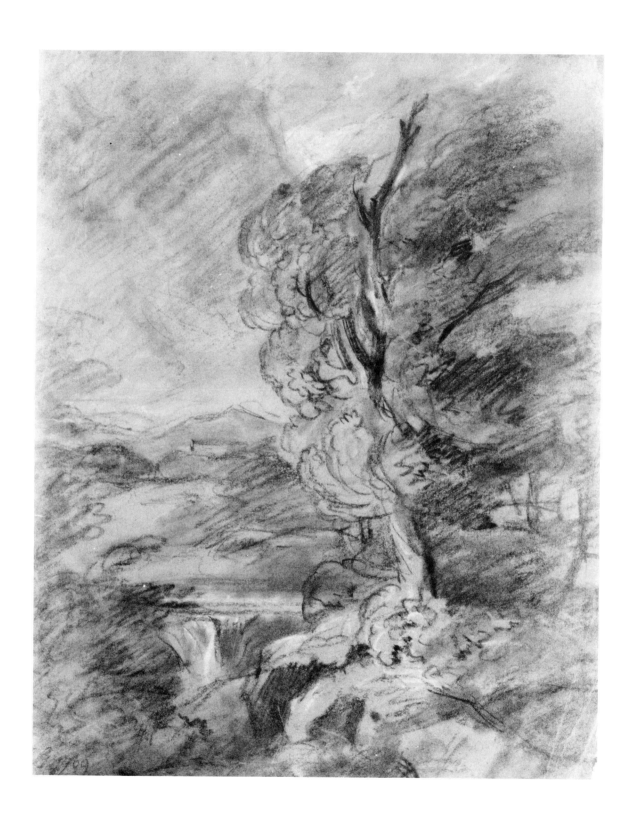

No. 45

John B. Crome
English, Norwich, 1768-1821

Landscape with Boy Fishing

Watercolor on paper, 10.3 x 27.5 cm. On back-up paper covering the verso: a gray-wash composition of a sea-scene. Inscribed in ink: *18 May 1818*.

Provenance: Collection of Mrs. Frederich C. Havemeyer, New York.

Bibliography: Norman L. Goldberg, *Landscapes of the Norwich School, An American Debut,* The Cummer Gallery of Art, Jacksonville, Fla., 1967, no. 18; D. Clifford and C. Clifford, *John Crome,* London, 1968, no. D205, p. 159; Norman L. Goldberg, *John Crome the Elder,* I-II, Oxford, 1978, no. 182, pp. 258-259.

John Crome, "Old Crome," spent his entire life in Norwich. At fifteen he was apprenticed to a coach and sign painter and later taught himself to paint on canvas. A local collector discovered the talents of this young painter and allowed him to copy paintings, including works by Richard Wilson, Gainsborough and Hobbema.

Around 1803, Crome with friends and disciples formed the Norwich Society, which later became the Norwich School. He was elected president in 1808; and during his lifetime, he exhibited close to 300 paintings with the group.

This watercolor dates from the last years of his life. It is a typical composition, uniting the dense wooded foreground with the airy landscape on the left. Although the colorscale is limited to dark browns, greens and yellows, the painting exudes an honest and pleasant autumnal feeling.

Paul Sandby
English, Nottingham, Edinburgh, London, 1725/26-1809

Travellers Entering a Town

Point of brush with watercolor washes on paper, 27.4 x 20.4 cm.

Provenance: Charlotte Sandby, the artist's daughter; William Arnold Sandby; G. J. A. Peake; Collection of Hubert Peake; acquired from Thos. Agnew & Sons, Ltd., London, 1960.

Bibliography: *87th Annual Exhibition of Water-Colour Drawings,* Thos. Agnew & Sons, Ltd., London, 1960, no. 50.

The landscape around a town-gate is more romantic and imaginary, than topographical. Thus, it is in contrast to most of Sandby's drawings representing well-known sights and sites in England, Wales and Scotland (L. Herrmann, *Paul and Thomas Sandby,* The Victoria and Albert Museum, London, 1986).

The tall trees and the voluminous ruins inside the gate provide perfect material for the artist to demonstrate his dexterity in the medium. The cypress-like trees in the background and the costumes of the travellers lend to the Mediterranean feeling. Sandby never travelled in Italy, yet this drawing may be one of the Italian fantasies by the "Father of English Watercolors."

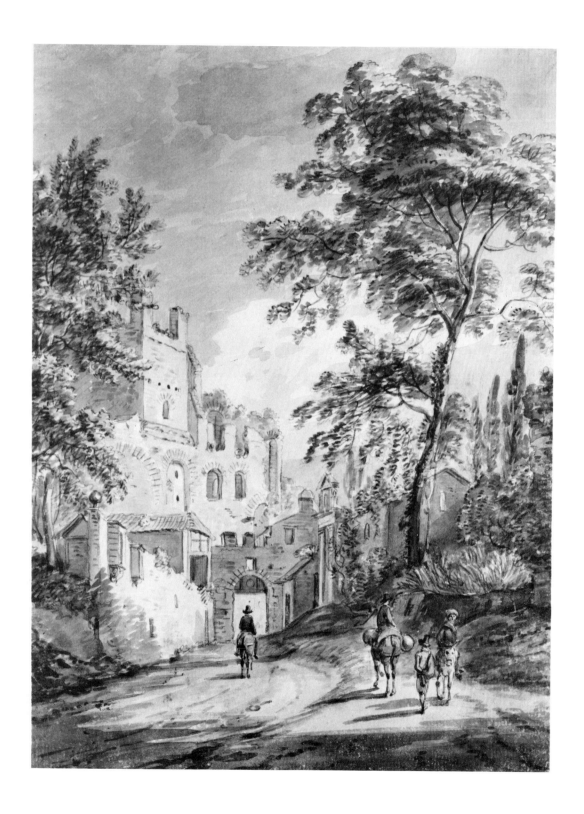

Thomas Creswick
English, Sheffield (Yorkshire), London, 1811-1869

Landscape with Stagecoach

Watercolor on paper, 19 x 16.6 cm.

Provenance: Unknown; acquired from Thos. Agnew & Sons, LTD., London, 1960s

Bibliography: Unpublished.

After receiving his initial artistic training in Birmingham, Creswick settled in 1828 in London, where he spent the rest of his life. With steady and dependable work as a landscape painter and engraver, he successfully became first an associate and then a full member of the Royal Academy in 1851 (*A Catalogue of the Works of Thomas Creswick*, International Exhibition, London, 1873). This watercolor composition successfully unites the main fields of his interest. There is a painterly chiaroscuro in the dense bushes in the foreground while the large tree in the center and the distant church are rather dry, closer to the manner of an engraver.

No. 48

John Varley
English, London, 1778-1842

View of a Town with Harbor

Watercolor on paper, 12.4 x 18.1 cm. Signed and dated in ink in lower right corner: *J. Varley 1836.*

Provenance: Unknown; acquired from Thos. Agnew & Sons, Ltd., London, 1960.

Bibliography: *87th Annual Exhibition of Water-Colour Drawings,* Thos. Agnew & Sons, Ltd., London, 1960, no. 100.

Varley was another successful English landscape painter working in the first half of the nineteenth century. He was especially appreciated for his topographical watercolors that faithfully registered famous and little-known landmarks in a rather pleasing and light manner. Although in this view of a castle, town and harbor he carefully depicts the features of each component, the exact location is not identifiable.

John Ruskin
English, London, Brentwood, 1819-1900

Italian Landscape

Watercolor and pencil on paper, 26.5 x 38.6 cm. Inscribed and signed by artist in ink in lower right corner: *Il Resegone di Lecco from San Stefano Mars April 1885*. On verso: the same text in pencil with artist's name.

Provenance: Collection of Philip Hofer, Cambridge, Mass.

Bibliography: Unpublished.

The famous English philosopher, aesthete and historian of ideas and art, was also an accomplished artist, especially in the medium of watercolor. For fifty years, Ruskin was a member and exhibited regularly at the Society of Water Colours. Ruskin illustrated many of his own books both with drawings and watercolors, among them the *Stones of Venice*. As a teacher, he was also concerned with the technique and aesthetics of watercolor, a concern he shared with his friends Turner, Hunt, Millais and Rossetti. In appreciation of Ruskin's watercolors, his minute technique and the organic construction of landscape are always mentioned as hallmarks of his style.

This seemingly unfinished watercolor is an extraordinary document for Ruskin's topographical interest, exhibiting an unerring eye to capture the monumental shapes of mountains as well as for a descriptive technique. The mountains of the Bergamo Alps as seen from Lecco – a town on the eastern shores of Lake Como – majestically tower over the small villages in the valleys, some of which he even named with minute inscriptions.

The exceptional care in the execution of the snow-capped rocks and the light sketchy style of the valley landscape constitute a dramatic and curious contrast. This raises the question whether Ruskin intended to finish the watercolor or leave it in this state with its superb portrayal of the "Resegono di Lecco."

❦ No. 50

Jean-Baptiste-Camille Corot
French, Paris, 1796-1875

Gelloli in the "Province de Milan"

Pencil on paper, 21 x 24.8 cm. Inscribed by the artist in upper right corner: *fornace com.*^me *a Gelloli province de Milan 7 au 1834.*

Provenance: Unknown; acquired from Lock Galleries, New York, 1959.

Bibliography: Szabo, French Drawings, 1980, no. 10.

As the artist's notation explains, the drawing was done during his second trip to Italy in 1834. As he travelled through Lombardy, Corot sketched the picturesque furnace in the village of Gelloli, in the province of Milan (D. Baud-Bovy, *Corot*, Geneva, 1957, pp. 84-85). He made a great number of similar topographical sketches while travelling with the painter Grandjean. Corot's impressions of the famous Italian art centers were formalized in many large canvases depicting Venice and Volterra. However, the fleeting views and moments represented on the drawings better present his emotions as expressed in his diary, when stopping in Como, "Beaux pays, beaux arbres, beaux terrains."

No. 51

Jean-Baptiste-Camille Corot
French, Paris, 1796-1875

Landscape

Charcoal with white chalk on buff paper, 33 x 42.5 cm. Inscribed by the artist in charcoal in lower left corner: *COROT*.

Provenance: Unknown; acquired from Lock Galleries, New York, 1962.

Bibliography: Szabo, French Drawings, 1980, no. 12.

The velvety chiaroscuro of this charcoal composition is in marked contrast to the dry, crisp lines and well-defined character of his landscape, *Gelloli in the "Province de Milan"* (no. 50). The features are defined by the masterful combination and juxtaposition of dense dark shapes in the foreground with the lighter, sometimes almost white, sky and the wide-ranging vista of the plain fields in the background.

The figures and two houses in the right back are characterized and emphasized with the addition of white chalk lines; their angularity resembles the white voids on Seurat's celebrated black and white conté-crayon drawings from the early 1880s.

Corot's drawing is quite difficult to date. It certainly belongs to the last decade of his life and, by the style of the signature, might be dated to around 1860.

No. 52

Narcisse Virgile Diaz de la Peña
French, Bordeaux, Paris, Menton, 1808-1876

Wooded Landscape

Crayon on paper, 15 x 21.3 cm. Signed with monogram in lower left corner: *N.D.*

Provenance: Unknown; acquired from Galerie de Bayser et Strolin, Paris, 1960.

Bibliography: Szabo, French Drawings, 1980, no. 39; *Profil du Metropolitan Museum of Art de New York, de Ramsès à Picasso*, Galerie des Beaux-Arts, Bordeaux, 1981, no. 164.

Diaz de la Peña was born in Bordeaux to an exiled Spanish family. After some wandering, he settled in Paris and worked as a painter on porcelain. He first exhibited at the Salon in 1831 and again later with paintings in the spirit of Romanticism.

In 1837, he met Théodore Rousseau and became acquainted with the painters of the Barbizon School. Diaz de la Peña's paintings are distinguished from those of this School by their luminosity and fluid outlines, the very same characteristics which may be observed on the present drawing. The dry branches of the trees and their foliage are represented in a soft manner that is in marked contrast to the drawings by other Barbizon painters as illustrated in this exhibition.

No. 53

Charles-François Daubigny
French, Paris, 1817-1878

Landscape

Black crayon heightened with white chalk on paper, 42.2 x 25.6 cm. Signed in crayon in lower left corner: *Daubigny*. In upper right corner, mostly illegible crayon inscriptions of several lines including the words *Constant* and *Mardi*. On verso: sketch of a horizontal landscape, also in black crayon.

Provenance: Unknown; acquired from Lock Galleries, New York, 1960.

Bibliography: Szabo, French Drawings, 1980, nos. 28 a, b; Ordrupgaard Cat., 1986, no. 11.

Daubigny was one of the most accomplished and acclaimed French landscape painters of the mid-nineteenth century. As he travelled a great deal around the countryside, even on a barge, it is very difficult to identify the scene of this drawing (M. Fidel-Beaufort and J. Bailly-Herzberg, *Daubigny,* Paris, 1975). His acute awareness of natural light and form is clearly demonstrated even in this fleeting and sparse landscape. Although undated, the work is probably from the last decade of his life, from the late 1860s or early 1870s.

The problems of appreciation, past and present, are interestingly revealed by this drawing. Today, the simple beauty of the almost calligraphic lines and the fleeting indication of light and shadow are the most appealing features of his compositions. This is in almost total contrast to the opinion of his contemporaries. As one of his main critics Théophile Gautier expressed, "It is a shame that Daubigny, this landscapist of such true feeling - so right, so natural - is satisfied with a first impression and neglects details to this point."

Henri-Joseph Harpignies
French, Valenciennes, Paris, Saint-Privé (Yonne), 1819-1916

Landscape

Watercolor over pencil drawing on paper, 32.5 x 23.7 cm. Signed in lower left corner: *H. Harpignies*. Inscribed in upper left corner: *FAMARS 8bre 63*.

Provenance: Unknown.

Bibliography: Szabo, French Drawings, 1980, no. 46.

The inscription dates this luminous watercolor to October of 1863. It depicts two figures, maybe a woman and a child, walking on a winding road near Famars, the small town where the artist's father was a part-owner of a sugar factory (*Henri Harpignies,* Musée des Beaux-Arts, Valenciennes, 1970, p. 2).

Of historical interest, in 1863 Harpignies decided to return to Italy, where he spent the next two years. It is quite possible that before leaving he visited his relatives and painted this delightful composition to commemorate the occasion. It is often said that Harpignies' best works dating from the 1860-70s are his watercolors. The rich tonality of autumn yellows, browns and greens, and the deft application of the patchy washes confirms this in every respect.

An interesting parallel and comparison to this watercolor is Harpignies' small oil painting, signed and dated 1854. It depicts two figures walking on a similar winding road among trees. This painting was acquired by Robert Lehman, together with a photograph inscribed by the artist in 1910 with the following, "I certify that this painting was painted by me in August of 1854: this work was painted solely after nature" (Szabo, *Guide,* p. 97, no. 85).

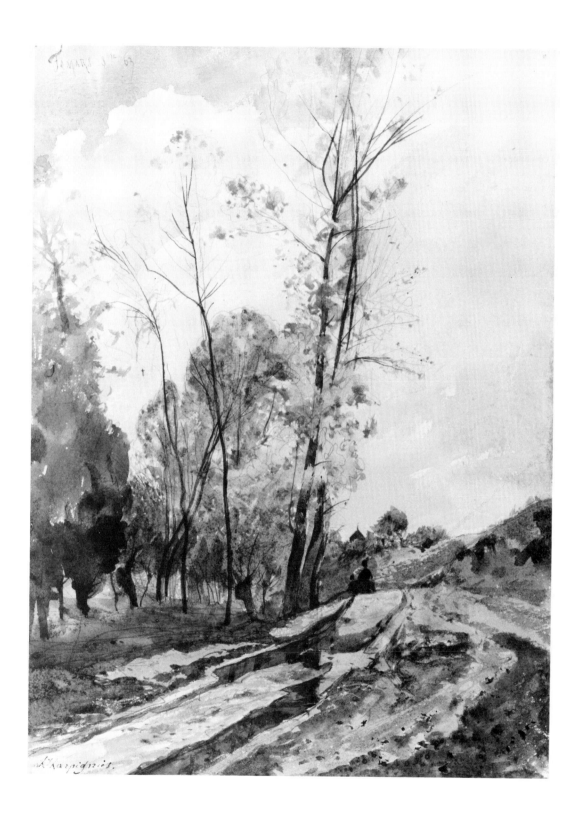

No. 55

Henri-Joseph Harpignies
French, Valenciennes, Paris, Saint-Privé (Yonne), 1819-1916

Moonlit Landscape

Charcoal on paper, 22.2 x 29.2 cm. Signed in lower left corner: *h. Harpignies.*

Provenance: Unknown; acquired from Jacques Seligmann & Co., Inc., New York, 1962.

Bibliography: *Master Drawings,* Jacques Seligmann & Co., Inc., New York, 1962, no. 20; Szabo, *French Drawings,* 1980, no. 50.

The interplay of black and white, with the dense, almost impenetrable dark outlines of the countryside, is in total contrast to the artist's watercolor in this exhibition (no. 54). Although compressed into the small pictorial field, the drama is heightened by the powerfully looming and dominating tree that dwarfs the two small figures trodding along the narrow road.

Tradition and some stylistic considerations suggest a date around 1900 for this vignette-like composition. Harpignies may have been already eighty years old, but the power and dexterity of his art are still here encapsulated.

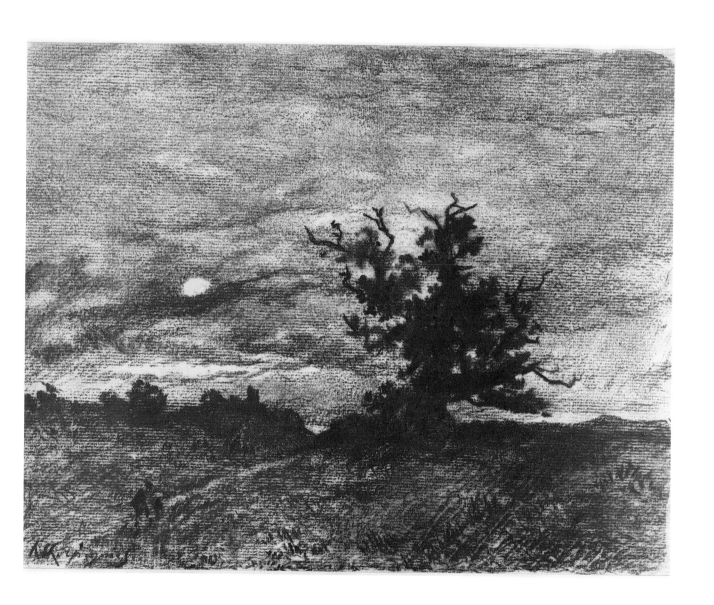

Pierre-Étienne-Théodore Rousseau
French, Paris, Barbizon, 1812-1867

Landscape with Pond

Point of brush and ink with wash on paper, 13 x 17.7 cm. Stamped in lower right corner with initials: *TH·R.*

Provenance: Unknown; acquired from Galerie de Bayser et Strolin, Paris, 1960.

Bibliography: *From Delacroix to Cézanne, French Watercolor Landscapes of the Nineteenth Century,* University of Maryland Art Gallery, College Park, Maryland, 1978, no. 145; Szabo, *French Drawings,* 1980, no. 75.

Most of Rousseau's drawings and watercolors represent scenery from Barbizon (A. Terrasse, *Théodore Rousseau's Universe,* Paris, 1976). Similar to many of these compositions, the forms and features of the landscape are closely observed and represented with short, regular and controlled brushstrokes as represented on this small sheet.

The color scheme is restricted, yet a certain liveliness is seen in the various tones of gray. Both technique, the observation and the successful depiction of the atmosphere date this drawing to the last decade of the artist's life, to after 1855.

Eugène Louis Boudin
French, Honfleur, Paris, 1824-1898

Beach Scene at Deauville

Pastel on paper, 14.6 x 20.3 cm. Signed with initials in lower right corner: *E.B.* On verso: beach scene with studio stamp.

Provenance: From the artist's studio; Collection of Mme. Kees van Dongen, Paris-Monaco(?).

Bibliography: Szabo, French Drawings, 1980, no. 5; Ordrupgaard Cat., 1986, no. 17.

Both sides of this delicate sheet demonstrate the light colors and fleeting lines of Boudin for which he was justly famous and appreciated by this contemporaries. The pastel beach scene is a balanced mixture of elegant ladies on the beach, the far-reaching sea and the sky. They are in marked contrast to the dense, darkish chiaroscuro that is displayed in his other drawing in this exhibition (no. 58).

No. 58

Eugène Louis Boudin
French, Honfleur, Paris, 1824-1898

Landscape

Black chalk on gray paper heightened with white chalk, 40 x 57 cm.

Provenance: Unknown; *Tableaux modernes-aquarelles-pastels-gouaches-dessins,* Hôtel Drouot, Paris, July 4, 1949, Lot 3.

Bibliography; Szabo, French Drawings, 1980, no. 6; Ordrupgaard Cat., 1986, no. 16.

An unusual and powerful drawing by the artist, who is well-known for his light and colorful seascapes and beach scenes of his native Honfleur and Trouville in Normandy, such as the pastel in this exhibition (no. 57). The rough texture and strong background color of the gray paper provide a dramatic contrast to the subtle variations of the soft black and white chalks. This technique somewhat resembles the gray grounding on his canvases.

The view depicted is unusual for Boudin. In contrast to the hundreds of seascapes, port and beach scenes, his landscapes of the interior ports of Normandy are relatively rare.

This drawing has some general relationship to the river scenes around Touques or other smaller rivers of the region, painted mostly in the 1880s. However, these oil paintings lack both the breadth and wide vista found in this drawing.

The *grisaille* depiction of the village in the interior of Normandy seems to reflect to a degree the experiments of Seurat in the straight black and white chiaroscuro of his conté-crayon drawings. Therefore, Boudin's drawing should be dated to the last decade of his life.

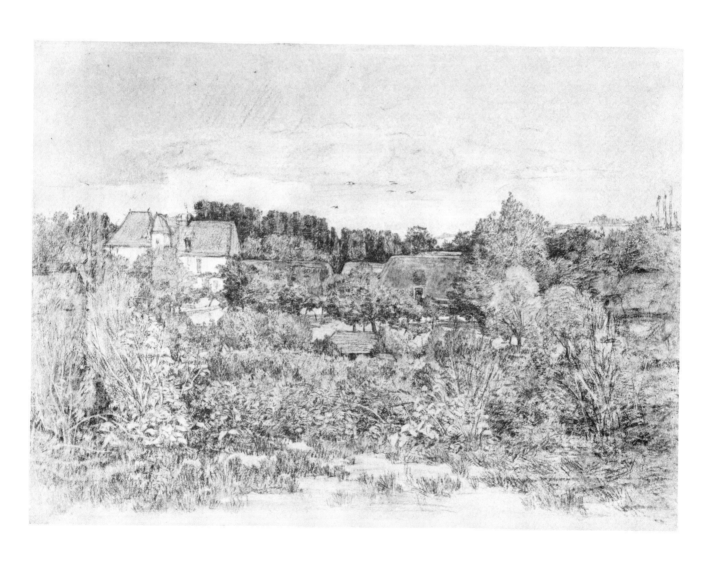

No. 59

Pierre-Auguste Renoir
French, Limoges, Paris, Cagnes-sur-Mer, 1841-1919

Landscape with Girl

Watercolor on paper, 24.8 x 27.3 cm. Signed in lower right corner with initial: *R.*

Provenance: Unknown.

Bibliography: *Renoir, Degas: A Loan Exhibition of Drawings, Pastels, Sculptures,* Charles E. Slatkin Galleries, New York, 1958, no. 68; Szabo, French Drawings, 1980, no. 72.

The small sheet with its light patches of color contains the two most successful elements of Renoir's repertory: a young woman and trees. According to his son, Jean Renoir, the artist made hundreds of these watercolor sketches. The floor of his studio was littered with them and many times Renoir instructed the maid to start the fire in the stove using these sheets.

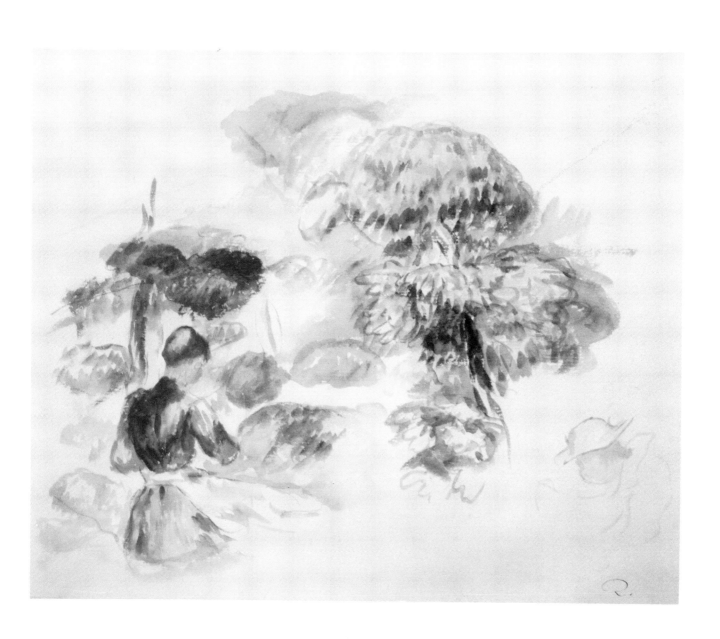

Vincent van Gogh
Dutch, Zundert, London, Paris, Arles, St. Rémy, Auvers, 1853-1890

Road near Nuenen

Chalk, pencil, pastel and watercolor on paper, 39.4 x 57.8 cm.

Provenance: Private collection, Schipluiden, Holland; acquired from Dr. Peter Nathan, Zurich, 1962.

Bibliography: Szabo, *Guide,* 1975, no. 193; J. Hulsker, *The Complete Van Gogh,* New York, 1977, p. 22, no. 46; *The Genius of Van Gogh,* The Dixon Gallery, Memphis, Tenn., 1982, no. 2.

This magisterial drawing, also known as *Road with Pollard Willows* and *Man with Broom*, is certainly the best of Van Gogh's early landscape compositions. He probably did it in October of 1881 while staying in Etten.

The use of various materials suggests that he had taken to heart the advice given by the visiting artist, Anton Mauve, "You should try it with charcoal and chalk and brush and stumps." However difficult Van Gogh found it to use these materials, he certainly overcame and mastered them in this drawing.

The long stretch of the rough road is lined with pollard willows; their bare, knotty and leafless tops look as if they were rooted up and replanted upside down. The decay and desolation of the Fall atmosphere is fully conveyed in his use of earthy blacks and browns. The almost evenly placed but distant figures contribute even more to this by their complete isolation. The low setting sun casts long shadows of the pollards and, at the same time, illuminates touches of color in the composition: the reddish brown on the bushes in the foreground are followed in the receding landscape by the blue on the walking man's jacket and the little red dots on the roofs of the houses on the horizon. The horizontals of the road and its juxtapositioning with the upward reaching bare boughs of the pollards imbues the drawing with the sense of tense but controlled drama.

No. 61

Georges Seurat
French, Paris, 1859-1891

The Lighthouse at Honfleur

Conté crayon heightened with white gouache on paper, 24.9 x 30.7 cm.

Provenance: Collection of Maximilian Luce, Paris; Collection of Émile Seurat; Félix Fénéon, Paris; Collection of John Rewald, New York.

Bibliography: C. M. de Hauke, *Seurat et son oeuvre,* Paris, 1961, no. 656; R. Herbert, *Seurat's Drawings,* New York, 1962, no. 103; R. Herbert, *Neo-Impressionism,* The Solomon R. Guggenheim Museum, New York, 1968, no. 78; Szabo, French Drawings, 1980, no. 77; E. Frans and B. Crowe, *Georges Seurat,* München, 1983, no. 75, p. 192; Ordrupgaard Cat., 1986, no. 42.

The striking landscape with its mysterious blacks and luminous whites depicts the same view as Seurat's famous painting, *End of the Jetty, Honfleur,* dated 1886, now in the Rijksmuseum Kroller-Müller, Otterlo. Most critics, however, do not consider it to be a study for that canvas, but still date it to the summer of 1886.

As an independent landscape it has always been highly praised. This is reflected in its distinguished provenance, as well as a rich bibliography, more than forty citations are found in monographs and exhibition catalogues. The *Lighthouse at Honfleur* is listed in Maximilian Luce's posthumous inventory of Seurat's studio; it then passed from the artist's family to the Collection of Félix Fénéon, the passionate defender of the "Pointillists." Later, the drawing was owned by John Rewald, the scholar and connoisseur of post-impressionism, who reproduced it in his well-known work, *Post-Impressionism from Van Gogh to Gauguin* (New York, 1956, p. 125).

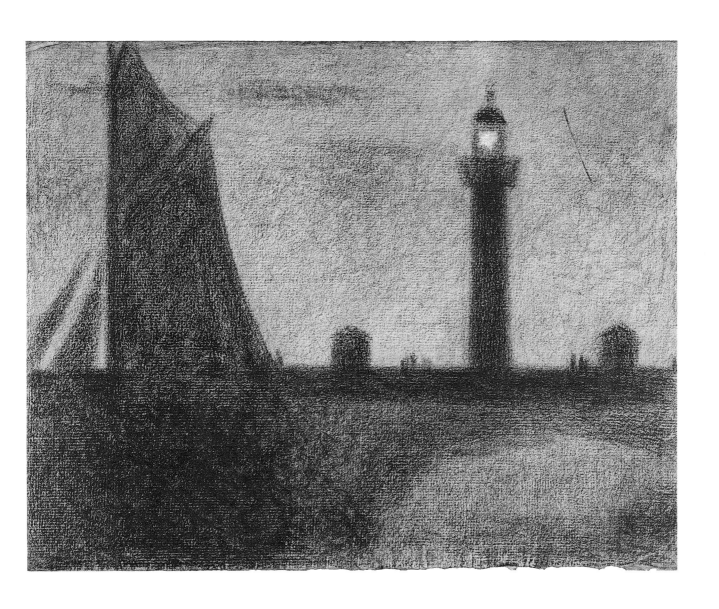

No. 62

Jean-François Raffaelli
French, Paris, 1850-1924

Landscape with Road Approaching the City

Charcoal with white paint on gray paper, 8.3 x 15.9 cm.
Signed in lower right: *J. F. RAFFAËLLI*.

Provenance: Unknown; acquired from Lock Galleries, New York, 1961.

Bibliography: Szabo, French Drawings, 1980, no. 63.

This haunting little landscape probably represents the gas tanks at Clichy. It is not dated, however, comparisons with other works of the artist date it to around 1880. At that time, Raffaelli was deeply involved in depicting the suburbs of Paris; this drawing probably belongs to the series showing the new sights and landscapes created by the industrial development. In 1878, the critic J.-K. Huysmans remarked about the artist: "Raffaelli is one of the few who had grasped the original beauty of these districts...It is a world apart, sad, dreary but for this very reason lonely and charming."

Among the few who discovered the special nature of the industrial-surburban landscape was Paul Signac. His *Gas Tanks at Clichy* of 1886, combines the vanishing rural charm of the suburb with the powerful and menacing shapes of encroaching factories and gas tanks (National Gallery of Victoria, Melbourne; F. Cachin, *Paul Signac,* New York, 1971, pp. 28-29, 34). But while Raffaelli still treated this new landscape in a melancholic genre, Signac stripped it to show the cruel intruding components and to illustrate Rimbaud's dictum "the suburbs are lost grotesquely in the countryside."

Paul Signac
French, Paris, 1863-1935

Windmills

China ink and brush on paper, 29.9 x 37.7 cm. Signed in ink in lower right corner: *P. Signac.*

Provenance: Unknown; acquired from Le Chapelin Gallery, Paris, 1961.

Bibliography: Szabo, Signac, 1977, no. 7; Szabo, Twentieth Century French Drawings, 1981, no. 28.

Although the drawing is not dated, it can be assumed the artist made it during his second journey to Holland in 1906. Its style with the broad brushstrokes is closely related to his drawings dating from this period.

Moreover, the long row of windmills is very reminiscent of those in Overschie, which appear in several of Signac's drawings dated to 1906 (G. Bessin, *Paul Signac,* Paris, 1954, no. 37).

No. 64

Paul Signac
French, Paris, 1863-1935

La Rochelle

Pen and china ink with brush on paper, 70 x 100 cm. Signed and dated in lower right corner: *Paul Signac, 1912.*

Provenance: Galerie Druet, Paris; Galerie Bernheim-Jeune, Paris; acquired from sale at Hotel Drouot, Paris, June 22, 1949, Lot 64.

Bibliography: M. Sandoz, "L'Oeuvre de Paul Signac à La Rochelle, Croix-de-Vie, Les Sables-d'Olonne de 1911 à 1930," *Bulletin de la Société de l'Histoire de l'Art Français,* Année 1955, Paris, 1956, pp. 160-182; Szabo, Signac, 1977, no. 8; Szabo, Twentieth Century French Drawings, 1981, no. 33.

Marc Sandoz devoted a detailed study and compiled a catalogue of those works of Signac which represent La Rochelle in various forms and media. According to him, between 1912 and 1928, the artist painted no less than eleven oils of this important and picturesque French port. The first of these, now in the Museum of Johannesburg (South Africa), shows a whole view of the busy harbor, as seen from the sea, with its various buildings, especially the four landmark towers.

Our large drawing is apparently a full-size preparatory study for this painting. Starting from the left, the four towers are the Tour à la Lanterne, with the spire; the Tour de la Chaine, the squat, round tower; the Tour de l'Horloge, with the clock in the center background; and finally the famous Tour Saint Nicholas, with its crenellated top at the right.

The drawing is executed with rapid lines and embellished with quick patches of gray and black wash. This is a rare document of Signac's working methods for the preparation of compositions in oil. L. Cousturier describes how the artist made a similar study for another painting, "On a paper the size of his canvas he summarized his thoughts in drawing. He would start developing with charcoal or China ink the principal arabesque, the point of departure of his emotion and its characteristic, then he would figure out the great curves by the power of the rhythm . . ." (*Paul Signac,* Paris, 1922, pp. 26-28).

The port of La Rochelle, with its vibrant colors and movements, continued to fascinate Signac for twenty more years. He continued to paint it on canvas and, later primarily in watercolors, one of which is in the Robert Lehman Collection (Szabo, *Signac,* 1977, no. 17).

Paul Signac
French, Paris, 1863-1935

Petit Andelys: The Barge

Watercolor over pencil on paper, 26.5 x 42.5 cm. Signed and inscribed in lower right corner: *Petit Andelys P. Signac.*

Provenance: Collection of Madame S(ignac), Paris; acquired from Galerie de l'Elysée, Paris, 1952.

Bibliography: Orangerie Cat., 1957, no. 147; Cincinnati Cat., 1959, no. 300; Szabo, Signac, 1977, no. 16; Szabo, Twentieth Century French Drawings, 1981, no. 44.

Signac frequently travelled and worked in the region of the Andelys between 1920 and 1929. Thus, this lucid watercolor should be dated to that period. Like in his seaport landscapes, the artist captured again the tranquility of the river and that of the buildings on the shore.

Paul Signac
French, Paris, 1863-1935

Le Croisic

Watercolor over pencil on paper, 25 x 40.8 cm. Signed, inscribed and dated in pencil in lower right corner: *2 Aout 28 Le Croisic P. Signac.*

Provenance: Collection of Madame S(ignac), Paris; acquired from Galerie de l'Elysée, Paris, 1952.

Bibliography: Szabo, Signac, 1977, no. 28; Szabo, Twentieth Century French Drawings, 1981, no. 38.

This small fishing village and port is in the Loire-Inferiéure province of France. Signac, who owned and sailed several sailing boats, frequently visited the small picturesque ports and depicted them mostly in light, fleeting watercolors.

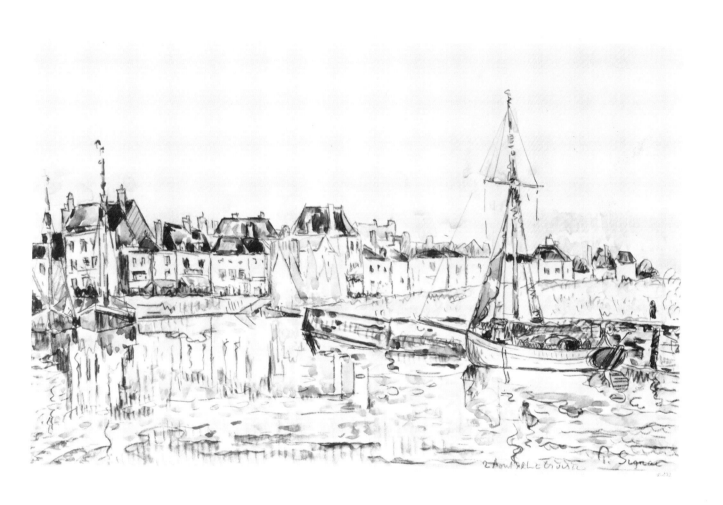

No. 67

Henri-Edmond Cross
French, Duoai, Paris, St.-Clair, 1856-1910

Landscape with Stars

Watercolor over pencil on paper, 20.5 x 32.5 cm. Stamped with oval red studio stamp in lower right corner: *H.E.C.*

Provenance: Collection of Madame S(ignac); acquired from Galerie de l'Elysée, Paris, 1952.

Bibliography: I. Compin, *H. E. Cross,* Paris, 1964, p. 343, fig. K; *From Delacroix to Cézanne, French Watercolor Landscapes of the Nineteenth Century,* University of Maryland Gallery, College Park, Maryland, 1977, no. 33, pp. 95, 157; Szabo, *French Drawings,* 1980, no. 23; *Ordrupgaard Cat.,* 1986, no. 38.

Henri-Edmond Cross - he changed his original name Delacroix - belonged to the same circle as Seurat and Signac, but was a latecomer to Neo-Impressionism and Pointillism. Only in 1881, when he settled in the south of France in St.-Clair, did he first paint in this style. His individual approach is characterized by the careful harmonization of the different color values; the hues of yellow, lavender, blue and green are brought together with firm, even strokes.

In her catalogue raisonné, Isabelle Compin places this striking aquarelle among those dated to around 1906.

Recently it was observed that, "the unique style and technique of *Landscape with Stars* makes it difficult to place chronologically within Cross' oeuvre. The shadowy wash landscape is set against the divided bright blues and yellows of the starry sky, visually combining two aspects -the decorative and the scientific" (*French Watercolor Landscapes,* no. 30). It is worthy to note here that Robert Lehman was especially fond of the oils and watercolors painted by the Pointillists, more than a dozen by Signac, several by Cross and by Petitjean are in his collection (*Ordrupgaard Cat.,* nos. 36-38, 45-49).

No. 68

Henri-Edmond Cross
French, Douai, Paris, St.-Clair, 1856-1910

Le Port or Le Cap Nègre

Watercolor over pencil on paper, 22 x 38 cm. Signed and dated in pencil in lower left corner: *Henri Edmond Cross 09.*

Provenance: Collection of Madame S(ignac), Paris; acquired from the Galerie de l'Elysée, Paris, 1952.

Bibliography: I. Compin, *Henri-Edmond Cross,* Paris, 1964, p. 345, fig. T; Szabo, *French Drawings,* 1980, no. 19.

One of the last watercolors by the artist, it is unusual that he signed and dated it. However, the provenance does offer an explanation. The sheet is from the collection of Madame Signac, so it is quite possible that Cross gave it to his friend, Paul Signac. As to the different titles, it could be assumed that *Le Port,* as given in the sales catalogue, was the more traditional (*Collection de Madame S. . . Tableaux modernes, dessins-aquarelles-pastels,* Galerie Charpentier, Paris, May 9, 1952, no. 2).

No. 69

Hippolyte Petitjean
French, Mâcon, Paris, 1854-1929

Landscape in Mâcon

Watercolor on paper, 32 x 42.7 cm. Rectangular red atelier stamp on lower right: *Atelier Hipp. Petitjean.*

Provenance: Unknown, possibly Mlle. Marcelle Petitjean, Paris.

Bibliography: Szabo, Twentieth Century French Drawings, 1981, no. 24.

Petitjean was a follower of Neo-Impressionism, not a participant in its achievements. He returned to the round brushstrokes and the round dots several times during his career. As R. Herbert remarks, "About 1912, perhaps realizing that his work lost decisive quality, Petitjean returned to the Neo-Impressionists palette and produced a great many watercolors and a few oils, of which the best are pure landscapes. With their characteristic round dots, rather widely spaced and showing white paper between, his watercolors are easily recognized..." (*Neo-Impressionism,* The Solomon R. Guggenheim Museum, New York, 1968, p. 79).

This landscape, showing Mâcon, illustrates the late flowering of Petitjean's pointillist leanings, possibly dating in the years from 1912 to 1914.

Pierre Laprade
French, Narbonne, Paris, Fontenay-aux-Roses, 1875-1932

Landscape in the Pyrénées at Arudy

Watercolor on paper, 11.1 x 15 cm. Inscribed in lower right corner: *A l'excellent ami Courtine. Laprade.* Also inscribed (under mat): *ARUDY (Basses Pyr.) 9 août 1902.*

Provenance: Unknown.

Bibliography: Szabo, Twentieth Century French Drawings, 1981, no. 14.

Laprade, together with Vuillard and Rouault, founded the Salon d'Automne in 1903. "He was a gentle, self-effacing figure who liked to venture into a world of mysteries without ever losing his common sense" (L. G. Cann, *Laprade,* Paris, 1930). He travelled widely. His journey to Italy made a lasting impression as shown in his paintings of parks, views, and terraces overlooking lakes.

According to most critics, his watercolors are his best work.

This small composition captures perfectly the image of the small village nestled among the harsh mountains. Despite its small size, it conveys a sense of monumentality, partly due to the deft juxaposition of the dark masses and the light foreground.

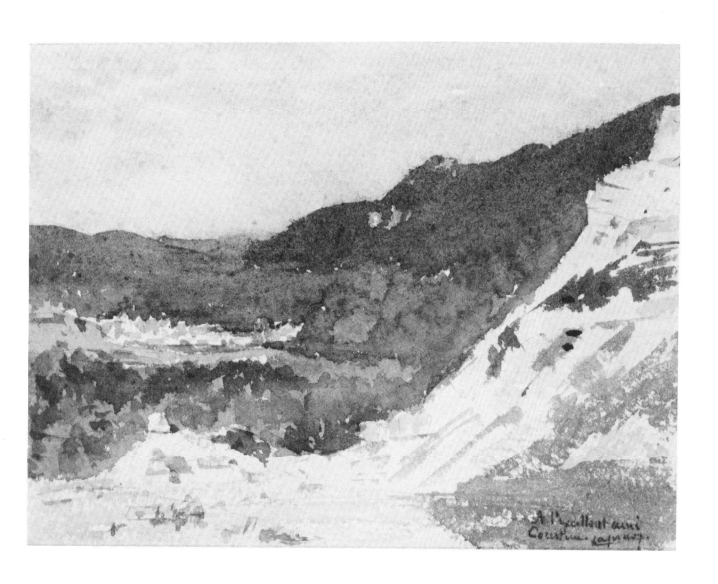

Maurice Utrillo
French, Paris, Dax (Landes), 1883-1955

Landscape

Pencil on paper, 33 x 49.5 cm. Signed in lower right corner: *Maurice Utrillo V.*

Provenance: Unknown, probably from the artist's estate; acquired from P. Pétridès, Paris.

Bibliography: Cincinnati Cat., 1959, no. 310; Szabo, Twentieth Century French Drawings, 1981, no. 49.

Maurice Utrillo, son of Suzanne Valadon - hence the V. in his signature - was the painter par excellence of the Monmartre in Paris. One of his finest oil-landscapes, representing the Rue Ravignan, is in the Robert Lehman Collection (Ordrupgaard Cat., 1986, no. 77).

The landscape on this drawing is, however, from the outside of Paris. It was drawn in Montmagny where Suzanne Valadon owned a small property and maintained a studio. Utrillo painted his first oils here between 1903-1906, while recovering from acute alcoholism. He returned many times to the tranquility of this small village. This drawing is not dated, but its strong lines and the dense foliage recall those compositions he made around 1912 (P. Pétridès, *L'Oeuvre complet de Maurice Utrillo,* Paris, 1974, nos. D92-94). Unfortunately, Utrillo never painted this landscape in oil.

No. 72

Maurice de Vlaminck
French, Paris, 1876-1958

Village Street: Boissy-les-Perches

Black ink applied with wooden stick on paper, 34.6 x 42.2 cm. Signed in lower left corner: *Vlaminck.*

Provenance: Unknown.

Bibliography: Cincinnati Cat., 1959, no. 308; Szabo, Twentieth Century French Drawings, 1981, no. 62.

This village street in Boissy-les-Perches, where the artist lived since 1925, can be identified by comparison with identical views in two etchings made by Vlaminck. The technique of strong lines and powerful contrasts of black and white is similar to his lithographs from the mid-1920s (K. von Walterskirchen, *Maurice de Vlaminck. Verzeichnis des Graphischen Werkes,* Bern, 1974, nos. 148, 157-160).

The strict monochrome of the drawing is quite a contrast to the exuberantly wild colors of Vlaminck's earlier paintings. With Derain, he was one of the original Fauves, who defied the traditions upheld by the academics and even by many of the Impressionists and Post-Impressionists. It is interesting to note that Robert Lehman was especially fond of Vlaminck's Fauve canvases. At one time he owned almost a dozen and several important ones are still in the Robert Lehman Collection (Ordrupgaard Cat., 1986, nos. 71-72).

No. 73

Pierre Bonnard
French, Fontenay-aux-Roses, Paris, Le Cannet, 1867-1947

Study with Window

Black pencil on paper, 26.6 x 21 cm. On recto: *The Goatherd* in black and red pencil. Signed in lower right: *Bonnard.*

Provenance: *Tableaux modernes, aquarelles-pastels-gouaches-dessins,* Hotel Drouot, Paris, July 4, 1949, Lot 2.

Bibliography: Szabo, Twentieth Century French Drawings, 1981, no. 5 a,b.

This quick sketch shows the landscape framed by a window, possibly a view from the artist's villa "Le Bosquet" in Le Cannet on the Riviera. The sheet is not dated, but the style of the nervous crosshatching on the recto and the character of the signature suggest a date in the late 1920s or early 1930s. This dating is confirmed by a number of similar compositions concentrating on and including windows painted by Bonnard during these years; the *Window at Le Cannet* of c. 1925 (The Tate Gallery, London) or *The Room on the Garden* (The Solomon R. Guggenheim Museum, New York) are the hallmarks (A. Ferminger, *Pierre Bonnard,* New York, 1969, pp. 23, 141-142).

The importance of the window in Bonnard's art is explained almost poetically in the reminiscences of Thadée Natanson, his friend; he writes, "Et lorsque enfin le paysage entrera par les fenêtres dans les chambres blanches de la maison du Cannet, elles conjugueront avec le sienne la richesse diversifiée des taches jaunes, orangées et des bleus de leur ronde joyeuse" (T. Natanson, *Le Bonnard que je propose, 1867-1947,* Genève, 1951, pp. 182-183).

Thus, this fleeting drawing might be a first *pensée* for a larger canvas. Its empty white spaces were filled in the artist's imagination with the diverse richness of yellows, oranges and blues.

✍ No. 74

André Dunoyer de Segonzac
French, Boussy-St. Antoine, Paris, 1884-1974

Landscape with Trees and Children

Pen and ink with wash on paper, 48.9 x 35.2 cm. Signed at lower left: *A. Dunoyer de Segonzac.*

Provenance: Unknown; acquired from Acquavella Galleries, New York, 1966.

Bibliography: *Dunoyer de Segonzac,* Acquavella Galleries, New York, 1966, no. 33; Szabo, Twentieth Century French Drawings, 1981, no. 9.

Although Dunoyer de Segonzac began to work on his own around 1906 and spent his entire life in Paris, he is still relatively unknown. Before the First World War he knew Max Jacob and Apollinaire intimately, both of whom admired his art. He also had friends among the Cubists and mingled with the Fauves. Vollard supported his art and he made illustrations for the books by Colette (P. Jamat, *Dunoyer de Segonzac,* Paris, 1929; *Dunoyer de Segonzac,* Orangerie des Tuileries, Paris, 1976).

As it was observed by many French critics and phrased by an American, "Segonzac chooses to stand apart, often at the price of appearing out of date. He has resisted all theories and fashions and has neither influenced nor been influenced by any of his confrères throughout his long career. Ever since he discovered early in the century that he had a facility for drawing figures and landscapes, he has put all his energies into his draughtsmanship, almost to the exclusion of everything else. Whether it is in pen and ink, or copper plate, or washed over with watercolor, the drawing is paramount to anything he produces" (M. Amaya, "The Quality of Segonzac," *Apollo,* 76, 1962, pp. 294-295).

This drawing from the early 1950s could serve as an illustration to this acclaim. It is simple both in subject and technique, but still powerful in the representation of the tall trees and their intricate pattern. By comparison to other drawings by Dunoyer de Segonzac, it might have been drawn in St. Tropez or in the Provence (M.-P. Fouchet, *Segonzac, Saint Tropez et la Provence,* Paris, 1965, pl. 11).

à Dunoyer de Segonzac

197

CATALOGUE
ABBREVIATIONS AND BIBLIOGRAPHY

Bean, 1960.
Bayonne, Musée Bonnat. *Les dessins italiens de la collection Bonnat.*
Catalogue by Jacob Bean. Paris, 1960.

Bean-Stampfle, 1965.
New York, The Metropolitan Museum of Art. *Drawings from New York
Collections. I. The Italian Renaissance.* Catalogue by Jacob Bean and Felice
Stampfle. New York, 1965.

Berenson, 1938.
Berenson, Bernard. *The Drawings of the Florentine Painters.* Amplified ed.
3 vols. Chicago, 1938.

Berenson, 1961.
Berenson, Bernard. *I disegni dei pittori fiorentini.* Rev. ed. 3 vols. Milano,
1961.

Cincinnati Cat., 1959.
Cincinnati Art Museum. *The Lehman Collection.* Cincinnati, 1959.

Columbia Exh., 1959.
New York, M. Knoedler and Co. *Great Master Drawings of Seven
Centuries. A Benefit Exhibition of Columbia University.* New York, 1959.

Douglas, R. Langton, 1946.
Douglas, R. Langton. *Piero di Cosimo.* Chicago, 1946.

Fleming, 1958.
Fleming, John. "Mr. Kent, Art Dealer and the Fra Bartolommeo
Drawings," *Connoisseur,* LXLI (1958), p. 227.

Fry, 1906-1907.
Fry, Roger. Vasari Society. *Drawings by Old Masters.* 1st series, II, no.
14. London, 1906-7.

Grassi Sale Cat., 1924.
London, Sotheby & Co. *Catalogue of Important Drawings by Old Masters
Mainly of the Italian School---Sold 13 May 1924.* London, 1924.

Heinemann, 1962
Heinemann, Fritz. *Giovanni Bellini e I Belleiniani.* Venezia, 1962.

Images of Love and Death, 1975.
University of Michigan Museum of Art. *Images of Love and Death in Late
Medieval and Renaissance Art.* Catalogue by William R. Levin. Ann
Arbor, Mich., 1975.

Kennedy, 1959.
Kennedy, Ruth Wedgwood. "A Landscape Drawing by Fra
Bartolommeo," *Smith College Museum of Art, Bulletin,* no. 39 (1959), pp.
1-12.

Master Drawings, 1934.
Buffalo Fine Arts Academy, Albright Art Gallery. *Master Drawings,
Selected from the Museums and Private Collections of America.* Buffalo,
1934.

Morassi, 1959.
Morassi, Antonio. *Venezianische Handzeichnungen des XVIII Jahrhundert
aus der Sammlung Paul Wallraf.* Köln, 1959.

Oberhuber-Walker, 1973.
Oberhuber, Konrad and Dean, Walker. *Sixteenth Century Italian Drawings
from the Collection of Janos Scholz.* Washington, D.C., 1973.

Orangerie Cat., 1957.
Paris, Musée de l'Orangerie. *Exposition de la collection Lehman de New
York.* 2d ed. Paris, 1957.

Ordrupgaard Cat., 1986.
Szabo, George. *Franske mestervaerker - French Masterpieces. XIX and XX
Century Paintings and Drawings from The Robert Lehman Collection of the
Metropolitan Museum of Art.* Ordrupgaardsamlingen, Kobenhavn, 1986.

Parker, 1927.
Parker, K.T. *North Italian Drawings of the Quattrocento.* London, 1927.

Pignatti, 1974.
Pignatti, Terisio. *Venetian Drawings from American Collections. Catalogue
of a Loan Exhibition, Organized and Circulated by the International
Exhibitions Foundation.* Washington, D.C., 1974.

Popham, 1937.
Popham, A. E. "The Drawings at the Burlington Fine Arts Club,"
Burlington Magazine, LIX (1937), pp. 85-87.

Puppi, 1962.
Puppi, Lionello. *Bartolomeo Montagna.* Venezia, 1962.

Ragghianti, 1972.
Ragghianti, Carlo Ludovico. "Bonnatiana, I," *Critica d'Arte,* XLII (1972),
pp. 116-134.

Rembrandt After Three Hundred Years, 1969.
Art Institute of Chicago. *Rembrandt After Three Hundred Years.*
Exhibition Catalogue. Chicago, 1969.

Ruhmer, 1958.
Ruhmer, Eberhard. "Bernardo Parentino und der Stecher PP," *Arte
Veneta,* XII (1958), pp. 38-42.

Szabo, 1975.
New York, The Metropolitan Museum of Art. *The Robert Lehman
Collection. A Guide.* Text by George Szabo. New York, 1975.

Szabo, 1977.
Tokyo, National Museum of Western Art. *Renaissance Decorative Arts
from the Robert Lehman Collection of the Metropolitan Museum of Art,*
New York. Text by George Szabo, in Japanese with English titles. Tokyo,
1977.

Szabo, Signac, 1977.
New York, The Metropolitan Museum of Art. *P. Signac (1863-1935).
Paintings, Watercolors, Drawings and Prints.* Catalogue by George Szabo.
New York, 1977.

Szabo, 1978.
New York, The Metropolitan Museum of Art. *XV Century Italian
Drawings from the Robert Lehman Collection.* Catalogue by George Szabo.
New York, 1978.

Szabo, Northern Drawings, 1978.
New York, The Metropolitan Museum of Art. *XV-XVI Century
Northern Drawings from the Robert Lehman Collection.* Catalogue by
George Szabo. New York, 1978.

Szabo, 1979.
New York, The Metropolitan Museum of Art. *XVI Century Italian Drawings from the Robert Lehman Collection.* Catalogue by George Szabo. New York, 1979.

Szabo, Dutch and Flemish Drawings, 1979.
New York, The Metropolitan Museum of Art. *Seventeenth Century Dutch and Flemish Drawings from the Robert Lehman Collection.* Catalogue by George Szabo. New York, 1979.

Szabo, 1980.
New York, The Metropolitan Museum of Art. *Seventeenth and Eighteenth Century French Drawings from the Robert Lehman Collection.* Catalogue by George Szabo. New York, 1980.

Szabo, French Drawings, 1980.
New York, The Metropolitan Museum of Art. *19th Century French Drawings from the Robert Lehman Collection.* Catalogue by George Szabo. New York, 1980.

Szabo, 1981.
New York, The Metropolitan Museum of Art. *Eighteenth Century Italian Drawings from the Robert Lehman Collection.* Catalogue by George Szabo. New York, 1981.

Szabo, Twentieth Century French Drawings, 1981.
New York, The Metropolitan Museum of Art. *Twentieth Century French Drawings from the Robert Lehman Collection.* Catalogue by George Szabo. New York, 1981.

Szabo, 1982.
Szabo, George. *I grandi disegni italiani della Collezione Lehman al Metropolitan Museum di New York.* Milano, 1982.

Szabo, 1983.
Szabo, George. *Masterpieces of Italian Drawing in the Robert Lehman Collection.* The Metropolitan Museum of Art. New York, 1983.

Szabo, Eighteenth Century Italian Drawings, 1983.
Szabo, George. *Eighteenth Century Italian Drawings from the Robert Lehman Collection of the Metropolitan Museum of Art.* Calalogue of an Exhibition Organized and Circulated by the International Exhibitions Foundation. Washington, D.C., 1983.

Szabo, 1985.
Szabo, George. *Eighteenth Century Venetian Drawings from the Robert Lehman Collection of the Metropolitan Museum of Art.* The Frick Museum, Pittsburgh, 1985.

Wazbinski, 1968.
Wazbinski, Zygmunt. "'Vir Melancholicus.' Z dziejow renesansowego obrazowania geniusza," *Folia historiae artium,* V (1968), pp. 5-17.